Entrepreneurship for the Cultural Industries

Artists, musicians, actors, singers, designers and other creative individuals need to understand basic business concepts if they are to successfully pursue their chosen artistic profession. These skills have historically not been taught to creative students, which leaves them unprepared to make a living from their artistic efforts. *Entrepreneurship for the Creative and Cultural Industries* will teach the basics of business in a way that is relevant to the challenges of running a small business marketing a creative product.

Whether it is understanding the basics of business language, appreciating the crucial importance of finance, or using social media marketing, this innovative textbook covers the entrepreneurial skills required to succeed in the creative sector. Including advice from artists who have turned their idea into a profitable business and worksheets that can be combined into a simple business plan, Kolb helps non-business-minded creatives to understand everything they need to succeed in the increasingly competitive creative economy.

This textbook is essential reading for non-business students who are looking to understand the business side of the creative sector, while its practical style will also suit recent graduates in these industries.

Bonita M. Kolb is Associate Professor of Business Administration at Lycoming College, USA.

Mastering Management in the Creative and Cultural Industries

Edited by Ruth Rentschler

Creative and cultural industries account for a significant share of the global economy and working in these sectors is proving increasingly popular for graduates across a wide array of educational institutions. Business and Management skills are a vital part of the future of these sectors, and there are a growing number of degree schemes reflecting this.

This series provides a range of relatively short textbooks covering all the key business and management themes of interest within the creative and cultural industries. With consistent production quality, pedagogical features and writing style, each book provides essential reading for a core unit of any arts/cultural management or creative industries degree and the series as a whole provides a comprehensive resource for those studying in this field.

Entrepreneurship for the Creative and Cultural Industries
Bonita M. Kolb

Entrepreneurship for the Creative and Cultural Industries

Bonita M. Kolb

Routledge
Taylor & Francis Group

LONDON AND NEW YORK

First published 2015
by Routledge
2 Park Square, Milton Park, Abingdon, Oxon OX14 4RN

and by Routledge
711 Third Avenue, New York, NY 10017

Routledge is an imprint of the Taylor & Francis Group, an informa business

Simultaneously published in the USA and Canada

British Library Cataloguing in Publication Data
A catalogue record for this book is available from the British Library

Library of Congress Cataloging in Publication Data
Kolb, Bonita M.
 Entrepreneurship for the creative and cultural industries / Bonita M. Kolb.
 pages cm. – (Mastering management in the creative and cultural industries)
 Includes bibliographical references and index.
 1. Artists. 2. Entrepreneurship. 3. Arts–Marketing. 4. Arts–Economic aspects. 5.
Cultural industries–Management. I. Title.
 NX163.K66 2015
 700.68–dc23
 2014040038

ISBN: 978-1-138-01953-9 (hbk)
ISBN: 978-1-138-01954-6 (pbk)
ISBN: 978-1-315-77890-7 (ebk)

Typeset in Bembo
by Taylor & Francis Books

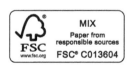

MIX
Paper from
responsible sources
FSC
www.fsc.org FSC® C013604

Printed and bound by CPI Group (UK) Ltd, Croydon, CR0 4YY

Contents

List of illustrations vii

Introduction 1

PART 1
Finding your entrepreneurial inspiration 5

1 Art, culture and entrepreneurship 7

2 Making the dream a reality 24

3 Researching competitors and customers 41

PART 2
Creating your entrepreneurial business 59

4 Analyzing the product and its benefits 61

5 Targeting the right customer 79

6 Mastering the numbers 97

7 Distributing your product 114

8 Promoting the creative product 132

9 Building social media relationships 149

PART 3
Growing your business to the next level 167

10 Financial concepts for success 169

11 Expanding the business 186

12 Legal and management issues for growth 203

Appendix: Business plan template for creative industries and
cultural organizations 221
Index 227

Illustrations

Figures

A.1 Sample Income Statement 224
A.2 Sample Balance Sheet 225
A.3 Sample Cash Flow Statement 226

Table

1.1 Business structures 14

Boxes

What creatives have to say: Helena Vyvozilová 7
What do industry and artists have in common? They are both
needed by designers. 10
What makes an artist a success? 17
What creatives have to say: Jenny-Lind Angel 24
Even organizations of arts intermediaries have missions 26
Sample mission statements 28
What creatives have to say: Stephanie Robinson 41
Trade associations already know 47
Assessing your competitors 54
What creatives have to say: David Ruess 61
Why do corporations buy art? 66
Art versus craft – does it matter? 69
More than a package 71
What creatives have to say: Allison Lyke 79
Understanding your community as customers 85
Why people buy art 90
What creatives have to say: Chelsea Moore 97
Learn the lessons before you price 102
Choosing your bank 106
What creatives have to say: Leenda Bonilla 114

Living the artist lifestyle	120
MakeWork in Chattanooga	128
What creatives have to say: Hillary Frisbie	132
Brand success	134
Using online marketplaces	144
What creatives have to say: Jonathan Chang	149
Sharing your brand on social media	157
Simple rules for social media success	160
What creatives have to say: Mariko Tanaka	169
Research before you sign	171
How much is an artist worth per hour?	174
What creatives have to say: Amanda Horn Gunderson and Bill Ciabattri	186
You don't have to use a gallery	191
Everyone wants economic development	196
What creatives have to say: Sean Farley	203
Getting the learning you need	209
Creative workers are critical in achieving city livability	211
Top ten reasons to copyright	213
Sometimes you have to say goodbye	218

Introduction

Many creative people have known that they are artists, musicians, writers, designers and performers from a young age. They may have spent years at a university, college, art school or conservatory being inspired, finding role models and perfecting techniques. During this exciting few years of their lives, not much may have been said about what awaits them after they graduate.

Of course, in uncertain economic times, any student graduating from university is no longer guaranteed a job. If this is true of students graduating with degrees in such career fields as business, law and teaching, it is even truer in the creative fields. Some students will be lucky enough to support themselves by becoming full-time artists, musicians, writers, designers or performers. But what is to become of the other talented creative graduates?

There are other approaches to structuring a life for creative individuals that involve entrepreneurship. They may decide to start their own business selling their creative work. Even if they decide to take a position in an existing for-profit creative industry or a nonprofit cultural organization, they will quickly learn that both exist in highly competitive environments where entrepreneurial skill will be valued.

What is an entrepreneur? The traditional definition has always contained the words that it is the person who organizes, manages and assumes the risk of a business. The newer definitions have expanded the definition to include any enterprise, whether a business, a government agency or a nonprofit organization. Also included in new definitions is the word initiative. Entrepreneurship requires an individual to take a leadership role, rather than just follow directions. It requires someone who can see a possibility and then make the possibility a reality. Of course this is the process that all creative individuals incorporate into their own work. Using the information in this book, creative people can now not only create a product, they can create a new business or nonprofit opportunity.

The business plan

Whether creative individuals decide to work in an existing organization, start their own business, or both, they need to understand how to take the idea for a product or service and turn it into a reality by writing a business plan. Being entrepreneurial is not unlike the creative process that an artist undertakes from the first inspiration to

the completed artwork. The process begins with exploration of an idea, continues with creation of the object and then finally ends with installation or performance.

The entrepreneurial process begins with exploring the consumer marketplace to discover how a product produced by the creative individual or organization provides a unique benefit that is different from the products of competitors. The entrepreneur will then analyze the product, find the right customers and decide on pricing, distribution and promotion. Once the business plan is created, the final step is implementation. This includes financial, legal and management issues. While entrepreneurship may not be for everyone, understanding how businesses function will make anyone a more valued employee.

Part 1: Finding your entrepreneurial inspiration

There are some basic entrepreneurial concepts that must be understood before a business plan can be created. These concepts are covered in the first three chapters of the book. The first chapter covers creativity and culture as a business. While both may be universal, society's view of what is art and the monetary value of art has changed. In addition to explaining basic business concepts Chapter 1 will discuss how this changing view has affected the production, distribution and purchase of cultural products. While there are opposing views of the difference between art and craft, the entrepreneurial process is the same for both. In addition, while most creative businesses are for profit, while cultural organizations are nonprofit, both follow the same structure when developing a business plan.

Chapter 2 will start with the necessity of determining the artist's own mission, vision and values, and those of the potential creative business. After doing so, there needs to be an honest appraisal of the internal resources of the creative entrepreneur, including financial and personal qualities. Next, the external environment in which the business exists needs to be examined, including competitors, sociocultural changes, technological developments and economic conditions. After this, information is gathered and strengths, weaknesses, threats and opportunities are analyzed. Finally, marketing goals, objectives and tactics must be determined. Of course, creative individuals may not be aware of the external environment. They may also be unsure as to whom to target as a customer. For these reasons, Chapter 3 will focus on research methods.

Part 2: Creating your entrepreneurial business

The first step in starting a business is to determine the match between the product benefits and customer desires. To find this match, the creative business owner must first understand the benefits that the product provides to customers. Therefore Chapter 4 discusses how to analyze the core, actual, augmented and ancillary benefits of a product. This analysis will enable the creative entrepreneur to decide upon their competitive advantage. The creative entrepreneur then must find a group of consumers who are interested in purchasing the product so that they can obtain these benefits. Chapter 5 analyzes who will be targeted as customers, using

geographic, demographic and psychographic characteristics. While creative individuals may wish to skip this step, usually because they believe so strongly in their creative efforts that they assume everyone will purchase, in fact without this step any success will be pure luck.

Chapter 6 will explain the concepts of revenue, cost of goods sold, operating expenses and profit. In addition, pricing models will be discussed, as the ability to choose the correct price is essential to ensure the organization's financial survival. Many entrepreneurs do not consider how to distribute their product. Chapter 7 covers direct distribution channels using a studio, a shop, online or fairs. In addition, indirect methods including retailers are discussed.

Finally, creative entrepreneurs are ready to develop a promotion plan. Chapter 8 covers the importance of branding and also explains the need for a marketing message that communicates product benefits. This message can be communicated through the traditional promotional methods of advertising, sales incentive, public relations and personal selling. With the increased use of social media in promotion, the new distinction of owned, paid and earned media must be understood. Chapter 9, therefore, explains how to develop a social media strategy that also incorporates traditional promotional methods.

Part 3: Growing your business to the next level

Once the business is launched, other knowledge areas must be understood if the business is to grow. Chapter 10 provides additional financial information including banking, sources of funding and financial statements. Chapter 11 covers additional distribution options and logistical issues. In addition, the chapter will cover how to take advantage of various programs provided by communities seeking to encourage economic development through creative businesses. Finally Chapter 12 provides helpful information on legal and tax issues. Because a successful creative entrepreneur may wish to add employees, the chapter also includes basic information on the hiring process.

Additional resources

At the end of each of the chapters are exercises that will help with writing a business plan. In the Appendix is the outline for the business plan along with which chapters will help provide the needed information. In addition, sample financial statements are included.

Part 1

Finding your entrepreneurial inspiration

This is where you start the journey; not with a musical instrument, or an artistic medium but with an idea. You are already creative – now you need to find how your creativity can earn you an income.

Chapter 1: Art, culture and entrepreneurship
Chapter 2: Making the dream a reality
Chapter 3: Researching competitors and customers

> Well-matured and well-disciplined talent is always sure of a market, provided it exerts itself: but it must not cower at home and expect to be sought for.
> Washington Irving, letter to Pierre Paris Irving, 1824

1 Art, culture and entrepreneurship

Introduction

Individual artists, creative industries and even cultural organizations have always been businesses, although not all have been successful at the pricing, marketing and distribution of what they produce. In fact some creative individuals reject the idea that art and culture should be considered a business, believing that they should be kept separate from the commercial world. However, art and culture has always been priced, distributed and promoted. In the past these activities were often undertaken by the promoter, agent or gallery that sold the work, rather than the creator. Today, communication technology allows creative individuals to promote and sell directly to potential customers. However, few creative individuals have been taught the skills to be successful business people as business involves more than creating a product.

The mission of this book is to teach an understanding of the fundamental skills of entrepreneurship so that creative individuals can successfully start their own businesses, run for-profit creative industries or manage nonprofit cultural organizations. By learning the skills of business, creative individuals can then spend more time on producing their art or cultural product as they are freed from the need to hold a second job to bring in income. In addition, if creative individuals working in nonprofits can increase the organization's revenue, they can spend less time and effort on fundraising. These artist/business people who run their own small businesses focused on selling their artistic product or manage creative or cultural organizations are often referred to as creative entrepreneurs or sometimes simply creatives. To be successful, creative entrepreneurs must learn the various business structures and ownership models that can be used. Second, the unique features of creative entrepreneurial startups must be appreciated. Finally, the uses and components of a business plan must be understood.

What creatives have to say: Helena Vyvozilová

Helena doesn't think of it as selling, but her company provides music groups and ensembles for any type of occasion. In addition, she also organizes events for clients: anything from team building to galas. Helena markets

online but gets most of her new clients through personal recommendations. She prides herself on providing a service that is highly personalized. In terms of business skills, Helena wishes that earlier she had been:

- more patient as business builds over time;
- more proactive in raising funds;
- less idealistic, with more insight into cruel reality.

You can see Helena's work at www.hmmanagement.cz.

Art and people

A first step in understanding the relationship between art, culture and business is to review how society's view of art has changed. The common definition of art is that it is something that is produced by a professional artist solely for contemplation and not for use. However, this definition of art as an object that is the individual expression of an artist with no utilitarian function became accepted only in the eighteenth century (Staniszewski 1995). Prior to this time, art objects and performances were considered an expression of a society's culture. The art created, rather than being focused only on the artist's vision, was expected to be a visible production of a society's values and beliefs.

As a result, the objects were produced not as art, even though they may now be considered art, but to meet specific human needs. These needs were pragmatic ones, such as creating pottery dishes for eating, but they also included spiritual needs, such as statues or music for worship. Both types of objects, those to meet pragmatic and those to meet spiritual needs, were created to express the values of the society's culture. It was not considered necessary for the artist to incorporate a personal vision into the product.

In fact it is a modern invention to think of an individual's inner vision as necessary to produce art. In earlier historical times, only technical skills were considered necessary to produce the object (Greffe 2002). The object might have been considered beautiful or meaningful by its users, but the first purpose was for it to be useful. Technical skill, not vision, was considered necessary to produce art.

During the Renaissance art was elevated above the level of a mechanical skill. However, the creation of art was still considered to be a skill that could be learned. It was not until the eighteenth century that vision and genius were added to technical skill as what was necessary for the production of art. While fine artists might have wished to gain technical skill so as to better create their vision, technical skills alone were not enough to be considered an artist. To be a true artist, vision was essential.

Valuing the art product – aesthetic, financial or both

Since individuals with artistic vision were rare, their creations, besides having aesthetic value as art, would have value as a scarce commodity. In the Middle Ages these

rare objects were only affordable by royal courts and churches. However, with the rise of the market economy during the eighteenth century, merchants also had the wealth to purchase art. These merchants may have purchased art because they wished to enjoy the beauty of the object and the satisfaction of sharing in the artist's unique vision. However, the value of art does not come only from the object itself, but it also results from the scarcity of the art object (Budd 1995). Merchants understood the value of a scarce commodity and also bought art because it would retain its value and could be resold at a profit.

Highbrow/Lowbrow: The distinction between art versus craft has been explained as art being the expression of the inner vision of the artist, while craft is made for the appreciation of someone else. However, craft can also be the result of an inner vision, even though the objects produced are also meant to be useful to the consumer. A means to understand the artificial division between those who decide the definition of art and the judgment of consumers can be seen in the distinction between highbrow and lowbrow culture that developed in the seventeenth century (Woodmansee 1994). Those in the upper classes were disappointed that, as more people had the money to pay for artistic objects or performances, they did not choose what was considered high art but instead spent their money on popular entertainment such as romantic novels and music hall performances. The upper classes believed that the choice not to attend high art must have been because of a lack of intelligence. If the public is not willing to pay for art, that is the fault of the public and not the art. Under this view, art that is popular with the public cannot be good (Gans 1997). Therefore people who enjoyed popular culture were considered less intelligent, hence the term, dumbing down, used to refer to the popularization of culture.

Traditionally, high art has been considered to communicate an inner truth that should be contemplated disinterestedly for its internal attributes, not for external aesthetics. Such high art was considered beyond the vulgar concept of price, although its purchase provided both intellectual and financial status to its owner. While the upper classes thought price consideration vulgar, many famous artists were very interested in earning money. The artists employed in Italy during the Renaissance were savvy businessmen. Even Shakespeare's plays were written and produced for profit derived from ticket sales (Levine 1988). Theatrical companies wrote contracts, demanded fees that they thought were commensurate with their talent and would walk away if the commission was not satisfactory.

Value of Art: Art, therefore, has two values: its aesthetic value and its monetary value. Of course these two values can be combined in the purchase motivation of the customer. An individual can highly value the aesthetic value of a work of art and therefore be willing to pay an amount of money commensurate with this aesthetic value. Or an individual may buy a work of art simply for the monetary value. In this case, whether the individual believes the work of art has aesthetic value is unimportant as long as the artwork retains monetary value and can be resold at a future date at a profit. Of course an individual may believe the work has both aesthetic and monetary value. In this case the work will be bought both for enjoyment but also for resale if the need for cash arises.

Individuals who are buying art for personal enjoyment of its aesthetic appeal may make a purchase decision based solely on what they like. However, if individuals are also buying for its monetary value, as they may sell the art work in the future, they will most likely ask the advice of someone who is knowledgeable in the field, such as a dealer, gallery owner, agent or promoter.

Question to consider: How do I believe art and culture should be valued?

What do industry and artists have in common? They are both needed by designers.

The Rudy Art Class Studio, founded in 1897 and located in Pennsylvania in the United States, has artisan roots. However, it now does architectural glass fabrication for large projects. While it can meet the needs of these customers, it also wanted to serve small designers who needed a unique product. As a result, the Rudy Art Collective, consisting of metalworkers, glass makers and woodworkers, was formed. Now designers have a one-stop shop where they can find creative products for their clients.

A disadvantage of belonging to the collective is that the individual artist does not have complete control of a project. However, the strength of the collective is that the members bring complementary skills and the artists can be inspired by the work of others. The most important benefit to the individual artist members in collaborating with a large industrial company as part of the collective is that they now have access to clients who previously would not have sought them out. While working for industry, members of the collective still consider themselves to be artists and have mounted shows of the collaborative work that has been completed.

As is explained on the collective's Facebook page, "Rudy Collective combines artistry + industry. We are artists, craftsmen, and engineers who transform architectural concepts into artistic fabrication."

Rudy Collective and Burkey 2013

Question to consider: Are there local industries that might find my creative talents useful in meeting their clients' needs?

The business of art

Potential customers for art and culture are divided into a consumer market, where products are bought by individuals for personal use, and the business market, where products are bought by organizations to be either resold or used in the production of other products. In the consumer market for art, individuals purchase art for their own

use, for display in their homes or to give as gifts. Marketing to the consumer marketplace stresses the personal benefits that will be received from ownership.

The business market for art includes organizations such as educational institutions, civic organizations and corporations that purchase art for display in public spaces or offices, or to add to collections. When marketing to businesses, rather than personal benefits, the quality and price of the artistic product are promoted.

Art intermediaries – between the creator and the purchaser

When organizations, such as galleries and dealers, purchase art for later resale to consumers, they are acting as intermediaries. The artist has a choice when selling a work of art of using an intermediary or selling the work directly to the consumer. Historically it was difficult for artists to sell directly to the consumer as they did not have the ability to easily promote and distribute their work. Since few people have the desire to purchase art, intermediaries were needed to locate potential customers and market the artist's work. While the advantage of intermediaries is that they promote the art, the disadvantage is that they also take part of the profit.

It has been advances in communication technology and the ability to conduct electronic commerce that has made it easier for creatives to promote directly. Social networking sites increase the ability to promote directly to consumers by allowing two-way communication between the creative and the consumer about the features and benefits of the product. Advances in payment technology provide the ability to process monetary transactions from anyone, anywhere, allowing the creative entrepreneur to obtain payment without being physically present. As a result of communication and payment technology, artists can now act as their own intermediaries by creating online studios, promoting via social media and selling their work directly to consumers.

Creative entrepreneurs who create performance-based art, such as music, theatre and dance, also face the decision of whether to use intermediaries or to sell directly to consumers. A performance intermediary is the agent who will book venues for a percentage of the revenue. If the concert is poorly attended, the performers still must be paid the contracted amount. Because of this financial risk agents are often only interested in acting as intermediaries for performers who are already brand names as this makes selling tickets easier. If the performers act as their own intermediary, they contract for a venue and then promote and sell tickets directly to consumers. The performers will bear the risk if tickets do not sell, as they must still pay for the venue. Therefore they must spend the time and money to promote the event. However, they will also have the advantage of directly benefiting from higher ticket sales.

Question to consider: Will I be using an intermediary or I will I deal directly with the customers?

Business defined

It can be argued that creativity and business are a natural fit. In fact it can be argued that entrepreneurship is just another means of creative expression (Hansen 2014). Creatives are by nature innovative and driven, which are also two of the necessary components of business success. However, in the past it was difficult for an artist to have the time to create their artistic product while also managing a business. As discussed early, technology now makes promotion and selling of a product directly to consumers easier. However, there is another reason for more creatives to be interested in marketing their products or organizations. With the decline of grant funding from government sources, it has become increasingly necessary for creatives to obtain revenue through sale of their products.

Creatives are willing to take risks in the creation of new artistic work because of a strong belief in the quality of what they produce (Cowen 1998). This same belief in how a product will benefit consumers is what defines the successful entrepreneur. For both the creative and the entrepreneur, financial success is not the ultimate goal, but rather money is a means to an end. For traditional entrepreneurs, financial success is proof that their product provides benefits to the consumer, and the financial rewards enable the company to grow. For creative entrepreneurs, financial success means that their work is appreciated by the public, and the money is a means to pay the bills, buy more materials and have the freedom to be more creative.

Unfortunately, few universities offer students enrolled in music, art, design and theatre programs classes that teach basic business skills. Even if it is recognized that the skills of management, marketing and finance should be learned, the classes to teach the subjects are not offered to creatives. This is unfortunate as especially needed by students enrolled in both arts-related and cultural management programs are classes that teach the entrepreneurial skills needed for a startup business (Bauer *et al.* 2011).

Types of organizations – all businesses are organizations, but not all organizations are businesses

All businesses are organizations, but not all organizations are businesses. Organizations are simply groups of people who share a common goal. The major forms of organizations are government, nonprofit and business, which differ by ownership, taxation and purpose.

Government: Government organizations are formed by elected officials. The purpose of these organizations is to provide core government functions such as education, health or social welfare needs. They can also have as their purpose enhancing the lives of the citizens though maintaining facilities such as parks, theatres and museums. These government organizations can be formed at the national or regional level. They can even be specific to a single community. The people who work in government organizations are paid from taxes or through the sale of nationally owned resources.

Nonprofits: Some organizations are started by groups of people to address specific public needs that are not being met by government or business. Nonprofit organizations, which can also be called non-governmental organizations or charities, are formed by concerned citizens who feel the desire to solve a social problem. They

include arts and cultural organizations, health and human services agencies, and religious institutions. Whether they provide services along with government agencies or instead of government agencies will vary from country to country.

These organizations may receive money directly from those served through fees or payments. However, even when this is true, there is still not enough revenue from these sources to cover expenses. Therefore nonprofit organizations must receive additional revenue through government grants or private contributions. It is the lack of the necessary level of revenue to provide a profit that keeps businesses from being interested in providing these services. Because nonprofit organizations are providing a public service that cannot be served by businesses, in many countries they are tax exempt. Cultural organizations are often nonprofits, so they need to engage in fundraising to have adequate revenue to survive. However, donors are more likely to support entrepreneurial nonprofits that understand business as they are more likely to be successful in meeting their mission.

Businesses: Businesses are created by a single person or a group of people to provide a product in exchange for money. The product that is provided can be a tangible good or a service. In business the money received from sales must cover the expense of producing the tangible product or providing the service. In addition there must be enough revenue to cover the overhead expenses of the business and also to provide a profit to support the business owners. Any additional profit can then either be spent, saved or reinvested in the business. Business taxes are a major form of revenue for governments. Creative industries, such as design, fashion and technology along with individual businesses started by artists, are for-profit businesses.

Question to consider: Will I be forming a nonprofit or starting a business?

Business structures

If a creative entrepreneur wishes to start a business, a decision must be made as to its structure. A business can be organized in four different ways that either increase or lessen the financial risk and financial reward. A business can be organized as a sole proprietorship, a partnership, a corporation or a cooperative (Table 1.1).

Sole proprietorship – going it alone

A sole proprietorship is a business owned and managed by a single person. The owner bears all the financial risk if the business loses money but will also receive all the financial reward if there are profits. Most small businesses, including creative startups, are structured in this manner. While bearing all financial risk, the advantage of a sole proprietorship is that decision making does not need to be shared and entrepreneurs can create their own vision of the company. This is appealing to the creative entrepreneur who does not wish to make compromises on the type of product that will be produced or the mission of the organization. Many creative

Table 1.1 Business structures

Business/Organization	Advantage	Disadvantages
Sole proprietorship	No sharing of decisions	Sole financial risk
Partnership	Two sources of funds/ideas	Risk of disagreements
Corporation	Protects personal funds	Legal/financial paperwork
Cooperative	Shared expenses	No control over products
Nonprofit	No taxation	Answerable to board

entrepreneurs start a business with the intention to remain small so that they can retain control over all business decisions.

Partnership – two are better than one

A partnership is a second form of structure where ownership of the business is shared between two or more individuals. The advantage to a partnership is that there is more than one person to provide startup funding and the needed creative and business skills. A partnership has the additional advantage of having more than one person working diligently to create a successful business. The disadvantage is that if this does not prove to be the case, the partnership may end. If both partners do not focus equally on making the business successful, the end of the partnership can be acrimonious. If the partnership fails, each partner can be held liable for the debts of the other, which can be a major expense. Therefore, if a partnership is established, a legal agreement should be written as to the rights and responsibilities of the partners.

Corporation – yes, legally it is a person

Corporations are a distinct form of business where the company is considered on the same legal standing as a person. This can seem odd, as everyone knows that corporations are not people. However, having the corporation have the same legal standing as a person is useful for several reasons. If the business is incorporated, the revenue goes to the corporation, which in turns pays the management and owners. If the business does not do well and the corporation goes bankrupt, the corporation can lose all of its money, but the personal savings and property of the owners will not be at risk. This is the reason that corporations are referred to as limited liability. When this form of business entity was first established in Britain in the 1840s, one of the rationales for its creation was that limited liability would enable poor people to start businesses because they would not have to put all their money at risk (Micklethwait and Wooldridge 2003). To incorporate a business involves the filing of paperwork that is specific to each country. While in the past it might have been necessary to hire an attorney, today there are self-help websites that can aid the entrepreneur with the process. As a sole proprietorship or partnership grows, it may be decided to incorporate so that personal assets can be protected. Some forms of corporations allow for ownership shares to be sold that allow shareholders a share

in the profits. This type of incorporation would be a very unusual structure for a creative entrepreneurial startup.

Cooperative – we are all in this together

A fourth form of business structure is the cooperative. In this form of ownership, the producers of goods come together to share certain expenses. A common cooperative structure is to share the expense of a store lease and also marketing expenses. However, the people involved in the cooperative do not share revenue on an equal basis. Each product will be coded as to its owner and the revenue will be tracked separately. An advantage of a cooperative is that the cost of operating the business will be lower if the members of the cooperative take turns in staffing the store. The disadvantage is that the creative entrepreneur will have little control over what other products are sold, which may not be of the same quality and may even compete directly for sales.

Nonprofit – still need to pay the bills

A group of dedicated creative individuals working together to create a product or provide a service that assists society may decide that, because they have a mission, they are automatically a nonprofit, but it is not that simple. The difference between nonprofits and other forms of business structures is that the nonprofit does not have owners, but only managers. A nonprofit organization can be started by an individual, but in most countries to be officially incorporated more people must be involved to form a board of directors. It is the board who has the ultimate responsibility for the organization. A nonprofit relies on donations to fill the gap between revenue and expenses, and the donors will want to ensure that their money is spent on the mission. The managers run the nonprofit while the board of directors oversees operations to ensure that the mission is accomplished. Excess profits are not taxed but rather reinvested in meeting the mission.

Question to consider: What form of business structure will work best for me?

Revenue vs. profit

The business model, whether used by a for-profit business or nonprofit cultural organization, is based upon the concept of earning a profit by providing a product needed or desired by a customer. The difference between revenue and profit is simple but crucial to understand. Without this understanding, the business can fail, even though the product is purchased by consumers. This happens when the new entrepreneur considers the money received from the sale of a product as profit available to spend. However, in a for-profit business the revenue received from the sale of the product must cover all the costs of producing the product and operating the business before there is a profit. The revenue received from the sale of the

product minus the cost of producing the product is called gross profit. Subtracting overhead, all the costs of operating a business, from gross profit leaves net profit. Only when net profit is a positive number is there remaining revenue to be used to provide for the living expenses of the owner.

Not understanding the difference between gross profit, the amount of revenue after costs of producing the product are subtracted, and net profit, the amount of revenue that is left after overhead expenses are paid, has been the reason for many business failures (Niemand 2013). While for-profit businesses must cover expenses or go bankrupt, nonprofits are able to make up for the gap between revenue and expenses with grants or donations. However, the smaller the gap, the less time and effort must be spent on grant writing and fundraising.

Because expenses must be paid before there is any profit, it is critical for a new business or organization to minimize expenses. To do so, creative entrepreneurs must understand the distinction between variable and fixed, the two types of expenses, or costs, that businesses incur.

Fixed and variable costs – nothing in life is free

Some expenses must be paid even if the creative entrepreneur does not sell any products. These fixed costs, such as rent and utilities, are due each month even if there have been no sales and, therefore, no revenue. Since it may take several months to promote a product and attract customers, a business must have sufficient capital, or startup money, to cover all costs until the business becomes self-sustaining by making a profit.

While the business as a whole has fixed costs, each item sold has a variable cost, which is the cost of the raw materials and any employee wages necessary for its production. Only after the variable expenses are covered for each item sold, can the remaining revenue be used to pay for fixed expenses. Breaking even, which is covering all expenses with revenue, is challenging for all types of businesses, but particularly startups. Only after breaking even does the business make a profit. This is the reason that careful planning of expenses before a business is started and careful control of costs when the business is in operation is crucial.

Traditional business people start a business after seeing an unmet need in the marketplace. These business people realize that they can develop and sell a product that meets this need and, therefore, make a profit. Creative entrepreneurs start businesses because of a personal need to create, not just to provide a product to make a profit. It is the challenge of the creative entrepreneur to find customers who will appreciate and purchase their product, thereby producing sufficient revenue to make a profit.

Supplemental income – keeping the "day" job

People with a creative ability feel a need to express themselves in ways that cannot be met by having a job in an established business. They therefore may start their own business to share their creativity, while at the same time bringing in revenue.

However, if the revenue isn't sufficient to cover all fixed and variable expenses, creative entrepreneurs will still need to work for someone else to bring in additional revenue to support themselves and their families. While creative individuals are natural entrepreneurs, unfortunately in every country they need additional revenue to survive, as income for artists tends to be lower than average (Greffe 2002). However, the more money that creative entrepreneurs can generate from promoting and selling their own creative work, the less they will need to work for someone else for a paycheck.

Question to consider: Will I need another source of revenue when I start my business?

What makes an artist a success?

It takes more than talent to be a successful artist, although that is certainly a good place to start. There is no one path to artistic success. In fact there are probably as many different paths as there are artists. Listed below are five common attributes that describe successful artists.

1 Have art at the core of their life: They wake up thinking about both the making and marketing of their art.
2 Understand how art works in the business world: They are willing to learn unfamiliar business concepts and realize that networking is necessary for success.
3 Have a strong work ethic: They balance the time spent between creating art and marketing art and spend the needed time on business tasks without complaint.
4 Are resilient: When they face a setback in their plans, they focus on solutions. When things go right, they try to improve so results are even better next time.
5 Spend time only with supportive people: True friends support the choice of art as a career.

Many of the traits central to artistic success are also central to business success. Maybe artists aren't that different after all!

De Wal 2014

Business ownership

A creative individual has available three methods to launch a business. They can buy an existing business, start a full-time business in its own production or retail space, or start a lifestyle business that may be supplemented with other income sources.

Buy existing – let someone else get it started

If a person wants to make a living on their own rather than working for someone else they can buy an existing business. This may appeal to some creative entrepreneurs as there may be an existing business that feeds their passion such as a craft shop or music studio. However, to buy and manage an existing business takes both a large financial commitment and a high level of business skill. The most common advice given to anyone who is interested in this approach to entrepreneurship is to work in a similar existing business for at least six months before the purchase to learn if they have the needed skills for success.

Full-time startup – start it yourself

The second approach is to start a new business. This involves developing the product idea, finding a location for the business, targeting the right customers and launching a promotional campaign. Because the business has a location for which a rent or lease payment must be made, it is necessary to produce sufficient revenue as quickly as possible. As a result the business will take the majority of the entrepreneur's time and effort, making it difficult to bring in money by having a job working for someone else.

Lifestyle business – just for fun, but still a real business

The third option is to have what is commonly called a lifestyle, or creative, business. With this type of business, an existing interest of the owner is turned into a business to bring in revenue. The business operations will most likely be conducted at the same location where the owner lives to save on expenses. However, creative individuals, rather than work where they live, may live where their work is created, such as in a studio or warehouse. Some lifestyle businesses start at home with the intention of finding a location when the business reaches a critical size and produces sufficient revenue. However, now that there are so many methods to distribute a product online, some creative businesses will never need a retail outlet. Even if no shop is needed, if the business grows sufficiently it may be necessary to have another location to produce the product.

Ways to establish a business

- Buy existing: takes money and skill.
- Start your own: full-time effort.
- Lifestyle: doing what you love for money.

Entrepreneurship

The term, entrepreneurial is often used without any thought as to what it means. The term only became frequently used in the 1980s. To understand why it did so at that time, it is necessary to understand a bit of business history. After the end of World War II, many businesses in the United States became very large. In fact, the yearly revenue of General Motors in the United States exceeded the combined yearly revenue of the ten largest companies in Europe. The growth of US businesses was the result of the devastation from war in the 1940s. Since there was very little competition from Europe or Asia, but a great need of products for the rebuilding effort, US businesses thrived.

While the drive to be entrepreneurial does not know any national, age or gender barriers, in the United States during the 1950s and 1960s there was little incentive for individuals to go out and risk their money starting a new business. It made more sense to work for a large established company that provided well-paying employment with job security.

Increased competition: However, the dominance of large US corporations started to change in the 1970s for a number of reasons (Hoopes 2011). First the world started to go through macroeconomic changes as political systems became less stable, with many countries becoming more capitalistic. As a result international competition increased. Suddenly entire US industries, such as automobile manufacturing, found it difficult to compete with products from other countries. In the case of the automobile industry, there were Japanese companies focused on providing Americans with cars that were of higher quality. Because American consumers preferred better-built Japanese cars, an entire US industry, along with all the companies that provided it with raw materials, component parts and business services, was disrupted. People in the United States became aware that working for a large corporation did not guarantee job security.

Technological changes: In addition to new global competition, technological changes disrupted the business environment. In the 1970s microprocessors hit the marketplace and made entire industries obsolete as the ability of computers to manipulate data much faster than humans changed how work was done. Those who understood how to use the new technology to complete tasks more efficiently had the financial incentive to start new businesses to compete with older established firms. Because of the disruption in the dominance of large corporations and the many opportunities offered by technology, many individuals found entrepreneurship to be not only personally but also financially rewarding.

The twenty-first century brought additional challenges to the dominance of large businesses with the growth of social media. Again, large corporations found it difficult to quickly take advantage of the ways in which social media could aid in promotion and customer service. Existing large companies were so enmeshed in how they were currently doing business that they did not have the time or ability to use the new media innovatively. However, small entrepreneurial startups were again able to compete. Entrepreneurship also tends to trend along with the unemployment rate. In the United States in 2009 at the height of economic recession, 558,000 new businesses were started each month (Stangler 2014).

Strategic goals – depends on your motivation

There is a difference in the strategic goals of the small business owner, the startup entrepreneur and the creative entrepreneur because each has different motives for being in business. Someone who starts a small business does not usually intend to grow it into a major competitor with many employees. In fact the strategic goal of a small business may be simply to provide a living for the owner and family. A traditional entrepreneur usually has a desire to grow a company to a size where it can compete with large established businesses. It usually can do so because the entrepreneur's product is innovative enough to attract customers from competing products. In the traditional entrepreneurial model, the emphasis is on finding the most profitable product opportunity, and the strategic goal is growth. The traditional entrepreneur believes that the company will one day be a major competitor. Creative entrepreneurs are people who start businesses built on their talents and interests. Their strategic goal is to earn enough profit to support their creative lifestyle. While the strategic goal of a nonprofit organization is to meet a social need, entrepreneurial skills are increasingly being sought as they also engage in business activities such as consumer research, product development and financial planning.

Differing strategic goals

- Small business: provide living for owner and family.
- Traditional entrepreneur: desire to grow.
- Creative entrepreneur: earning enough to support their lifestyle.

End of the venture – death is part of life

Entrepreneurial ventures may grow and mature to where they are providing a steady stream of income. It might be thought that this would continue indefinitely, but this is rarely the case. The public's taste can change and a previously popular product may decline in sales. The entrepreneur must respond by varying the product to again increase sales. However, another choice might be for the entrepreneur to decide to end the venture. This is not failure, simply a realization that the venture no longer meets the needs of the founder. Even when there is no decline in sales, the venture might end because of other life experiences. For example, the creative entrepreneur might need to relocate or there might be a change in their family that may mean that the venture is no longer possible. This same entrepreneur may at some point in the future again feel the need to start a new venture (Ochse 2014).

The business plan

The chance of success for a new business is greatly increased by creating a business plan. Many creative entrepreneurs may think that going through this planning process will constrain their creativity. They may also feel that it will be a process

that is boring and, therefore, a project they will never be able to complete. In fact a business plan is simply the dream of the creative individual put into writing (Beam 2008).

Rationale for writing – not just for you

Writing a business plan provides the creative entrepreneur with a roadmap for implementation of the business idea. While creative entrepreneurs enjoy the process of creating the product, they may enjoy much less the day-to-day details of establishing a promotion plan and tracking expenses. However, if these tasks are not done, there will be no revenue and, as a result, no profit. Without profit, the creative entrepreneur will no longer have the financial ability to continue to create the product.

While the business plan should be written in sections, each component of the plan must work together to ensure success. The plan is not static and, even after it is written, it will need to be constantly reviewed and, if necessary, revised, as the external forces affecting the business change. In addition, after the business is in operation, it should continue to be revised as the interests of the creative entrepreneur evolve.

Business plan components – many parts are needed to create the whole

The business plan for the creative entrepreneur includes a description of the business, the product and the customer. In addition it has plans for operations, distribution and promotion. Finally it will have financial projections.

The section on the description of the business should include not just details on the creative entrepreneurs who are starting the business but also the organizational structure of the business if more than one person will be involved. Most importantly it will include the mission, vision and value statements of the creative entrepreneurs founding the business. The section on the product will not just describe the creative output of the entrepreneur; it will also describe the product's benefits and competitive advantage. One of the critical sections of the business plan will describe the targeted customer segment using demographic, geographic and psychographic characteristics.

After describing the business, the product and the customer, the plan continues with the more mundane but necessary component of a distribution plan. This section will explain how and where the customer will be able to purchase the product. Without the ability to communicate with the public about the product, there can be no sales. Therefore a promotion plan is needed to make the targeted customers aware of the product and its benefits. A clear description of the message and media used to communicate the product benefits will be included in the plan. Finally financial projections must be made on both anticipated revenue and expenses. Without any of these components it is very difficult, or impossible, to have a successful business.

The components are usually completed in the order that they are presented above. However, there is one significant difference. A traditional entrepreneur will start the process of writing a plan with a product in mind that will meet the needs

of a group of consumers. However, if, during research, the entrepreneur finds there is no market for the product, the product will be changed. In contrast, creative entrepreneurs start with the product they wish to create. They must then analyze the product to determine the benefits that it offers so as to be able to find the segment of customers who would be most interested in purchasing.

Question to consider: Am I willing to commit both the time and effort to write a business plan?

Summary

While many people see art and business as separate, in fact there is no reason why creative individuals cannot also be successful business people. Businesses, which can be sole proprietorships, partnerships, corporations or cooperatives, differ from government agencies and nonprofits as they are formed with the motive of making a profit by providing a needed product to consumers. Making a profit requires that the sales price of the product be sufficient to cover all fixed and variable expenses. Only after these expenses have been covered is there a profit that can either be reinvested in the business or spent. Someone interested in having a business can buy an existing operation or start a full-time retail or service enterprise. They may also have a lifestyle business that supplies supplemental income while they continue to work for others. More people are interested in entrepreneurship, as working for corporations no longer provides job security and new technological advancements allow creative people to develop and sell products without an intermediary. Traditional entrepreneurs first look to fill a consumer need, while creative entrepreneurs wish to start a business to produce revenue from a product that they already create. In both cases a business plan is a necessary planning tool if a business is to be successful.

References

Bauer, Christine, Katharina Viola and Christine Strauss. "Management Skills for Artists: 'Learning by Doing'?" *International Journal of Cultural Policy* 17, no. 5 (November 2011): 626–644.

Beam, Lisa Sonora. *The Creative Entrepreneur: A DIY Visual Guidebook for Making Business Ideas Real*, Beverly, MA: Quarry Books, 2008.

Budd, Malcom. *Values of Art: Pictures, Poetry and Music*, New York: Penguin, 1995.

Burkey, Brent. "Marketing the Creative Sum." *Central Penn Business Journal* 29, no. 23 (May 31, 2013): 1–9.

Cowen, Tyler. *In Praise of Commercial Culture*, Cambridge, MA: Harvard University Press, 1998.

De Wal, Aletta. "5 Common Traits of Successful Artists." *Fine Art Tips with Lori McNee*, n.d. Web. Accessed August 20, 2014.

Gans, Herbert. *Popular Culture and High Culture: An Analysis and Evaluation of Taste*, New York: Basic Books, 1997.

Greffe, Xavier. *Arts and Artists from an Economic Perspective*, London: Unesco 2002.

Hansen, Drew. "Jay-Z and 5 Lessons Artists Teach Entrepreneurs." *Forbes.com*, February 16, 2012.

Hoopes, James. *Corporate Dreams: Big Business in American Democracy from the Great Depression to the Great Recession*, New Brunswick, NJ: Rutgers University Press, 2011.

Levine, Lawrence W. *Highbrow Lowbrow: The Emergence of Cultural Hierarchy in America*, Cambridge, MA: Harvard University Press, 1988.

Micklethwait, John and Adrian Wooldridge. *The Company: A Short History of a Revolutionary Idea*, New York: Modern Library, 2003.

Niemand, Thayn. "7 Deadly Sins of Business Owners: Ignoring the Numbers." *Finweek*, August 1, 2013.

Ochse, Gareth. "Why I Want You To Fail Fast." *Finweek*, May 1, 2014.

Rudy Collective. "About." *Facebook*. www.facebook.com/RudyCollective. Accessed July 2, 2014.

Stangler, Diane. *Ewing Marion Kauffmann Foundation*. Report. April 9, 2014. www.kauffman. org/newsroom/2014/04/entrepreneurial-activity-declines-again-in-2013-as-labor-market-strengthens. Accessed July 1, 2014.

Staniszewski, Mary Ann. *Believing is Seeing: Creating the Culture of Art*, New York: Penguin, 1995.

Woodmansee, Martha. *The Author, Art, and the Market: Rereading the History of Aesthetics*, New York: Columbia University Press, 1994.

Tasks to complete

Answers to these questions will assist in writing the Introduction to the business plan.

1 Personal information

 a Write in one sentence your passion in life.
 b List your professional training.
 c Give examples of paid or unpaid work experience.
 d Give five reasons why you believe you will be successful.

2 The business

 a Rank in preference buying a business, starting a full-time business and having a lifestyle business while working another job.
 b Research online the history of the market for your product.
 c Describe in detail the product, service or idea you will be providing.
 d Describe your potential customers.

Visualization exercises

1 Draw a tree with you as the trunk and your accomplishments as the branches.
2 Draw a picture of someone enjoying your product.
3 Place your product on a line with high culture at one end and popular culture at the other.
4 Quickly write ten possible names for your product, business or both.

2 Making the dream a reality

Introduction

Before creative entrepreneurs start writing a business plan, they should reflect upon their organization's mission, vision and values, as it is these principles that will guide the necessary decisions as they develop their business plan. Creative entrepreneurs must also evaluate their internal resources including available financial assets, the skills they possess and the personal qualities needed by successful entrepreneurs. In addition, to increase the likelihood of success, the external environment in which the organization will compete must also be researched including competitors and socio-cultural, technological and economic conditions. Both the creative entrepreneur's internal resources and the external environment will shape the strategic decisions that must be made regarding the product that will be produced and the customers who will be targeted. After collecting this internal and external information, creative entrepreneurs need to conduct an analysis of the organization's strengths, weaknesses, opportunities and threats. Finally creative entrepreneurs are ready to determine their strategic goal, objectives and tactics.

What creatives have to say: Jenny-Lind Angel

Besides working in nonprofit cultural organizations, including museum education programs, J-L also has her own business tutoring children. She faces the challenge that all creatives face: making a living when the career fields of interest do not pay well. For this reason she recommends the following to creatives who are mixing working in a cultural organization with having their own business:

- Develop skill sets in more than one area, not just social media.
- Learn to use development and donor software.
- Cultivate your leadership and management skills.

You can see J-L's LinkedIn profile at www.linkedin.com/in/jlangel25.

The portfolio life of the artist

Before creative individuals can successfully learn the business skills needed to sell their product or service, they must come to terms with their original dream of only focusing on creating their art. Throughout the years they devoted to perfecting their skills, they may have planned on making their living by achieving artistic success. For some creative individuals it is a rude awakening to learn that they will have to use other skills in order to support themselves and their families. However, rather than think either/or, creative entrepreneurs should think and/both. Many creatives often have a portfolio of different ways to bring in revenue (Greffe 2002). In fact, the possibilities for earning income are as varied as the individuals themselves. Some creatives will earn money through the production of creative work, such as visual artists who support themselves through the sale of paintings or prints that they produce. However, other visual artists might also be interested in opening a storefront that sells the work of other creatives. Because it is challenging for performers to make a living performing, they might also decide to open a studio to teach their skills. Writers might make money from book royalties but not enough to pay the bills, so they might also have a second career as a professional blogger. All of these individuals will benefit from having a business plan as they make these possibilities a reality.

Determining a mission, vision and values

While they probably do not write it down as formal statements, most people feel they have a mission, vision and values for their lives. For many creative people, their personal mission, vision and values will involve producing a creative product, whether it is art, music, design or writing. Businesses also have a mission, vision and values that shape how the business operates on a daily basis. The difference is that the business formalizes these ideas into statements so that employees of the company will make the correct strategic decisions when faced with ethical issues (Gegax 2007). The mission of a business, organization or an individual is the principal reason for their existence, while the vision is what they hope to achieve in the future. Their values will shape how the mission and vision are achieved.

Mission – your purpose in life

Some individuals' mission in life may be personal, such as marrying and having children. For others, their mission may embrace a social cause or service to the community. For creatives, their mission will include developing and expressing their individual talent. While some people may not think much about their life in terms of a mission as they are busy with the day-to-day decisions that life requires, creative individuals will have thought a great deal about the purpose of their lives. Their mission may be to express themselves through their work. However, part of the mission is also to share their work with others. While this desire to share might be just with family and friends, it might also be the creative individual's mission to

share their work with a wider community. Together, the purpose and the people to whom this purpose is directed, is the mission.

All organizations, including business, also have missions that incorporate what they do and for whom they do it. For businesses their mission is to provide a product or service that is needed or desired by a group of consumers. To meet their mission, any business will want to produce the very best product that they can at a price that is affordable for their customers. In addition, today most businesses will include in their mission statements how they will make society better through service to the community. Consumers particularly expect small companies' mission statements to contain ethical standards (Baucus and Cochran 2010).

An individual may be free to choose more than one mission over a lifetime. However, to be successful, a business needs a single, well-defined mission. While individuals have a lifetime to accomplish their missions, a business has a shorter timeframe and limited resources. Too broad a mission will result in organizational resources being spread too thinly with the danger that nothing will be achieved.

There is a basic difference in the missions of for-profit businesses and creative entrepreneurs. If a for-profit company discovers that the product they produce is no longer wanted by consumers, they will change their mission and product to something that is desired. Because creative entrepreneurs have a mission to express themselves, they may be unable or unwilling to change the product. This means that creative entrepreneurs will have to work harder to find the individuals who will value their work. This also means that they may never sell a large quantity of goods to a mass group of customers. On the other hand, growing to be a large company with numerous employees was probably never part of their mission.

Even organizations of arts intermediaries have missions

The Association of Professional Art Advisors (APAA) is a not-for-profit organization comprised of leading independent art advisors, curators and corporate art managers. Our mission is to establish and disseminate the highest possible principles and guidelines for acquiring, maintaining and presenting art. We are united by our high standards of professionalism, and uphold these standards in our work with corporations, public art projects and private collections.

APAA members are proven experts in their fields, and are committed to promoting the value of art in the public and private sectors. As advisors, we are objective advocates who work solely for our clients, and unlike art dealers, do not maintain inventories for sale nor represent artists.

This is an example of a mission statement that clearly states:

- Who it is: art advisors, curators and corporate art managers.
- What it does: establish and disseminate principles and guidelines.

- For whom it does it: our clients.
- Its values: promote the value of art.

<div align="right">APPA 2014</div>

Vision – where you want to be in the future

While the mission statement states the current purpose of the business, the vision statement describes what the creative entrepreneur wants the business to become in the future. This may be a question that will take some time to answer as creative entrepreneurs may be focused only on current opportunities to obtain revenue. However, even while planning for today it can be useful to consider the production of future products, new methods of distribution or targeting new groups of customers. For example, a visual artist currently creating paintings that are sold to individuals might in the future also want to paint large murals in homes. The vision could also involve new ways of distributing the product. For example, a creative entrepreneur who currently shows at art fairs might have a future vision of having a retail shop. The vision could also be to expand to serve new geographic markets, with the creative entrepreneur hoping to expand by performing in neighboring cities or states. In addition the vision might be about reaching new age, ethnic or lifestyle customer segments that are currently not being served.

Values – what you believe in

An organization is more than just its mission and vision. Organizations, just like individuals, also have values. Values, deep-seated beliefs about what actions are right and just, will affect how the mission and vision are implemented. Each organization's value statement will be unique. While challenging to write, such statements can provide guidance in making the many choices faced in the daily life of business. The values might express how employees in the company will be treated or they can explain how customers will be served. Finally they can focus on how the company will make the community a better place, whether that is the local neighborhood or the global community. When companies make future strategic decisions affecting their employees, customers and society, these value statements will assist in the decision-making process.

The creative individual may actually have two mission, vision and value statements; one individual and one for the business. The individual mission may be to create art that communicates an inner vision even if no one else appreciates what is created. Meanwhile, the mission for the business is to create a product, while still expressing a creative vision desired by a group of consumers. The income from the sale of the second product makes the creation of the first product possible. While creative entrepreneurs may have personal mission and vision statements that differ from the ones written for the business, the values should be similar because what is

right and just in the creative entrepreneur's personal life should be the same as what is right and just in their business (Baroncini-Moe 2013).

Questions to consider: How does my personal mission differ from my professional mission? How do I want my community, country or world to be better five years from now through my efforts?

The statements – put it in writing

Creative entrepreneurs might not want to take the time to determine their mission, vision and values. However, these statements are necessary as they act as the compass that guides the many strategic decisions that must be made when starting and managing a business. It is these statements about mission, vision and values that will form the basis of the business's culture. All future decisions must be in alignment with the statements, or the business will not succeed. The statements do not need to be long and beautifully edited. In fact it is better if they are short and easily understood. While creative entrepreneurs might decide to display their mission, vision and values on their website and other promotional material, it is not necessary to do so. More important is that the creative entrepreneur's actions reflect the statements.

Sample mission statements

Below are two community theatre mission statements, one succinct and one longer, that clearly explain the reason for their existence.

Waimea Community Theatre, Kamuela, HI

> To provide an outlet for creative community involvement, while seeking to produce quality entertainment.

Weathervane Community Playhouse, Akron, Ohio

> The mission of Weathervane Community Playhouse is to entertain, inform, and educate, thereby enriching the cultural life of the Greater Akron area. Weathervane shall provide area residents the opportunity both to attend and to participate in quality presentations of a cross-section of the finest theatrical works available. Weathervane shall provide education in the theater arts to adults and children. In meeting these goals, Weathervane shall be mindful of the standards of its audiences and shall maintain fiscally sound management.

The mission statement is simply a description of why you exist.

AACT

Analyzing internal resources

Starting an entrepreneurial organization means that the creative entrepreneur has the entire responsibility for ensuring success. If a person is employed in an existing company, he or she could communicate with the manager to request the resources that were needed to successfully create and sell a product. However, when creative entrepreneurs are self-employed, or when they are the manager of an organization, they must ensure that the resources for success are available. Interestingly, one of the skills most needed by entrepreneurs is considered to be creativity, a skill that artists, musicians, designers and writers already possess (Smith *et al.* 2007).

The popular view of artists as isolated individuals who work alone in attics is outdated. In this traditional view, all that artists needed to survive was their talent and determination. Now artists understand that more is needed than artistic vision to be successful (Eikhof and Haunschild 2006). The other crucial factors for success include the necessary financial resources. In addition there are personal and organizational skills needed to manage the business. While personal skills may be innate to certain personality types, organizational skills can certainly be learned by anyone.

Internal resources

- Financial: Do I have the money to start the business?
- Personal: Do I have the ability to negotiate contracts and sell products?
- Organizational: Can I set and stick to priorities?

Financial resources – show me the money

Creative entrepreneurs will need money, or startup capital, to pay for initial expenses, such as the purchase of specialized equipment that is needed in the production of the product. Even if no equipment is needed, the creative entrepreneur must purchase the raw materials that are required for the product's creation. In addition, if the business will be located in a separate facility, an initial rent or a lease payment must be paid. For most entrepreneurs these funds come from personal savings, friends, family or a combination of all three. Because new businesses are risky, getting a bank or other type of business loan is difficult (McKeever 2008).

Working Capital: However, the largest financial hurdle is not the funds to pay for the initial equipment or materials but the funds that will be needed to cover the daily expenses of the business until a profit can be made. The term used for this cash is working capital. Earning enough profit each month to cover business expenses can be difficult for a startup. Earning enough profit to also pay for the creative entrepreneur's food, shelter and clothing can be impossible for a new business. Therefore working capital will be needed to pay the bills while the creative entrepreneur builds a reputation and customer base.

Unless the creative entrepreneur has recently won the lottery or received a bequest from an elderly relative, they are unlikely to have sufficient working capital available. As a result, the creative entrepreneur will need an additional source of

revenue until there is enough profit from the business. This is of particular concern if the entrepreneur must support a family. One solution to this problem is to have the entrepreneur continue working a full-time "day" job while starting the business part-time (Sonora Beam 2008). While this certainly may solve the financial issue, it puts constraints on the business's growth. While working another full-time job, the creative entrepreneur will not be able to focus exclusively on the business. Therefore creative entrepreneurs may be able to focus more time on their business by taking only temporary positions or finding positions that allow flexible hours. Only after creative entrepreneurs are sure that they have a steady income stream that provides enough profit from their business will quitting the day job be an option.

Other creative entrepreneurs, particularly those with no dependent family members, approach the income situation differently. They decide to lower their standard of living to a minimum while they build their business. As revenue and profit from the creative enterprise increases, they will then be able to raise their standard of living. The reason for this decision to not seek outside employment is because it takes time to produce the product but also promote the business. If the entrepreneur is working at other jobs, there may be insufficient time to devote to building the business.

Personal skills – it's what's inside that counts

While there has been considerable research on the qualities that make for a successful entrepreneur, they are difficult to quantify, and research findings vary. In addition, successful entrepreneurs can be found without these skills. However, most research has found that there are skills that, if possessed by the creative entrepreneur, increase the chances for success (Brown 2007).

Persuade and negotiate: The personal skills that are needed to be a successful creative entrepreneur include the ability to persuade and negotiate. These skills are needed to make the deals that keep the business in operation. For example, the entrepreneur will need to negotiate the prices for raw materials and supplies. By getting supplies at a lower price, the creative entrepreneur can then lower the sales price of the product, thereby increasing sales. Or, the price can be kept the same, resulting in a higher profit. There will also be lease payments to negotiate. Getting a reasonable price on premises is even more critical to keeping the business solvent than the cost of supplies, as lease or rent payments must be paid monthly. The creative entrepreneur may even need to renegotiate the payment during the term of the lease if the business is not bringing in sufficient revenue. In addition, contracts will need to be negotiated when the product is being sold through a retail distribution channel as the creative entrepreneur will need to persuade the distributor on the price and quality of the product.

If the creative entrepreneur has a retail location, it will be necessary to sell the product, and therefore sales ability is another skill that is essential. However, sales ability in a creative business is not only used to sell the product, it is also used to sell the story of the creative entrepreneur to everyone encountered in daily life. In a creative business, the owner and the product are packaged together, and it is the

story of both that intrigues the potential customer. With so many competing pro-
ducts available, creative entrepreneurs do not have the luxury of hoping that the
product will sell itself.

Personal skills are also necessary, because the business owner will need to deal
with the public on a daily basis. Some creative entrepreneurs tend to be introverts
who live inner-directed lives. If so, they will need to learn how to interact with
the public, including unhappy customers, in a way that maintains the reputation of
the business. In addition, if the business owner requires additional staffing, they will
have to hire and manage employees. Keeping these employees happy and pro-
ductive will be the responsibility of the creative entrepreneur. If the creative
entrepreneur decides that they do not wish to develop more skills in interpersonal
relationships, they may need to distribute their work through a retail channel
where the staff will have the needed skills in interacting with the public.

Perseverance and self-confidence: Additional personal skills needed by creative
entrepreneurs are perseverance and self-confidence. The ability to self-start and
persist with effort over time is essential. Successful entrepreneurs need to be able to
work on their own without supervision for as many hours, days and months as is
needed to complete a task. In addition, the entrepreneur has to have an optimistic
nature and confidence in themselves and their product. After all, if the entrepreneur
does not believe in the product, no one else will (Surowiecki 2014). However,
these are characteristics that also define successful artists, who are used to struggling
on creative efforts on their own over long periods of time because they continue to
believe in their inner vision.

Organizational skills – the structured mind

The organizational skills needed to be a successful entrepreneur include the ability
to gather and analyze the information necessary to make strategic decisions on the
product, its price, distribution and promotion. An effective decision-making process
requires an organized system for maintaining data on the business's financial assets,
sales numbers and product inventory. Without this system, decisions will be based
on guesses or assumptions rather than facts, which can lead to costly mistakes. Of
course even after analyzing the numbers, a decision may be made incorrectly.
However, if a decision is wrong, the creative entrepreneur can re-analyze the data
to learn what went wrong so that next time the correct decision will be made.

Time management: Perhaps the most critical quality for a creative entrepreneur is
time management, including the ability to prioritize and maintain focus (Bisht
2013). There will always be more tasks than time as the creative entrepreneur is
responsible for all aspects of the business. This would be true for any business, but
is doubly true for a creative business, as the owner must also create the product. A
successful entrepreneur needs to get in the habit of starting each day with a clear
idea of what is to be achieved, prioritizing what needs to be done and then refusing to
be distracted.

All of these people skills and organization skills are routinely used by creative
people. They have had to persuade and negotiate to get their creative work shown.

They have certainly "sold" their ideas to other creatives, professors and intermediaries. In addition, they have become experts at explaining the process and meaning of their creative work to the public. Creatives often work alone and need to remain focused on completing their work without any direct supervision. All of these people and organizational skills can be transferred from being used to create the art to being used to create the for-profit creative business or nonprofit cultural organization.

Questions to consider: What financial resources will I be able to access for my business or organization? What people skills do I need to improve? On a scale of one to ten, how would I rate my organizational skills?

The external environment

In addition to internal resources, creative entrepreneurs must also analyze the external environmental forces that will affect their business. The word environment is used so often in the context of caring for the natural environment that it is forgotten that the word has a broader meaning. In business the word is used to describe all the factors that affect the operations of an organization. Artists already understand that they are affected by the external environment in which they live as creative inspiration can result from contact with other people and events. They know that their art is shaped not only by their inner vision but also by external events that inspire creative ideas.

To be successful in business the creative entrepreneur must understand that the same external forces that affect creativity also affect business strategy (Bensoussan and Fleisher 2008). The external factors that can most affect a new creative business or cultural organization are competitors, socio-cultural changes, technological changes and the current state of the economy. Information on all of these forces can be gathered by simply being aware of the general news that is easily found online. However, to minimize risk and help ensure business success, it may be necessary to take a more focused approach to analyzing the external environment by putting aside some time each week to check various news sources for information that might impact the business. This process of analyzing the external environment is known as environmental scanning.

When evaluating internal resources, creative entrepreneurs need to analyze available resources and personal skills. If necessary, resources can be found and skills can be learned. However forces from the external environment are outside of the creative entrepreneur's control. They cannot be changed, but are forces to which the business must react. For example, weak economic conditions are outside of a single business's ability to change, as one company alone cannot cause economic growth. In this case, rather than focus on changing the external factor, the business must decide how to react. For example, if economic conditions are poor, the creative entrepreneur might decide to offer a temporary discount to maintain sales.

When analyzing the external environment, creative entrepreneurs will be looking for threats to the business which must be countered by taking action. In

addition, the creative entrepreneur will be looking for opportunities of which the business can take advantage.

External environment

- Competitors: How does my product compare to my competitors'?
- Socio-cultural: How have changing values and lifestyles affected the desire for my product?
- Technological: How has technology affected how I will produce my product and conduct my business?
- Economic: Will people be able to purchase my product?

Competitors – know your enemy (or friends)

One of the most critical external environmental factors is the competitor environment. Competitors are companies that sell products that meet the same needs as the product that the creative entrepreneur is offering, which means that the product does not need to be an exact match to be a competitor. When analyzing competitors, creative entrepreneurs should compare the benefits that their product provides against those provided by the competitor's product. Products that provide similar benefits are competitors even if they are produced and distributed differently.

For example, if the creative entrepreneur is producing handmade leather purses, their competitors would be other companies that produce similar handmade goods. However, as not all people are concerned with how a product is made, their competitors would also be mass produced leather purses. In this case, the task of the creative entrepreneur is to analyze their product's competitive advantage over competitors', such as a unique design, better quality materials or that it is made in a specific location where employment is provided to the local community. Rarely will creative entrepreneurs state that their product has the competitive advantage of a lower price as the consumer has the choice of buying a mass produced purse that will almost certainly be less expensive.

Questions to consider: Who will be my closet competitor once I start my business? Against what mass produced products will I be competing?

Socio-cultural – understanding change

Another external factor that must be analyzed is socio-cultural changes in society. The term socio-cultural refers to changes in people's values and lifestyles. Values, deep-seated beliefs on how life should be lived, affect the type of products that are purchased. While people choose to purchase products that fulfill a need, the type of product chosen will be affected by their values. For example, a person's attitude toward caring for the natural environment will affect the type of art they wish to purchase and display. First, it might affect the content of the art, as scenes from nature may be preferred over cityscapes. However, the purchase decision might

also be affected by the types of materials that are used to produce the artwork. For example, a consumer concerned about the overuse of chemicals in the production of goods, might purchase a piece of clothing because it is made of all natural fibers. Of course there is a broad range of values that people hold. They may value the fact that a product is handmade or they may value products that add beauty to their lives. For some consumers, the status that a product provides is valued, while for others it is the pleasure received from a product's use. By understanding the values of consumers, creative entrepreneurs can target the correct consumer segment and develop an appropriate marketing message.

Another important consideration is the many lifestyles with which people associate. While values are deep-seated beliefs, lifestyles consist of the daily choices that people make on how to live life. These choices of what people eat, where people live and with whom people associate directly affect consumption decisions. Lifestyle choices can even join people together into informal communities. For example there are many people with deeply held religious or spiritual beliefs. Such people will want to purchase and consume products that represent their beliefs to the public.

When individuals focus on a specific interest they have been called fans, people who simply have an interest in an artistic field (Abercrombie and Longhurst 1998). For example, fans who have an interest in painting will go to an art show and purchase any painting whose color and form they find appealing. However, a deeper interest can develop into a lifestyle, where the cultural enthusiast will travel to see specific performances, read about artists on websites and discuss new artists on blogs. They may become so involved that they will collect the work of only a specific artist. By understanding the lifestyle of the targeted consumers, creative entrepreneurs can better provide a product that meets their needs.

Questions to consider: How will I find out about the social and cultural changes that are affecting my future customers' values and lifestyles? Do I know of any recent changes that present an opportunity?

Technological – the only constant is constant change

When analyzing the technological environment, the creative entrepreneur needs a deeper understanding of how technology affects artistic production. In addition, it is necessary to understand how technology is changing consumer purchasing and how business is conducted. While technology results in new products, most creative entrepreneurs will not be creating and selling a high-tech product, as such products take significant financial resources for research and development and are usually mass produced. However, changes in the technological environment do affect how some artwork is produced, as artists have incorporated digital technology into artwork.

In addition, technological changes have certainly affected how consumers research and purchase products and, as a result, how creative entrepreneurs conduct their business. Technology provides the creative entrepreneur with the means to market directly to consumers via social media. Second, technology has allowed electronic commerce so that the creative entrepreneur can now sell products to

anyone, anywhere in the world. Finally, technology has eased the process of payment. Electronic payments can now be made not only online in any currency, but also using a cell phone at any location. Consumers will expect these technological advancements to be used by companies. Consumers do not expect to hear a creative entrepreneur explain that credit card payments cannot be taken at the craft fair. In this case the sale will be lost to a competitor who can do so.

Question to consider: What technological changes are affecting my product and how I will conduct business?

Economic – does anyone have any money?

One the most critical external factors for the creative entrepreneur to analyze is economic changes. Changes in economic growth and the unemployment rate directly affect consumer spending. If unemployment is high as a result of low economic growth, there will be more people who are either unemployed or underemployed. As a result, they will have less discretionary income, which is the amount they will have to spend after the necessities of life, such as food, clothing and shelter, have been purchased. If they have less discretionary income, they will have less money to buy creative products that are not necessities.

However, during tough economic times even people who do have jobs are less likely to spend money on items that are not necessities. This is a psychological effect from the constant news about the weak economy (Cooper 2008). As a result of constantly hearing news of layoffs and company closings, people become fearful that they also might lose their job and, instead of spending, they will save any extra money. As a result some businesses will lose revenue and may even close because of fewer customers.

This does not mean that when the economy is weak no one should start a business. Instead it means that understanding the current economic situation is critical to correctly pricing and promoting a product (Schindler 2012). There is always the temptation to believe that difficult economic times can be overcome by lowering prices. Lowering prices simply cuts into revenue and may even result in the potential buyer believing that the low price is a sign that the quality must be inferior. A better approach is for the creative entrepreneur to ascertain what are the benefits valued by the buyer and focus the promotional message to communicate these benefits. Explaining the value of the product will help consumers understand why the purchase of the product is a wise decision.

Questions to consider: How would I rate the economic health of my community? How can I find out if I do not know?

SWOT analysis

A SWOT (strengths, weaknesses, opportunities and threats) analysis is a standard business tool that is used to analyze all the information that has been obtained from

conducting the internal and external environmental scan. The SWOT starts with identifying internal strengths and weaknesses of the organization and then identifies the external factors that are either opportunities or threats. The results of the SWOT analysis will be the basis of the business plan. Only after creative entrepreneurs understand their strengths can they then use them to focus on an opportunity (Galbraith 2007). In addition, creative entrepreneurs must correct any internal weaknesses while protecting themselves from external threats.

A standard four-square table is usually used to list the strengths, weaknesses, opportunities and threats, with one category in each square, but they can also simply be listed on a sheet of paper. Here is where creativity can be employed. Creative entrepreneurs might find it useful to do their thinking on a large scale on a wall. They might even use images instead of words. All of the information gathered during the internal and external scanning process should be analyzed when conducting the SWOT. However, just because an internal factor or external force is included in the SWOT does not mean that the information will be used as part of the final business plan strategy.

Strengths and weaknesses – know thyself

Analyzing the internal strengths and weaknesses of the new business is the first step in the SWOT process. One of the strengths that would be included would certainly be the talent of the creative entrepreneur and the benefits provided by the product. However, other strengths might include the location of the business, the source of raw materials, friendly and helpful service, and the ability to customize the product. Additional strengths might be the creative entrepreneur's financial resources, marketing expertise and people skills. In addition the artist's reputation and brand image would be business strengths. Some of the analyzed strengths can be used in deciding on the business's strategy. For example, if the creative entrepreneur has strong people skills, then having a storefront or going to art or craft fairs should be part of the business plan.

The weaknesses of the new business might be a lack of any of the items listed above. A lack of financial resources or the skills required to manage the business would be weaknesses. If the creative entrepreneur does not have sufficient funding, the business idea is not doomed because of the weakness; rather it just means this is an issue that needs to be overcome. In this case the strategy might be for the business to start on a part-time basis while a regular job is maintained. Likewise, if a weakness is the creative entrepreneur's lack of marketing expertise, a strategy might be to find a college intern to assist in this area.

Opportunities and threats – be prepared for both

Analyzing internal strengths and weaknesses should be easy, as creative entrepreneurs will already be knowledgeable as to what they are bringing to the business. More difficult will be analyzing the opportunities and threats that are external to the organization and cannot be controlled or changed. The opportunities might

come from competitors who have higher priced products, economic forces that make people more likely to spend money, socio-cultural changes that result in more people being interested in a specific type of product or technological advances that make it easier to sell the product online. The threats might come from changes in these exact same forces.

The next step is the most critical and is the basis of an organization's successful strategy. An internal strength of the organization must be matched with an external opportunity. For example, an analysis of the products sold by competitors can provide insights as to what might be offered by the creative entrepreneur. If the creative entrepreneur is skilled at photographing pets and an analysis of the external environment reveals that no local photographers are targeting this market segment, while owning dogs is increasingly becoming part of the urban lifestyle, this can be the basis of the business strategy. Likewise the creative entrepreneur might have as an internal strength a process of producing handcrafted covers for tablet computers. An opportunity would arise if a technology company introduces into the marketplace a new tablet aimed at children. If another of the opportunities is that the creative entrepreneur lives in an affluent community, the strategy would be to produce covers in patterns attractive to children. Even threats can be used as a basis for strategy. If the economy is weak, the creative entrepreneur may decide as a strategy to focus on selling inexpensive prints rather than original paintings. The opportunity might also be based on targeting a new consumer segment. If the SWOT reveals that high-income tourists are visiting the area, this opportunity could be exploited by promoting high-quality, high-priced original artwork at this segment.

Question to consider: Where will I find the information to conduct a SWOT analysis?

Goal, objectives and tactics

Once the SWOT has been completed, the creative entrepreneur must decide upon a goal, objectives and tactics. The first step is for creative entrepreneurs to decide on the overall strategic goal, which is a broad statement of what the owner wishes to achieve. To ensure success, the goal must be supported by information discovered during the SWOT analysis and not just an idea without any evidence. However, even a goal supported by research does not automatically become reality, as a goal without a plan is only a fantasy. To make the goal a reality, the objectives that will have to be accomplished to meet the goal need to be written. For example, a goal might be to start a graphic arts business that creates logos for local companies. There will be more than one objective necessary to achieve this goal: a promotional strategy must be created; networking to build awareness must be conducted; and updated computer equipment must be purchased.

However, these objectives, creating a strategy, building awareness and purchasing equipment, are still too broad to accomplish easily. The next step is to determine the tactics that will be needed to accomplish each objective. For example the creative entrepreneur might decide that the first objective will be met by creating a

website, starting a social media site and developing a brochure that shows examples of work that has been completed.

The second goal of determining client needs through networking will also need specific tactics. The creative entrepreneur might decide to research competitors by calling companies to ask if they currently use the services of other independent graphic artists. They might also attend business networking events to discuss with business owners their graphic art needs. They can also research online what other graphic arts companies offer. Finally, purchasing new equipment will involve determining a budget, finding available funds and researching products. To ensure that these tactics are completed so that the objectives and ultimate goal are met, a timeline can be developed that gives specific dates for completion.

Achieving goals

- Goals: What do I want to achieve?
- Objectives: What will I need to do to achieve my goal?
- Tasks: What steps must be undertaken to ensure the objectives are met?

Question to consider: How far am I willing to change my goals if research demonstrates my idea will not work?

Summary

The planning process for any organization should start with writing mission, vision and value statements. These describe the purpose of the organization but also the entrepreneur's vision of what the organization will become, while always adhering to the owner's values. An analysis of the creative entrepreneur's internal situation, including financial resources and also people and organizational skills, is the next step. An environmental scan of the external environment including competitors, socio-cultural, technological and economic factors will be the basis of deciding the business's strategic plan. This process is aided by a SWOT analysis that determines the business's internal strengths and weaknesses and the external opportunities and threats. The business plan will be based on matching an internal strength with an external opportunity. The creative entrepreneur is now ready to set a goal, determine objectives to reach the goal and detail tactics necessary for each objective.

References

AACT. "Crafting the Mission Statement." www.aact.org/start/mission.html. Accessed July 28, 2014.

Abercrombie, Nicholas and Brian Longhurst. *Audiences: A Sociological Theory of Performance and Imagination*, London: Sage, 1998.

APAA. "Mission | APAA." www.artadvisors.org/mission. Accessed July 7, 2014.

Baroncini-Moe, Susan. *Business in Blue Jeans: How to Have a Successful Business on Your Own Terms, in Your Own Style*, Shippensburg, PA: Sound Wisdom, 2013.

Baucus, Melissa S. and Philip L. Cochran. "USA: An Overview of Empirical Research on Ethics in Entrepreneurial Firms within the United States." In Laura J. Spence and Mollie Painter-Morland (eds) *Ethics in Small and Medium Sized Enterprises: A Global Commentary*, New York: Springer, 2010, pp. 99–119.

Bensoussan, Babette E. and Craig S. Fleisher. *Analysis Without Paralysis: 10 Tools To Make Better Strategic Decisions*, Upper Saddle River, NJ: FT Press, 2008.

Bisht, Naveen. "Entrepreneur and Time Management: 4KTA." *Siliconindia* (February 2013): 44–45.

Brown, Stephanie. "Seven Skills for the Aspiring Entrepreneur." *Business & Economic Review* 53, no. 2 (January 2007): 16–18.

Cooper, James C. "The Great American Shopper Hits a Wall." *Business Week* no. 4113 (December, 2008): 10.

Eikhof, Doris Ruth and Axel Haunschild. "Lifestyle Meets Market: Bohemian Entrepreneurs in Creative Industries." *Creativity & Innovation Management* 15, no. 3 (September 2006): 234–241.

Galbraith, Sasha. *Anatomy of a Business: What It Is, What It Does, and How It Works*, Westport, CT: Greenwood Press, 2007.

Gegax, Tom. *The Big Book of Small Business: You Don't Have to Run Your Business by the Seat of Your Pants*, New York: Collins, 2007.

Greffe, Xavier. *Arts and Artists from an Economic Perspective*, London: Unesco, 2002.

McKeever, Mike P. *How to Write a Business Plan*, Berkeley, CA: Nolo, 2008.

Schindler, Robert. *Pricing Strategies: A Marketing Approach*, Thousand Oaks, CA: Sage Publications, 2012.

Smith, William L., Ken Schallenkamp and Douglas E. Eichholz. "Entrepreneurial Skills Assessment: An Exploratory Study." *International Journal of Management and Enterprise Development* 4, no. 2 (2007): 179.

Sonora Beam, Lisa. *The Creative Entrepreneur: A DIY Visual Guidebook for Making Business Ideas Real*, Beverly, MA: Quarry Books, 2008.

Surowiecki, James "Epic Fails of the Startup World." *New Yorker* 90, no. 13 (May 2014): 36–41.

Tasks to complete

Answers to these questions will assist in completing the Introduction and Situational Analysis sections of the business plan.

1 The essentials

 a Write out both your personal and professional mission statements.
 b List three accomplishments you would like your business to achieve.
 c Describe how you would like to make the world better.

2 Internal resources

 a List all your cash and any other valuables.
 b Give five accomplishments that demonstrate your people skills.

 c Give three examples of situations that you improved using your organizational skills.

3 External environment

 a List your three closest competitors and five less close competitors.
 b Provide an example of the most important socio-cultural trend affecting your customers.
 c Give an example of a technological trend that will affect how you do business.
 d Research online statistics that describe the state of the economy.

4 SWOT analysis

 a List at least three strengths, weaknesses, opportunities and threats.
 b Circle in blue the most exciting strength and opportunity.
 c Circle in red the most dangerous weakness and threat.

5 Goals

 a List your main professional goal.
 b List at least three objectives necessary to achieve the goal.
 c Give two tactics for each objective, describing how they will be met.

Visualization exercises

1 Draw a circle and write your mission and vision inside. Draw a larger circle around the first with as many of your values as you can.
2 Write the names of your competitors, using size to suggest their competitive strength.
3 List ten strengths and ten opportunities and draw lines connecting them in pairs.
4 Map goal, objectives and tactics on a timeline.

3 Researching competitors and customers

Introduction

After analyzing the internal and external environment, creative entrepreneurs may be eager to start writing a business plan. However, before doing so it is wise to take the time to research both competitors and potential customers. Conducting research before the business plan is implemented can greatly help its chance of success by ensuring that decisions are based on knowledge and not on assumptions. Determining how to develop the research question and the various research methods will help the creative entrepreneur obtain the needed information. However, even if the research question is appropriate and the right method is chosen, unless the right research participants are involved, the wrong data will be collected. If planned and conducted correctly, the information that results from the research will help the creative entrepreneur to decide on the correct business strategy.

What creatives have to say: Stephanie Robinson

Stephanie works in the entertainment industry booking all types of talent. She started in college with an internship at a nonprofit community arts center and now works professionally. She needs to ensure that the talents of the musicians, singers, comedians and poets whom she books match the benefits desired by her clients. She promotes her clients through emails, phone calls and personal selling. She believes the skills that are essential for targeting customers are:

1 developing cold calling tips and tricks;
2 understanding the legal lingo of contracts; and
3 using all types of business database programs.

You can learn more about Stephanie's company at their website: www. neon-entertainment.com.

Research definition and rationale

Research is a process of first collecting and then analyzing data in order to answer a question. Research of both competitors and customers is not an activity that should only be done at the start of the process of writing a business plan. Instead, the creative entrepreneur should understand that research is necessary to ongoing business success. Successful creative entrepreneurs should always want to know their competitors' products, prices and promotional strategies. In addition, they should always be researching both their current and potential customers' product preferences. The more information that creative entrepreneurs have, the more likely they are to price, promote and distribute their products successfully.

Research can be defined as the process of finding out what needs to be known for the business to succeed. There is a common saying that there are three types of knowledge. There are things that are known, things that are unknown and things that are not known are unknown. Research will not only help creative entrepreneurs to answer the questions for which they don't know the answers, it will also help creative entrepreneurs discover knowledge for which they didn't even know the questions.

The importance of understanding the business's potential competitors and customers cannot be overstated. To implement a business plan without this understanding is the same as starting a hike without a map. Hikers might know where they wish to travel but, if they arrive at their destination, it will be because of pure luck. Instead hikers use a map to both plan the route and survey the terrain before starting on the trip. If the terrain looks challenging, it does not mean the hiker gives up and stays home. It only means they need to bring more supplies and allow more time. The process and results of research are not meant to discourage creative entrepreneurs from starting a business but rather to ensure that they have the knowledge and resources that they need to be successful.

In the previous chapter the process of scanning the internal and external environments was explained. Creative entrepreneurs would already be aware of their internal resources. A simple online search of news sources would provide them with information on the external socio-cultural, technological and economic environments. However, to learn more about competitors and customers, systematic research gathering primary data must be undertaken.

Researching competitors – you can't know too much

While many creative entrepreneurs know that they must target their product to a consumer segment, they underappreciate the need to research their competitors (Krzyżanowska and Tkaczyk 2013). A competitor is a company or organization that provides a product with similar benefits that will meet the needs of the consumer. It does not need to be a direct copy of the product that is being offered by the creative entrepreneur. While the creative individual will notice differences between closely related products, the average consumer may not. It is better for the creative entrepreneur to research competitors too widely, than too narrowly.

Probably the best source of information on current and potential competitors is the organization's current customers (Bensoussan and Fleisher 2008). Asking them what other similar products they purchase will help creative entrepreneurs understand the competitive environment in which they compete.

Research should also provide creative entrepreneurs with information on what benefits the competing product provides, the price of the product, how the product is distributed and how it is promoted. This information can be used to make changes in the creative entrepreneur's own business plan or to understand how promotion will need to be used to explain the current product's competitive advantage.

Researching customers – you can't make them happy if you don't know what they want

It is essential for the entrepreneur to understand the concerns of potential customers. All creative entrepreneurs fall in love with their artistic creations. It is therefore understandable that they should believe that everyone else will feel the same. However, what entrepreneurs need to understand is that the customer's motivation for purchasing a product may be more complicated. This can be true for even such a practical product as a handcrafted chair. A chair may be purchased simply to have something to sit upon. However, a chair might also be bought because of its style and color and how it will look in a room. A third rationale for buying a chair might be that it reminds the purchaser of a specific occasion or person in the past. When the chair is marketed, its main purpose of providing seating is taken for granted. What creative entrepreneurs need to research is what other motivations are involved in the purchase so that they can communicate these benefits in their promotional message. Therefore the creative entrepreneur needs to use research to understand the needs and wants of different groups of consumers. This information will assist in matching the benefits of the product with the right group of customers.

It is critical that this research be done during the process of writing the business plan and not after the business venture has been launched, so that expensive mistakes, such as developing ineffective promotional materials, can be avoided. In fact, it should be second nature to a business person to always be thinking in terms of learning more about their competitors and customers, both current and potential.

Question to consider: What competitors and segments of customers will I need to research?

The research process

There is a formal research process that creative entrepreneurs should follow. The first step in the process is to determine what the creative entrepreneur needs to know that is not known now. The creative entrepreneur then writes a formal research question. Once this is written, the next issue is where the information to

answer the question can be found. For some research questions the answer may already have been researched by another organization and will be available as secondary data. However, it is more likely that the creative entrepreneur will to need conduct primary research. If this is so, the third step in the process is to determine the research method. Creative entrepreneurs may decide to conduct either quantitative research, which is the search for facts, or qualitative research, which is the search for opinions and attitudes, or they may decide to conduct both. After the research method has been planned, the fourth step in the process is to conduct the research. Finally the creative entrepreneur is ready to analyze the information obtained to determine the answer to the research question.

The research process

1 Write the research question: What do we need to know?
2 Decide on source of information: Whom should we ask?
3 Determine the research method: What kind of tool should we use?
4 Conduct the research: When, where and who will conduct the research?
5 Analyze the findings: Do we understand what the answers tell us?

Writing the research question

The first step in the research process is to determine what needs to be researched. While the creative entrepreneur may have numerous information needs, research takes time and effort, so not every question can or should be answered. The most critical topic for research is understanding what benefits the customer desires from the creative product. Additional research questions that need to be answered usually relate to how the product should be appropriately priced, distributed and promoted.

Too often, creative entrepreneurs will believe that they already understand their competitors and what their potential customers want from products. They then might write a business plan based on these assumptions. However, the success of the business depends on knowing the answers to these questions, not making assumptions. Even if research reveals that some of the creative entrepreneur's assumptions have been correct, the research is still worth the effort as new ideas may result from the information received. Some of the assumptions that might need to be tested are what motivates the customer to purchase the product, what pricing level is acceptable, what promotional message will motivate purchase and where the customer prefers to purchase the product. The creative entrepreneur might start with a very broad research question, such as "How should I price my product?" However, the final research question must be more specific, such as "What price are middle-class mothers willing to pay for a handcrafted lunch bag for children?" The research question must specify what needs to be known and also who needs to be asked.

It is quite simple to write a general question, such as "Why do consumers buy our competitors' products?" At first this question might seem adequate. However,

the question does not specify what consumers, what competitors or what products. A well-written research question will be as specific as possible. It will not only provide information on what needs to be known, it will also provide information on who will provide the information. If possible it should also quantify any information on demographics, quantity of usage or price. For example a research question such as "Why do people buy mass produced prints?" could be rewritten as "Why do professionally employed women, aged 25–35 buy prints from discount stores to decorate their offices?" This very specific research question is not written at the first attempt. Instead it will take several attempts before the question is specific enough to provide useful data. This process is best conducted by more than one person, as two people working together can challenge each other over what is specifically being asked. A research question will always start as broadly defining the question, but successive rewrites will clarify the meaning.

Sample research questions

- Competitor: What new products priced under $50 have our closest competitors introduced during the last year?
- Consumer: Why are consumers interested in buying organic products?
- Price: What prices are college students aged 17–22 willing to pay for jewelry handmade in Peru?
- Product: Are our handcrafted bowls bought by new customers purchased as gifts or for personal use?
- Place: Do our repeat customers who have purchased at least three times in the last year prefer to purchase on-site, online or both?
- Promotion: What social media do our current customers aged 45 and older use at least weekly?

Research questions which start with Who, What, How many or How often will need a quantitative research methodology, such as a survey. After all, there can only be a limited number of possible responses to questions about demographic characteristics or frequency of visits. Questions that start with the word Why need other research methods to uncover opinions, values and attitudes. These are questions that are not easy to answer with a few words, so qualitative technique such as focus groups, interviews and observation should be used.

Deciding on the source of the information

After the creative entrepreneur has defined the problem by writing the research question, the next step in the research process is to determine the source of the information. The two types of research data that can be obtained by researchers are commonly called secondary and primary. The researcher obtains primary data directly from research participants. In contrast, secondary data already exists because someone else has collected it as the result of previous research.

Secondary data – called secondary, but find it first

Secondary data, despite its name, is the first type of data that should be sought by creative entrepreneurs. Because secondary data already exists it is less costly than conducting research to obtain primary data. Not only do researchers not have to spend the money to conduct research, using secondary research data also saves time as there is a wealth of online sources of secondary data. In fact the amount of available data is so great that the creative entrepreneur might need to enlist the help of a librarian to determine what information is relevant and credible.

Government data: Both federal and local government organizations routinely collect information on the performance of the economy. These sources will provide data on whether the economy is growing or not in the country as a whole and also in specific regions. Besides economic growth, this data may include information on employment levels and trends. Demographic information on the public, such as age, education level and family status, is usually collected by the government when conducting a census. Depending on the country, census data can also provide very detailed information on everything from family status, to types of employment, to languages spoken and ancestry. Government data is useful in helping to decide pricing of a product and what consumer segment to target.

Academic and trade association journals: Also available online may be the results of consumer research that has already been conducted by academics or by trade associations on customer preferences, media use or price level acceptability. There are trade publications and trade associations for almost every type of product from fashion to art material suppliers. For example fashion magazines may conduct surveys on the color preferences of its readers. Trade associations for stained glass studios can supply information on how consumers are using stained glass in their homes. Sometimes access to this research is only available through subscription databases. If so, creative entrepreneurs should check with a public or university library for access.

Lifestyle publications: Socio-cultural data is often found in lifestyle publications. Creative entrepreneurs should regularly read the publications that relate to their creative field and also those aimed at their target market segment. These publications provide information on what is currently on the minds of consumers as they consider the purchase of products. Lifestyle publications provide information on general consumer trends such as interest in the environment, popularity of organic foods, travel preferences and other consumer attitudes and values, while trade journals are specific to industries such as jewelry, woodworking or galleries. To be successful in business, creative entrepreneurs need to keep current with what is happening in both their creative fields and also their community.

Questions to consider: Does my city, region or country have census or economic data available? What publications and journals should I start reading?

Trade associations already know

The International Art Materials Association serves the needs of the produ-
cers and retailers of art supplies. Their member organizations want to know
what types of art supplies they should produce and stock. The Association
does the research for them to answer these questions. A survey released
recently stated that most people make their decisions on what art supplies
to purchase based on recommendations from friends, what was recom-
mended on artists' websites and recommendations from art teachers. What
about whom the art supply stores should target as customers? The Asso-
ciation research found that art students are more likely to buy from a local
store than online. What do they buy? The most frequently purchased art
supplies are acrylic paint and pencils. Such information is invaluable when
deciding on a target market, stocking the correct products and planning a
promotional campaign. All of this research information, and more, is readily
available to association members.

Artists & Art Materials Study 2012

Primary data – information you find yourself

If the information needed is specific to the new business, primary research will
need to be conducted of both competitors and current or potential customers. If
primary research is to be conducted, thought must be given to finding the appro-
priate subjects so that the information obtained is representative of the consumer
group as a whole. This question deserves careful consideration because, if the
wrong people are asked, the information obtained will be at best irrelevant and, at
worst, incorrect. The business plan will then be based on faulty assumptions.

While the public may have a stereotype of the artist working alone in a loft, in
fact artists frequently network. While they may not share in the production of a
single product, they continually share ideas. In fact the success of individual artists
may depend on the artistic "community" in which they are located (Power 2010).
Because they communicate frequently, creative entrepreneurs should have no
problem gathering information personally. Research is just systemizing this process.

The process of determining and finding research participants will be different
based on whether the research method is quantitative or qualitative. The research
participants for a quantitative survey will most likely be chosen using a random
method so that the responses will not be biased by only choosing people who will
respond positively. However, the subjects for qualitative research are chosen indi-
vidually using a nonrandom process so that they reflect the characteristics of the
customers.

Quantitative research subjects: Research participants for a quantitative survey will be
chosen using a random method, which simply means that everyone has the same
probability of being selected to be in the study. If creative entrepreneurs only ask

people with whom they are acquainted to complete the survey, this will result in a biased response as the creative entrepreneurs' friends probably share the same product preferences. Therefore the results will not be reflective of the rest of the creative entrepreneur's targeted potential consumers.

The word population is commonly used to define everyone of interest who could possibly be included in a quantitative research study. The researchers may define the population using demographic characteristics as everyone that is a specific age, gender, income or ethnicity. Or, they may be defined geographically as everyone who lives in a specific area. Because marketing promotion is often targeted based on psychographic traits, researchers may also define the population based on interests, values or lifestyles. For example the research participants might be described as local females aged 20 to 45 who are interested in fiber arts. Product usage can also be a means for defining the population, such as nonusers, occasional users and frequent users of a particular product. For example, the population for a research question might be customers who buy the product only once.

The population should not be too large, such as all the women who live in New York City who purchase handcrafted jewelry. In this case the population should be narrowed by other characteristics of the target market segment such as income level or age. A population should also not be too small, such as all people over the age of 70 who live in Berlin and attend ceramics classes. In the first case it would be difficult to ask even a sample of the total population because they would be too many to reach and in the second case it would be difficult to locate these individuals.

Statistically valid research: The researcher may be attempting to prove a fact or hypothesis by conducting statistically valid research. This fact might be how many consumers would buy a product, what type of new promotion would work best, the effect of pricing on purchase behavior, or the right store in which to distribute the product. Of course if a 100-percent-accurate answer is needed, the researcher must ask every person who is included in the population. Asking everyone in the population is called a census. Conducting a census is possible if the number of people from whom information is needed is small and all of the members can be reached.

However, most research will involve sampling of the population rather than a census. For example creative entrepreneurs might be interested in the type of product that young couples like to purchase when attending gallery walks. Asking all the couples who attend will simply take too much time and money. In addition, the creative entrepreneur conducting the research does not need to know with 100 percent accuracy what product is preferred. Less accuracy will still provide information as to what product will be of interest to a significant percentage of couples who attend. Asking a sample of the population will still provide an accurate enough estimate of consumer preference and this will allow the creative entrepreneur to proceed with developing the business plan. If a statistically valid sample is not necessary, a simpler method of random sampling would be to ask every fifth couple that walks by.

Qualitative research subjects: The choice of subjects for qualitative research involves nonrandom sampling. When using nonrandom sampling, everyone in the population does not have an equal chance to be chosen as part of the sample. However, nonrandom does not mean that the researcher chooses the participants haphazardly or without thought. Even when conducting nonrandom sampling for focus groups, interviews and observational research, the subjects still need to be chosen with care. There are three basic issues to be considered for selecting research participants and these are demographic and psychographic characteristics, knowledge of the research issue and geographic location where the potential participant lives (Kolb 2008).

The description of the characteristics used in choosing qualitative research participants is called the participant profile. While there are similarities in the process for choosing participants for each type of qualitative research method, there are also specific issues related to the selection process that differ. For focus groups, the most important considerations are personal characteristics. For interviews, because so few participants will be involved, the most important criterion is knowledge of the research issue. For observation research, it is location. For example, if a focus group is being planned on the type of retail ambience attractive to young professionals interested in the arts, it is critical that the group consist of young professionals only. If interviews on the issue of sourcing materials from independent small producers are being conducted, only people with knowledge of this issue should be selected. Because observation research needs to be at the location where the participants of interest can be found, research on the behavior of gallery visitors would be conducted at the gallery.

Two methods that can be used to choose the qualitative research participants are the convenience and snowball methods. The convenience method uses those individuals who meet the criteria and whom the creative entrepreneur knows would be willing to participate. The second method, referred to as snowball, asks known participants who meet the profile to help recruit others to be involved in the research until the sample is large enough.

Question to consider: How will I find participants who are similar to my future customers?

Determining a research method

The next step in the research process is to determine what research method will best obtain the answer to the research question from the chosen participants. One type of research method is quantitative: a method that gathers numbers and facts. The most commonly used quantitative method is the traditional survey, where research participants answer questions with a predetermined list of possible responses. These responses are then quantified and expressed as percentages. While it is usually impossible to ask every potential research subject, if a large enough sample of people is asked the survey questions, it can even be said that the answer has been proven to be correct within a few percentage points of 100 percent certainty. While such a statistically valid survey will most likely not be undertaken by creative

entrepreneurs, smaller surveys can still provide valuable insights into customer preferences on a product's benefits, pricing, promotion and distribution.

Qualitative research methods include focus groups, interviews and observation. This type of research tries to understand research participants' attitudes and values rather than only gather facts. Because attitudes and values cannot be easily determined with survey questions, more in-depth discussions must take place in focus groups or interviews. Sometimes the answer is difficult to express in words, in which case the researcher might use observational research.

Quantitative research methods – just the facts

Once the research question is written and the participants selected, the creative entrepreneur must decide on which research method to use. If creative entrepreneurs are attempting to gather information to gain factual information, then a survey is appropriate. Surveys are written instruments that ask a series of predetermined questions. These questions can be answered by checking one of several suggested answers. However, sometimes the question might be open-ended and allow participants to answer in their own words. The benefit of conducting a survey is that the creative entrepreneur can tabulate and compare responses, as the same questions are asked of each participant. Because the questions and answers are standardized, if enough survey responses are collected, it can be said the response is true of the entire group.

Creative entrepreneurs may decide to conduct a traditional paper and pen survey that can be mailed or handed to subjects at a store, studio or an event. In addition, a survey can be conducted online using an email link, or a short survey can be posted onto social media or a website. Creative entrepreneurs who are trying to reach more than one target group of subjects might consider using multiple methods of survey distribution as some groups may rather answer online while others may need to be prompted to complete the survey by using a personal approach (Wenzel 2012).

Quantative Research Methods

- Surveys: same set of predetermined questions:

 a paper and pen
 b online using email
 c posted to social media or website.

Traditionally, surveys have been completed using paper and pen by being either mailed out or by having the form handed to the subject personally. Even the administration of traditional in- person surveys has changed as hand-held devices rather than the traditional paper forms can be used to enter responses (McGorry 2006). Technology also allows surveys to be completed online. There are software programs, many of them free, which can be used to distribute a survey via email or texting. By responding to the email or text message, the subject is taken to the survey form website. Short survey questions can also be posted on the organization's social networking site.

There are disadvantages to the survey method. A well-written survey will take time to develop, as the questions must be carefully written so that there is no ambiguity as to what they mean. To ensure that this is true, the survey form must be tested on sample participants before it is widely distributed. After a paper survey has been completed, if a large number of responses are received, to tabulate the response totals it will be necessary to enter the survey responses into a computer database program.

The challenge in administering any survey is that it is becoming increasingly difficult to motivate participants to complete a survey form. This may be because people are too busy or because they are becoming more sensitive to the issue of privacy. It has been found that using a networking site such as Facebook can be useful in getting survey responses as it allows subjects to complete the survey when they are already on a computer and have leisure time (Gregori and Baltar 2013). Members of some cultural or ethnic groups may be even more reluctant to participate in surveys. Because of this reluctance, the people who respond to the survey may not be representative of the people whom the creative entrepreneur needs to study.

Because it is difficult to convince people to respond to a survey, it is important that the survey form be well designed. The questions must be written clearly and simply since, if the question is confusing, the participant may choose not to respond. In addition, the number of questions must be kept to a minimum, because if the questionnaire is too long, the respondent may lose interest. The survey should also be visually attractive to encourage completion.

However, the advantage of conducting surveys is that creative entrepreneurs are then able to use the resulting data to support their contention that their product is desired by their target market. This can impress investors and lenders as it demonstrates that the business should be successful.

Qualitative research methods – how are they feeling?

While the survey is the only standard quantitative research method, there are several qualitative research methods available to the creative entrepreneur. Qualitative research methods result in findings that cannot be reduced to numbers for calculating percentages. Instead, the findings will be statements of opinion or, in the case of observational research, notes on behavior. These findings will need to be interpreted to arrive at the answer to the research question. While the main qualitative tools of focus groups, interviews and observational research have been in wide use since the middle of the twentieth century, it is only recently that they have been fully accepted as valid research (Bailey 2014). Creative entrepreneurs should find using qualitative research tools intuitive as they rely on perceptive skill to interpret meaning. Each of the qualitative research methods has a unique purpose. Using a focus group allows group dynamics to encourage a wide range of responses. Conducting interviews allows the researcher the time to explore a single topic in depth. Intercept interviews result in numerous responses to a few short questions from subjects who would not agree to a more time-consuming research method.

Observational research is unique in that it allows research of behavior that is either difficult to describe or difficult for the participant to remember.

Quanlitative Research Methods

- Focus groups: group dynamics to draw out responses.
- Interviews: one-to-one in-depth discussion.
- Intercept interviews: quick person-on-the street interviews.
- Observation: watching people's behavior and actions.

Focus groups: Focus groups are interviews conducted in a group setting. The moderator conducting the focus group will have a short list of questions and issues that will be introduced. However the moderator does more than merely ask questions, as a skilled moderator will use group dynamics to draw out responses from the participants. To encourage participation, while the moderator will have questions prepared in advance, the group will also be allowed leeway in what they wish to discuss as long as it remains on the general topic. Focus group participants are more likely to respond to comments from each other, than to questions from the moderator. This is particularly true if the participants have something in common, which is why the participants should be chosen with similar personal characteristics. They will then feel a level of trust that will allow them either to contradict each other's comments or to elaborate upon them.

A focus group can be used to get at the underlying reason for an attitude or behavior. For example if participants do not go downtown to visit a gallery because it is "scary," the focus group moderator can ask each participant about what they mean by "scary." The answers might reveal that it is not the people who are downtown that are the problem but that the trash on the street sends a message that downtown is not cared for and therefore unsafe.

If the creative entrepreneur does not have the needed skill to moderate the focus group, it may be possible to obtain the services of a volunteer from a local nonprofit that supports new business ventures or from a nearby academic institution that has graduate students capable of being moderators. In fact, it is best if the moderator is not the creative entrepreneur, since the focus group members may express negative opinions. If this happens, creative entrepreneurs may become defensive about their product. If this feeling is communicated either verbally or nonverbally to the group, they will cease to provide information.

Interviews: Conducting a successful interview requires writing appropriate questions and also finding the appropriate research subjects. Designing the interview questions can be done relatively quickly as the number of question is smaller than in a survey. However, because fewer participants will be involved in the research, time must be spent finding the right subjects. In addition, interview research will require more time to conduct, as each participant needs to be given sufficient time to respond. This longer research period allows the creative entrepreneur to explore in depth the research subject's opinions and motivation. Because finding subjects for interviews can be challenging, it should be remembered that research subjects

for interviews can be motivated to participate for both personal and collective reasons (Clark 2010). First the interview experience must be enjoyable for the research subject. When asking subjects to participate, it should be emphasized that the interview will be held at a pleasant location, refreshments will be served and the participant will be treated with respect. The collective reasons for participation are the opportunity to be heard and to enact change. The creative entrepreneur should assure the potential research subject that not only will their voice be heard, but that their ideas and opinions will be given serious consideration.

Besides the main interview questions, the interviewer will use probing follow-up questions to elicit additional information. The follow-up questioning is necessary because, when first asked a question, many people will respond with what they believe to be the correct or appropriate answer. Also many people want to be polite by answering in the affirmative and with positive praise whenever possible. Additional probing questions are needed before subjects may respond with their true feelings. For example, interviews might be used to probe the issue of what would motivate consumers to purchase original art. While the interview subject's first response might be that the price is too high, follow-up questions might reveal that galleries, where the creative entrepreneur feels right at home, are intimidating to those not in the art world. The interviewer can then ask more questions as to how the gallery experience can be made more user-friendly.

Question to consider: *What are five interview questions I would like to ask?*

Intercept interviews: Interviews have the advantage of obtaining in-depth informa-tion. However, they also have the disadvantage of taking time to conduct, which limits the number of participants who will be willing to be involved in the research. In contrast, intercept interviews involve many participants, with each participant being personally asked only two or three quick opened-ended questions. Intercept interviews are a useful technique when research subjects will not agree to a lengthy interview, as many more people will cooperate if they are told that the interview will only last three minutes. Another advantage of intercept interviews is that they can be conducted where the subjects can be found. This is why intercept interviews are often referred to as person-on-the-street interviews. For example, a creative entrepreneur might simply ask anyone coming into the gallery what three words describe the visitor's impressions. Another example might be asking people visiting a store for one idea on how the experience can be improved.

Question to consider: *What location do my potential customers frequent?*

Observation: Another research method that can be used by creative entrepreneurs is observation, which records what people actually do rather than what they say they do. This is an inexpensive technique that can be easily used by creative entrepre-neurs. For example, if creative entrepreneurs want to understand what type of display catches the eye of consumers, they can observe where consumers stop in the store and note how long they linger at each display. If asked about this

behavior as they leave the store, consumers would find it difficult to respond, because it is something to which they have not been aware. Even this type of interviewing should have some type of system for choosing subjects rather than being totally random. Perhaps it will be decided that only customers with children will be observed. In addition, the observations will be spread out over different days and time periods. If there are more people than can be observed, every third family could be chosen. From such a simple study it might be found that parents left because their children became bored. As a result of this research data, it might be decided that devoting a corner of the store to a play area might increase sales as parents would have time to shop.

Question to consider: What type of behavior do I need to understand more clearly?

Assessing your competitors

The more you know about your competitors' products the better able you will be to compete for customers. Some ways to learn more include:

- Internet: Google the names of competing artists, companies, organiza-tions and brand names. In addition, analyze competing products sold through online marketplaces such as Etsy.
- Visit: Visit stores that sell similar products to understand how the products are marketed and find additional competitors.
- Materials: Review competitors' marketing materials including traditional advertisements and also social media.

By following the above advice you will find ideas you can adapt for your own use.

SCORE 2013

Conducting the research

After all the planning, the next step is for the creative entrepreneur to conduct the research. However, if the creative entrepreneur feels that they do not have the skills to do so, another idea is to contact a local higher educational institution to determine if there might be a class in the business department that wishes to undertake the research as a class project. The business department might also be able to offer the services of an intern who could help with conducting the research. Such an arrangement can help the creative entrepreneur by providing free assis-tance and help the students by providing real world experience that they can then put on their resumes.

Because it is becoming increasingly difficult to convince subjects to participate in research, sometimes a financial incentive is used. This can be problematic as it can encourage participation only for the reward (Bednall *et al.* 2010). As a result, such research subjects will not fully participate in the process. However, there are other ways to obtain participation, such as using the name of an authority such as an existing cultural organization. If people know that the research is being sponsored by a respected institution, they are more likely to agree to participate in the research. The other effective method of obtaining a response is to inform potential participants that the research will benefit society in some way. This approach can be used if the creative entrepreneur describes how the business or organization will help the community through providing innovative products.

Question to consider: What are five questions about my business idea I wish I could answer?

Analyzing of data

The results of the research are then analyzed. The analysis of the data should be done by the creative entrepreneur, as sifting through the data can provide revealing insights into consumer behavior. Survey results can be easily compiled by software, but the analysis of qualitative data will require careful listening and thought.

Analysis of quantitative data – going by the numbers

The data from quantitative research is in the form of numbers. The total number of subjects that checked each possible answer is easily calculated into percentages. The resulting statistics describe a form of consumer behavior or consumer preference within the targeted population segment. It is not necessary for creative entrepreneurs to calculate the percentage as this will be done by the online software or, if the survey is paper and pen, by inputting the responses into a spreadsheet or a database program. It is not necessary to understand statistics to understand the averages and percentages and, therefore, trust the resulting information. For example, the data can provide such information as 43 percent of survey respondents prefer to buy in a store versus 57 percent who prefer to buy online. The numbers can also be compared and contrasted, such as 68 percent of males prefer online shopping while only 42 percent of females do so.

Analysis of qualitative data – listening for themes

In contrast, qualitative research results in data in the form of recordings or written notes. This data cannot be statistically manipulated, compared and contrasted, and does not result in easily understood percentages. Instead the researcher will analyze the data by looking for recurring themes. For this reason, while some people may

misunderstand and mistrust the resulting analysis, creative entrepreneurs should instinctively understand the process as it relies on insight rather than facts (Johnson et al. 2007).

As focus groups and interviews are often taped, the researcher will first listen to these tapes while making notes of the most common responses that are repeated by many of the research participants. While comments that fall outside these themes are also valuable, it is the most common themes upon which the creative entrepreneur must build a business strategy.

Rather than proving facts using statistics, the analysis of qualitative data has as its focus the search for meaning. Because qualitative research is used to answer the question of "Why?," the data obtained from participants is always more complicated to understand than percentages or averages. However, once understood, the reasons for consumer behavior that are uncovered through qualitative research can be extremely useful. For example if members of a focus group respond that they have no desire to buy original artwork because they have no knowledge of current artists, it may be decided to have videos of the artists describing their work available online.

A skilled qualitative researcher may find more in the data than just a single answer. Because the subjects involved in qualitative research are allowed to provide any additional information that they feel is important, there will be a wealth of data. This data may provide new insights to help answer the research question. In fact it may be found that the subjects have an entirely different view of the solution to a problem or an idea for a new opportunity. For example, it might be found that people are willing to pay more for a product if it can be customized to their preferences in some way. This type of information would be difficult to uncover from a survey because the question would not have been asked. Instead, it may come up in a focus group discussion when participants were asked about product prices.

Question to consider: Do I have the skills to interpret research data?

Summary

Conducting research is necessary so that the information can be used to develop a successful business strategy and plan. While the creative entrepreneur will not conduct that same level of research as a professional researcher, they still must understand the process. Formulating a detailed research question will help to clarify what it is that the creative entrepreneur needs to know about consumers' motivations and preferences. Choosing research subjects carefully will ensure that the information obtained is an accurate reflection of the creative entrepreneur's targeted market segment. The process of conducting either quantitative or qualitative research can be conducted by someone other than the creative entrepreneur. However, creative entrepreneurs should still be involved in the analysis of the resulting data. This data should not only answer the research question, it may also provide additional insights that will help ensure the success of the new business venture.

References

Artists & Art Materials Study 2012. *2012 Study Key Findings*, October 2012. www.namta. org/files/resource_library_files/ArtistsArtMaterialsPresentationMay2012NAMTA.pdf. Accessed July 31, 2014.

Bailey, Lawrence F. "The Origin and Success of Qualitative Research." *International Journal of Market Research* 56, no. 2 (March 2014): 167–184.

Bednall, David H. B., Stewart Adam and Katrine Plocinski. "Ethics in Practice." *International Journal of Market Research* 52, no. 2 (March 2010): 155–168.

Bensoussan, Babette E. and Craig S. Fleisher. *Analysis Without Paralysis: 10 Tools To Make Better Strategic Decisions*, Upper Saddle River, NJ: FT Press, 2008.

Clark, Tom. "On 'Being Researched': Why Do People Engage with Qualitative Research?" *Qualitative Research* 10, no. 4 (August 2010): 399–419.

Gregori, Aleix and Fabiola Baltar. "Ready to Complete the Survey on Facebook." *International Journal of Market Research* 55, no. 1 (January 2013): 131–148.

Johnson, R. B., A. J. Onwuegbuzie, and L. A. Turner. "Toward a Definition of Mixed Methods Research." *Journal of Mixed Methods Research* 1, no. 2 (2007): 112–133.

Kolb, Bonita M. *Marketing Research for Non-profit, Community and Creative Organizations: How to Improve Your Product, Find Customers and Effectively Promote Your Message*, Amsterdam: Butterworth-Heinemann/Elsevier, 2008.

Krzyżanowska, Magdalena and Jolanta Tkaczyk. "Identifying Competitors: Challenges for Start-up Firms." *International Journal of Management Cases* 15, no. 4 (December 2013): 234–246.

McGorry, Sue Y. "Data in the Palm of Your Hand." *Marketing Education Review* 16, no. 3. (2006)

Power, Dominic. "Social Economy of the Metropolis: Cognitive–Cultural Capitalism and the Global Resurgence of Cities." *Regional Studies* 44, no. 1 (2010): 131–132.

SCORE. "Marketing Research on a Shoestring for Small Businesses." *For the Life of Your Business.* April 29, 2013. www.score.org/resources/marketing-research-shoestring-small-business. Accessed August 20, 2014.

Wenzel, Anne M. *The Entrepreneur's Guide to Market Research*, Santa Barbara, CA: Praeger, 2012.

Tasks to complete

Answers to these questions will assist in completing the Research section of the business plan.

1 Research planning

 a Write your research question.

 b Look online to determine what information already exists.

 c Give a description of your research subjects.

 d Rank the research methods in your order of preference for use.

2 Conducting research

 a Using an online program write ten specific survey questions that will provide useful information.

 b Give five examples of topics for focus groups that would help answer your research question.

 c Write three short intercept questions and ask them to the next ten likely subjects.

 d List three behaviors you would like to observe, where the observations would take place and then go and record your observations.

3 After research

 a Give an example of how the information could be used to improve a product.

 b What themes might arise in a focus group of artists discussing starting a business?

Visualization exercises

1 Draw pictures of the research subjects who would know the answers.
2 Write comic strips without words that could elicit responses.

Part 2

Creating your entrepreneurial business

Now you are ready to take your inspiration to the next step by developing a business. When you communicate a message on the benefits that your product provides to customers willing to purchase, you have a business.

Chapter 4: Analyzing the product and its benefits
Chapter 5: Targeting the right customer
Chapter 6: Mastering the numbers
Chapter 7: Distributing your product
Chapter 8: Promoting the creative product
Chapter 9: Building social media relationships

> I have been impressed with the urgency of doing. Knowing is not enough; we must apply. Being willing is not enough; we must do.
>
> Leonardo da Vinci

4 Analyzing the product and its benefits

Introduction

Since they already know what they want to produce, creative entrepreneurs might think they do not need to spend time analyzing the benefits that their product provides. However, there are many product concepts that, if understood, will help creative entrepreneurs promote their product more effectively to their target market. In today's marketplace, which is overcrowded with products, a critical concept is commoditization. This refers to the fact that there are so many similar products available to consumers that it is increasingly difficult for businesses to position theirs as distinctive. In addition, understanding the categories of products will assist creative entrepreneurs in determining the relationship between their product and its pricing and distribution. Packaging the product should not be an afterthought. Instead it should be understood as part of the organization's brand image. For creative entrepreneurs whose product is performance based, appreciating the distinct characteristics of service products and their effect on pricing and promotion is critical to success. All of this information will be necessary to understand the product's competitive advantage. The process of positioning the product is communicating how this advantage compares to what is offered by competitors. Finally, creative entrepreneurs will need to consider brand attributes.

What creatives have to say: David Ruess

David creates and sells illustrations and fine art through his own company, Black Wolf Studios. He sells in both the business and consumer markets and is able to distribute much of his work electronically. David doesn't believe in making a strict distinction between creating illustrations and fine art. Instead he makes work that he finds aesthetically pleasing. David, a successful artist for over 20 years, would give the following advice to creatives starting their own business:

1 Don't just accept constructive criticism – embrace it.
2 When business is slow – don't panic, it will pass.
3 Know when to slow down – quality beats quantity.

You can see David's work at: www.blackwolfstudio.com.

Definition of products

Products can be categorized as a tangible good, an intangible service or an experience. However, a product can also be a combination of all three. This is exactly the case with most creative products. In the case of the visual arts or handcrafted items there is a physical good (even if it is digital). However, when purchasing the product the customer may also be provided with the intangible service of advice on how the product should be used or knowledge of how the product was produced. In addition, the experience of the purchase is part of the product. The studio, retail shop, event or venue where the product is sold along with the opportunity to meet the artist is part of the product experience. Of course the core of a performance-based product is an experience. However, the creative entrepreneur might also provide a tangible product by selling programs or refreshments. In addition, they might also provide other services, such as coat check.

Commoditization and consumer choice – is there anything different to buy?

Today people are surrounded by purchase opportunities. Consumers are no longer limited to what they can purchase in local retail establishments, as technology allows them to purchase products from almost anywhere in the world. Because consumers have so many choices, they can be very discriminating and find exactly the product that meets their needs. This search is not a new phenomenon as people have always wished to purchase unique products (Underhill 2009). For example, tourists have always shopped for distinctive products that they then brought home. The advent of catalogue shopping in the nineteenth century meant that consumers could now purchase specialty items and have them shipped directly to their home. However, most people did not travel or have access to catalogue distribution, which meant that consumers could only purchase what was available at the local store. If the product met the consumer's needs, the consumer was happy. If the product did not meet the needs of consumers, they would still purchase because they did not have any other choice.

Now technology allows consumers to purchase products from an almost limitless number of producers. However, many of these products will be similar as there are only so many ways that a product can be changed to be distinctive. This lack of differentiation is called commoditization (Ferrell and Hartline 2010). For example, there are only so many different ways that a chair can be designed. Of course, chairs can be designed for different uses. In addition the style, color and size might vary. However, a consumer could find numerous stores that sell similar chairs, all of which claim to be the best product available.

Creative entrepreneurs have the advantage because their work is distinctive, as it is designed and produced by an organization with a unique mission or an artist with a distinct vision. Therefore creative entrepreneurs must incorporate into their business strategy a way to communicate their mission and vision to differentiate themselves from their competitors. While the challenge of product differentiation is

faced by all organizations, creative goods have an advantage as they will be inherently unique.

Question to consider: How does the commoditization of products affect what I produce?

Categories of products

Products, including tangible goods, intangible services and experiences, can be classified into the categories of convenience, comparison or specialty. These product categories are based on differences in the pricing, promotion and distribution of the product and the consumer's purchase motivation. By understanding into which category their product falls, creative entrepreneurs can avoid pricing, promotion and distribution errors.

Categorization of products

- Convenience: intensively distributed, promoted as conveniently located and inexpensive.
- Comparison: selectively distributed, promoted by unique features.
- Specialty: exclusively distributed, promoted based on brand.

Convenience products – they're everywhere!

Convenience products are routinely purchased by consumers who put very little thought or research into the purchase decision. Convenience products are usually low cost for the consumer and low profit for the producer. This means that, in order to make sufficient revenue to cover businesses expenses, a large volume of convenience product must be sold. In order to sell this large volume the product must be distributed to many different retail locations to reach a large target market segment. Also, because of the need to sell the product in volume, convenience products are designed to appeal to a sufficiently broad consumer segment. They therefore often lack distinctive features. Rather than describe the benefits provided by a unique product, the promotional message for convenience products focuses on low cost and convenient purchase locations. Typical convenience products are soft drinks, fast food and toothpaste, all of which are relatively inexpensive and widely distributed.

Because of the need to sell in volume at low prices, most convenience products are mass produced. It would be a rare artistic product that would fall into the convenience product category. Original artwork and handcrafted products are simply too expensive and time consuming to produce to be sold as convenience products.

Comparison products – one among many

Comparison products are distinguished by having a higher price than convenience products. Comparison products are also available in fewer locations. Most importantly the product's features will vary between brands more than is true for convenience products. Consequently, consumers will spend time comparison shopping and researching such products before the purchase decision is made. While comparison products, such as a pair of shoes, may all supply the same main benefit, the consumer will choose individual pairs of shoes based on many other features. They may choose based on quality, stylishness, price or any combination of these characteristics. Therefore the producer of the product must understand what features are desired by their targeted consumers. Only then can they produce a promotional message that communicates that their product offers these features while competing products do not.

However, creative entrepreneurs will understand the unique features of their artistic product while many consumers may only see them as comparable to other paintings, craft items or performances. Creative entrepreneurs will need to use promotion to educate the consumer so that they will be willing to pay for the unique features. For example, when choosing a painting, even though all paintings may perform the same function, the decision of which to purchase will often be based on features such as the artist, the design, color and subject matter. If the unique features are promoted, the targeted segment should be willing to pay the price. In fact, consumers may even spend more money than they anticipated. Therefore, the promotional message for comparison products focuses on features and benefits, not on low price and the product's availability at many retail locations.

Specialty products – only for special people

Specialty products have distinctive features or a unique brand identity that is highly valued by a specific target market segment of consumers. As a result, consumers will not accept substitutes when they decide to purchase a specialty product. Not only are they willing to travel to a particular location to purchase the product, the fact that the product is not widely available adds to its image of exclusivity. An example of a specialty product is a piece of glass blown by Dale Chihuly. Other expensive pieces of glass sculpture may be just as lovely, but a segment of consumers will only purchase works by Chihuly because they consider the status of having the work worth the price. The promotional message for specialty products focuses on product and brand image, and less on the specific features of the product.

Many artistic products fall into the specialty products category. While the consumer may still have a budget in mind, they consider the value of the product to partly result from its high price and resulting exclusivity. While artists might start promoting their products in the comparison category, if their reputation grows, they will then reposition their product as a specialty product and charge higher prices. However, they must first build their brand and reputation before most

consumers will be willing to pay a higher price for the status value that the product provides.

Questions to consider: Should my product be classified as convenience, comparison or specialty? Why?

Product lines and product portfolios

Most businesses do not offer a single product only available in one color, one size and one type. Instead they offer a portfolio of products. Products that meet the same basic consumer need are said to be part of the same product line. At its simplest, the product line may consist of only variations of a single product. This variation might be practical, such as offering handcrafted tables in different sizes. The variation may also be based on consumer preferences, such as genres of music. For example, a performance company may offer one product line of concerts for families and a second for adults. Product lines are targeted at a market segment using a single promotional message. Small organizations are advised to stay with only one or two product lines because of the expense of developing and implementing a promotional message for each.

Because the items in the product line are so similar and they are targeted at the same target market segment, their sales figures will all be grouped together on one revenue line. In this way, creative entrepreneurs will be able to easily determine which product line produces the most profit.

Adding product lines – when you are ready to grow

Either because of new creative interests or a need to increase revenue, or both, creative entrepreneurs may decide to introduce new products. If the products are substantially different, by meeting a different consumer need or targeting a different market segment, they will constitute a new product line and will require a unique marketing message. For example the producer of handcrafted tables might decide to introduce a product line of cutting boards to target a market segment that wants handcrafted wood products but cannot afford to purchase a table.

The creative entrepreneur needs to consider carefully whether to introduce additional product lines. While having more than one product line does increase the choices for consumers and adds an additional revenue stream, it also increases the costs for the creative entrepreneur (Gordon 2004). There are several reasons why a new creative startup should have a limited number of product lines. Each new product may involve different raw materials, which adds to the time spent on ordering and inventorying materials. A new product line might also require different equipment and skill to produce. In addition each will need to be promoted separately if the product lines are targeted at different customer segments. All of these additional expenses will need to be incurred before the new product line produces revenue, which is why small creative entrepreneurs start with a limited

number of product lines. Another issue that results from introducing additional product lines is cannibalization. This word is used to describe what happens when sales of the new product line results in a decrease in sales of already existing products. Rather than attracting a new customer segment, the organization may find that current customers are simply changing their product preference. This will result in no additional revenue and less profit because of the expense of introducing the new product line.

Question to consider: What different product lines will I produce?

Why do corporations buy art?

Merchants have been investing in art since the Middle Ages for use in their homes. Now corporations purchase art for their corporate offices. In fact, worldwide, there are about 1,500 corporate art collections, some of which have so many pieces of art that they are curating and loaning collections to museums. The reasons for corporations to purchase art vary but include the visual appeal that complements the work space, their employees' enjoyment and a means of promoting their brand image. In addition, some corporations seek to purchase art from local artists to emphasize their connection to the community.

When large sums of money are going to be spent, many corporations will hire a consultant to help choose the pieces that will be purchased and displayed. This consultant may be a member of the Association of Professional Art Advisors. These individuals do not buy work for resale, nor do they represent artists. Rather, their mission is to advise their corporate clients on the availability of art that might be of interest and then help to maintain the collection.

Once hired, the consultant will often work with a committee of employees who will be involved in making the final purchase decision. After the artwork has been installed, the consultant will then educate the employees about the work that is being displayed. If an artist wishes to sell to a corporation, the first step will be to obtain the name of the corporation's consultant.

Efron 2013 and Linytzky 2013

Core, actual, augmented and ancillary product

A product is more than just the tangible good, intangible service or experience. Instead, products consist of a bundle of benefits that is purchased by the consumer. All products have a core benefit, without which it would not be a product. However, because consumers can choose from numerous products, often with

similar core benefits, they will chose a specific product based on its actual attributes such as price, quality, color and size. To further attract the consumer, the product offers augmented benefits, which are usually additional services that are provided along with the product. These may include customer service, warranties, delivery, financing and the purchase experience. For some products it is possible to describe the product even more clearly by including its ancillary benefits (Gordon 2014). These benefits derive from the mission of the organization. By purchasing the product, the consumer can also care about the environment, help those in need of employment, support animal rights or increase the availability of arts education in urban areas. These ancillary benefits are not included with all types of products but are an integral component of the mission of many creative entrepreneurs. By purchasing a product with these ancillary attributes, the consumer will develop a relationship with the creative entrepreneur beyond that of buyer and seller. Instead they will be united in a cause. Because there are so many competitors in the marketplace, all creative entrepreneurs need to think of their product as more than simply the core product.

Analyzing the product

- Core: reason the product exists.
- Actual: product attributes.
- Augmented: intangibles of image, service quality.
- Ancillary: incorporates values of organization.

Core product – the reason it exists

All products have a core reason for their existence. For most mass produced products, determining the core benefit is simple, such as a bed is purchased to provide a place to sleep. However, this is not true of creative products where the benefit might not be so easily discernable. After all, what is the purpose of a piece of art? While some people may purchase the piece of art simply to decorate a space on a wall, for others the core benefit might be how the form and color makes them feel. Other consumers might purchase the same piece of art as a status symbol. In addition, tourists might purchase the product because the core benefit would be a reminder of their visit. Creative entrepreneurs must remember that it is the purchaser of the product who determines its core benefit. Understanding the consumer's view of the product will enable creative entrepreneurs to develop a promotional message that speaks directly to this benefit.

For service products, the concept of a core product is more complex. Part of the core product for a service such as design advice or a musical performance is the people who produce the service. Consumers will view the interaction between themselves and the producers of the service as part of the core product. As a result, the producers of creative and performance services must have exceptional people skills. In addition, the core product can include the process of the delivery of the product, including the booking of the service and verifying with the customer after

the service has been provided to determine product satisfaction. Even if the booking and verifying is done through technology, the efficiency and design of the platform used is part of the core product. Finally all tangible evidence of the service is also part of the core. This would include any lettering and logos on vehicles, the website design and promotional material.

Actual product – what else comes with it?

The actual product attributes, such as additional materials, installation, delivery and customer care provided along with the core product, add value to the purchase. While the core product for creative entrepreneurs would be the artwork, providing a nicely printed postcard on how the product was produced would be part of the actual product. In addition, instead of putting the artwork in a plain plastic bag, it can be given to the purchaser in a beautiful bag that can then be reused for another purpose. Because of the benefits that are provided by the actual product, consumers are willing to pay more as they add value to the overall purchase.

In addition, if a consumer is at an event where numerous products are available with similar core benefits, it may be the fact that the creative entrepreneur's product will be packaged for shipment that affects the product purchase choice. If the product is expensive, having payment and financing information available may make the purchase decision easier. Lastly, ensuring that the creative entrepreneur stands behind the product with a guarantee that will address any future concerns may persuade the consumer to purchase one product instead of another. These additional actual product benefits assure the consumer that they are purchasing a product that provides more than just a core benefit.

It is a similar situation with a service, such as a performance. All performances provide the core product of entertainment. However, what actual benefits are included with the core product will vary. Some performing companies will provide customization, where the performers will work together with the purchaser to create a program geared specifically to their needs. For example, the consumer will choose the pieces of music that will be played.

Warranties may not be a part of the actual product that an artist or musician had considered, but they can apply to creative as well as manufactured products. All products that are sold have what is called an implied warranty. This states that the product should be able to be put to the use for which it is intended. For example, drinking glasses, whether utilitarian or created as an artistic statement, should not leak. Another example would be that the clasps on jewelry, whether mass produced or custom designed, should stay closed. If not, purchasers have a right to ask for their money to be returned.

However creative entrepreneurs may wish to provide an express warranty, which is a written guarantee that the product will perform to certain standards. For example it might be stated that a hand-knitted scarf is guaranteed to be washing machine safe or that a sculpture uses materials that can withstand outside weather. An express warranty is informational as it states what type of use the product can

endure, but it also reassures the purchaser that the producer has faith in the product.

Services also can have warranties. These usually state that satisfaction is guaranteed. In this case the creative entrepreneur needs to be careful that what is meant by satisfaction is clearly understood. Most people use products in good faith and only complain if necessary. However, it is still in the creative entrepreneur's best interest to make good on the promise of a guarantee even if the service was performed to specifications. Of course, if there is a case of chronically unsatisfied customers, the creative entrepreneur may decide to refer them to a business that can better meet their needs.

Augmented product – and for no extra charge!

The augmented product adds the intangibles of image into the product's bundle of core and actual benefits. This would include the ambience of the retail space, the knowledge of the staff, the purchase experience and the brand image of the product. Many people are willing to pay more for a product based on these enhanced features. In fact people often purchase creative products because they want the experience that the augmented product provides. Even if they are purchasing the product online, the unique style of the website and the personal stories of the product's creators, are part of the augmented product that is purchased.

Ancillary product – please join with us

Ancillary benefits are provided by the organization or business mission, not by the product. The product might be purchased because the creative entrepreneur's mission confirms a value held by the purchaser. For example, if consumers are concerned about poverty, the fact that the product is produced by people with low incomes would provide the supplemental benefit of supporting a cause. This combination of the core product benefit, as seen through the eyes of the consumer, and actual benefits, along with the augmented and ancillary product benefits comprises the bundle of benefits that is purchased by the consumer.

Questions to consider: What is my core product? What are the actual, augmented and ancillary attributes of my product?

Art versus craft – does it matter?

The debate over art versus craft is not new. However, there is a renewed focus on the difference as it is now common for individuals not trained in art, music or design to create objects which they consider art. The practice of sharing this art online has now lent the debate new emphasis while providing even less clarity. In addition, the ability of people to share their creations online means that they can skip the arts intermediary who would decide if it

was art or "merely" craft. The Maker Movement in the US and the Make Do and Mend movement in the UK have also added to the debate.

The old idea, that craft was for use, while art was for contemplation, seems no longer relevant. There are now new methods of categorizing art versus craft. One new argument for the distinction includes intention. If a maker believes that the work expresses meaning, then it is art. Another argument is that the categorization depends on the material used. In this way of thinking, objects made from textiles, ceramics and sometimes glass fall into the craft category. Some believe that it is the way that the creator learned their skill; only people with formal training can create objects considered to be art. One last distinction is use, with objects that can be worn or used in daily life to be considered craft while other objects are art.

A blogger at the Tate in London asked her readers what they thought. If the Tate cannot definitively say what is art versus craft, who can?

Beaven 2011

Packaging the product

It might seem that packaging a product is not a consideration on which much time or thought needs to be spent. However, packaging should be considered a part of the actual product attributes. Of course the product package's first function is protection. The creative entrepreneur must consider not just protection for the product leaving the store but also provide for protection until the product reaches the purchaser's home. Any damage to the product while it is being transported to the consumer's home would not legally be the producer's responsibility. However, the purchaser would feel as though it was. Therefore the producer should design the package so that it provides enough protection to ensure that the product survives, even if it is dropped on the car or subway floor. If the product is going to be shipped, additional protection will be needed. Packaging can also be designed so that it provides ancillary attributes such as being environmentally friendly. Some packaging can even be created so that it can be used for another purpose, therefore providing the consumer with additional benefits.

Besides protection, environmental issues and reuse, creative entrepreneurs should spend time considering how to package their product so that it is part of the promotional strategy. If well designed, the image of the packaging can contribute to the business's overall brand image. For example, if the brand image being promoted by the business is that it produces high-quality, unique products that are lovingly handmade, putting the finished product into cheap packaging will damage this image.

Labeling and product information should also be considered as contributing to the brand image. The creator of the product may consider labeling unnecessary as the product is self-explanatory. However, the label can contain biographical

information on the people who created the product and also explanatory information on how the product was produced. Since one of the motivations for purchase is the fact that the product is unique and original, purchasers need this information to validate their decision. Of course, design of the labeling should complement the design of the product. A trendy product needs to have trendy packaging and labeling, while a product that appeals to more conservative tastes needs a different type of package and label. Besides protection, the purpose of the packaging is to enhance the brand image.

Question to consider: How can the packaging of my product enhance my brand image?

More than a package

How you package your product says a lot about the quality of the work inside. There is an old saying that you can't tell a book by its cover, but today people believe if the cover is bad, so must be the book. Here is a process one artist goes through to package prints:

- Protect: First protect the print from dirt and moisture with plastic. Then add cardboard cut from supply boxes to provide a backing to protect from creases.
- Brand: Next is a paper wrapping that prominently displays the brand name of the company.
- Decorate: Since the brand involves art, so should the package. Artistic elements are then added to the packaging.
- As a result the package becomes part of the art product.

Corrigan 2012

Service characteristics

Services are considered a product, the same as a tangible good or experience. However, there are differences in the characteristics of service products that makes their promotion, distribution and pricing more difficult. In addition these unique service characteristics result in unique challenges when creating a brand image (De Chernatony and Segal-Horn 2001). The terms that are used to describe the unique characteristics of service products are perishability, inseparability, heterogeneity and intangibility. These are not words that creative entrepreneurs typically use, but understanding their meaning in relationship to services is critical to developing the correct pricing, distribution and promotion strategy for a business plan.

Perishability – here today, gone tomorrow

Services are considered a perishable product, which means that they are incapable of being stored for later use. A tangible product, if not sold one day, can be stored and sold on another. If it still doesn't sell, the price may need to be marked down, but the product still has value. On the other hand, if a ticket to a performance is not sold, after the performance is over, the ticket no longer has any value and the potential revenue is lost forever. If a seat at a concert is unsold, two people cannot share the same seat at the next performance to make up for the lost revenue. For this reason, pricing for services is often variable, which means the price varies depending on availability of seats and the nearness of the performance date. For example, tickets may initially be offered at the regular price but then be discounted as the date of sale approaches if insufficient tickets have been sold. However, the opposite approach may be taken if it is thought that the tickets to a performance might not sell well. In this case, tickets might be sold at a discounted price for a short period of time to encourage early purchase and create buzz. Later, when sufficient tickets have been sold, the price can be raised. While large businesses such as airlines have sophisticated software programs to gauge demand and vary prices, creative entrepreneurs must watch sales closely and use trial and error to determine the right pricing strategy.

Inseparability – buy the product, you get the producer too

Services are also affected by the fact that the performance of the service is inseparable from the service provider. This is not true of tangible products, as someone might buy a piece of furniture without any thought to the personality of the producer. If they like the furniture, they will purchase, even though they might find the woodworker unsociable. Because they will not have contact with the creator after the purchase, they may consider the personality irrelevant. While the piece of furniture can be bought with minimal contact with the creator, this is not true of a service product such as a lesson or music for a wedding. Here, the customer expects contact with the service providers, and their personalities will make a difference both in the purchase decision and after-purchase satisfaction. While the consumer may initially contact the business based on the known quality of the service, the personality of the provider will either encourage or discourage purchase. While a personable service provider will not make up for inferior product quality, an unfriendly service provider may affect the perception of a quality service.

Heterogeneity – every day is different

The term heterogeneity is used to describe the fact that the quality of service products will vary more than the quality of a tangible product. Because service products are created and consumed immediately, there is not time to repair errors. If a potter finds a ceramic vase unacceptable, it can be remade. If a performance or

lesson goes badly, the experience has already been received and cannot be fixed. The fact that the service product has greater heterogeneity means it is more challenging to promote. The potential purchaser of a service will want to know that what they will receive will be consistent with the product that was promised. This is easier for the producer of a tangible product. If the artist is not quite in a creative mood, the item on which he or she is working can be put aside until another day. If a finished product does not meet the artist's standards it can be discarded and will never be seen by potential customers. However, if the product is a series of lessons, artists must be in the same suitably friendly, helpful frame of mind each time they meet with students.

While some service providers work to reduce heterogeneity by instituting policies and procedures, this is not true of the creative entrepreneur, who would react negatively to such rules constraining behavior (Moeller 2010). Instead, creative entrepreneurs should position their product's lack of heterogeneity not as being a matter of a lack of quality but rather in terms of the fact that each product is distinctive in some way.

Intangibility – when you just can't see it

Finally, service products are intangible. They cannot be seen, touched or heard until they are being consumed by the purchaser. For this reason promoting a service product is more challenging than a physical product, which can be promoted using a photograph or a display, as it is difficult to take a photo of or display the mood that music creates in the mind of the listener. Therefore promotion of service products must rely on tangible cues. For example, the visuals used for promotion will show people enjoying the performance. In addition, testimonials and reviews from past customers will be used to build trust that the product will produce the benefits that are desired. In addition, samples using video can be distributed via social media.

Question to consider: If my product is a service, what additional challenges do I face?

Branding with product benefits

Each product has many benefits, but only some will be part of the brand image of the product. Branding involves the decision on what product attributes should be communicated through the brand. Of course, the brand image could only stress the benefits that the product provides to the consumer. However, there are other choices for branding that involve places, people and issues. For instance, the country of origin of the product or the materials from which the product is made could be stressed as part of the brand image. For some service products, the heart of the brand image focuses on the people who produce the product, such as the life story of the creative entrepreneur. Lastly, the creative entrepreneur could decide that an issue or social cause should be the basis of branding the product.

Brand loyalty – they always come back

The motivation for branding a product is not just to get a consumer to buy the product once. It is instead to have them develop a relationship with the product and business so that they purchase again. This relationship is known as brand loyalty. If consumers are brand loyal, they will make the business their first choice when they decide to purchase. They are also more likely to try any new product that the creative entrepreneur develops. Lastly, they will recommend to their friends that they purchase the product. Now, with social media, brand loyal customers will be more likely to post positive reviews online.

An additional benefit is that branding reduces risk to the consumer when purchasing products. With so many competing products and little time for product research, consumers are more likely to purchase a known brand then to try an unknown product. Branding also helps to communicate the company's competitive advantage. The brand acts as a quick reminder of what the product has to offer.

Branding is particularly helpful in communicating the image of the creative entrepreneur's mission and not just the benefits of a particular product. Rather than just a promotional message, the brand embodies the mission of what the business hopes to achieve. If customers believe in the brand, they are more likely to pay more for the product as they are secure in the knowledge that they will receive value for their money. Rather than a vague message that the product is the "best," the branded message focuses on specifics by stressing brand attributes and the business's mission.

Question to consider: What is my main brand attribute?

Competitive advantage

Creative entrepreneurs believe in the uniqueness of their product. However, in the minds of consumers, there may be other products that provide similar benefits. Even when creative entrepreneurs believe their products have no competition, consumers will compare and may put the product together with others into a single group of possible purchases. As a result of this process, one of the most critical tasks of creative entrepreneurs is to explain how their product differs from the competition. This difference is referred to as the product's competitive advantage. The competitive advantage for each product answers the consumer's question, "Why should I buy your product instead of the product produced by your competitor?" The three generic bases for differentiating products, referred to as value disciplines, are operational excellence, product leadership and customer intimacy (Treacy and Wiersema 1995). These are referred to as generic as they can apply to any type of business. All businesses exhibit one type of these advantages. Some can exhibit more than one, but it would extremely difficult to exhibit all three.

Operational excellence – we can do it for less

When a business has the competitive advantage of operational excellence, it is extremely efficient in the production of the product. Because the business can create the product efficiently, the product's price can be kept low. This operational excellence advantage can result from low labor costs, which is one of the reasons that companies might move production to another country with lower wages. It can also result from offering no extra services and minimal packaging, thereby cutting expenses. The product design can also be simplified to keep costs lower. Because the focus is on efficient production and, as a result, low price, creative entrepreneurs rarely compete on this basis.

The furniture and design company Ikea is a company that exemplifies operation excellence. Other examples of these types of companies are discount stores and companies that produce low-cost consumer products such as facial tissue. Customers patronize these companies because they know that they will get a good product at a reasonable price. There is little brand loyalty so a consumer may switch if a cheaper product becomes available. The companies started by creative entrepreneurs are not able to pursue operational excellence as a competitive advantage as handcrafted products and personalized services can never be produced cheaply in volume.

Product leadership – we have the latest and greatest

The second basis for competitive advantage is product leadership. In this situation, the business is able to offer the most cutting-edge and newest products. Product leadership can derive from having the latest in technologically innovative products or products that use new materials or processes. Product leadership can also result from products that are trend setters. Some creative entrepreneurs are able to pursue product leadership as a competitive advantage, if the artistic product is unique. This uniqueness could be based on the work's subject matter, a new production process or a new artistic style. If the creative entrepreneur is able to create products that no one else is producing, the product does not have to be priced inexpensively as it will be highly sought after by knowledgeable consumers. Because they may be the only artists creating a product in this manner or style, they will have a competitive advantage that will attract customers and allow them to charge higher prices.

Customer intimacy – where everybody knows your name

The third generic form of competitive advantage is customer intimacy. Companies that focus on customer intimacy emphasize developing relationships with their customers so that they can better serve their needs with the exact products they desire. To do so they carefully track the customer preferences so that they can be incorporated into products. In the past, companies that pursued this strategy tended to be small, as otherwise it would be difficult to personally know the customers. But the use of databases to track and analyze customer information has allowed

larger businesses to now pursue this strategy. In this situation what distinguishes the business is the emphasis on knowing and meeting the needs of customers, thereby developing a relationship.

Creative entrepreneurs and competitive advantage – finding what fits

Most creative entrepreneurs cannot focus on operational excellence as they cannot efficiently produce products. In fact to do so would probably go against the mission as they would need to reduce quality in order to reduce prices. Only some creative entrepreneurs can focus on product leadership because they produce products that have the latest technology or incorporate the latest trends. Instead, most creative entrepreneurs will focus on developing the competitive advantage of customer intimacy. These creative entrepreneurs will take the time to understand their customers' product needs and desires. They will then respond to the best of their ability to what their customers want. This does not mean that they will change entirely what they produce, as their mission depends on creating a specific type of product. However, it does mean that they will adjust the attributes of the product based on the desires of their consumers. Social media is extremely helpful in communicating with current and potential customers to establish this customer intimacy. This is particularly true if the creative entrepreneur does not have a storefront where they can interact with customers on a regular basis. Creative entrepreneurs who focus on customer intimacy will develop a relationship with their customers that will keep them brand loyal.

Question to consider: What is my organization's competitive advantage?

Summary

Producing a product is only the first step in having a product strategy. Because consumers have so many products from which to choose, it is said that products have become commoditized. Therefore creative entrepreneurs must understand how to differentiate and position their product. The first step is to understand the categorization of products as convenience, comparison and specialty, as pricing, promotion and distribution will vary. Because convenience products are mass produced so that they can be sold cheaply, most creative entrepreneurs produce either comparison or specialty products. Analyzing the product's core, actual, augmented and ancillary benefits can be the basis of a promotion message. Creative entrepreneurs who produce performance- or service-based products face additional challenges due to the factors of intangibility, perishability, inseparability and heterogeneity. Specific product attributes will be used as the basis of developing a brand image and brand loyalty. The value discipline model of operational excellence, product leadership and customer intimacy can be used to determine the business's competitive advantage.

References

Beaven, Kristie. "Tate Debate: When Is a Craft an Art?" Blog. October 13, 2011.

Corrigan, Charlie. "Barnum's Winter: The Art of Packaging a Print." June 17, 2012. http://barnumswinter.blogspot.com/2012/06/1.html. Accessed August 25, 2014.

De Chernatony, Leslie and Susan Segal-Horn. "Building on Services' Characteristics to Develop Successful Services Brands." *Journal of Marketing Management* 17, no. 7/8 (September 2001): 645–669.

Efron, Jean. "Art Makes a Statement for Business, Too." *New York Times*, March 13, 2013.

Ferrell, O. C. and Michael D. Hartline. *Marketing Strategy*, Mason, OH: South-Western, 2010.

Gordon, Ian. "Creating Product Addicts." *Ivey Business Journal* 78, no. 1 (January 2014): 1–4.

Gordon, Kim T. "Pros and Cons of Expanding Your Product Line." *Entrepreneur*, June 2004. www.entrepreneur.com/article/71094. Accessed August 1, 2014.

Linytzky, Ula. "Corporations Do More To Put Their Art on Public Display." *Yahoo News*, September 6, 2013. http://news.yahoo.com/corporations-more-put-art-public-display-063101780–finance.html. Accessed March 4, 2014.

Moeller, Sabine. "Characteristics of Services – A New Approach Uncovers Their Value." *Journal of Services Marketing* 24, no. 5 (2010): 359–368.

Treacy, Michael and Frederik D. Wiersema. *The Discipline of Market Leaders: Choose Your Customers, Narrow Your Focus, Dominate Your Market*, Reading, MA: Addison-Wesley Pub., 1995.

Underhill, Paco. *Why We Buy: The Science of Shopping: Updated and Revised for the Internet, the Global Consumer and Beyond*, New York: Simon & Schuster Paperbacks, 2009.

Tasks to complete

Answers to these questions will assist in completing the Product section of the business plan.

1 Product

 a Describe your product in as much detail as possible.
 b List all the variations of your product and arrange in product lines.

2 Product benefits

 a Write one sentence describing the core benefit of your product.
 b Write five words each on the actual and augmented benefits of your product.
 c List the values that are associated with the ancillary benefits of your product.

3 Competitive advantage

 a Give an example that demonstrates your organization's competitive advantage.
 b Describe five ways in which your product is different from your nearest competitor.
 c Answer the following question: "Why should I buy your product?"

Visualization exercises

1 Draw a picture of your product, labeling all the parts.
2 Draw a circle and in the middle write the product's core benefit.
3 Use concentric circles to add actual, augmented and ancillary benefits.
4 Write a tweet explaining why your product is best.
5 Draw an image that represents your brand.

5 Targeting the right customer

Introduction

Creative entrepreneurs start the process of developing a business plan by examining their internal resources and external environment. They also write mission, vision and values statements, and consider what research will need to be conducted. After these preliminary steps are completed the creative entrepreneur analyzes the benefits provided by the core, actual, augmented and ancillary product. The next step in the process of developing the business plan is to find and target the correct segment of potential customers. Although creative entrepreneurs may continue to produce their work because of their inner drive to create a product, they will not have a business until the product is purchased by a customer.

The creative business might decide to broadcast the same marketing message to everyone as if there is only one undifferentiated group of consumers all with the same needs and wants. However, by targeting a single consumer market segment with similar characteristics, the creative entrepreneur can develop and communicate a single message that will improve the chance of attracting the consumer segment to the product. Finding the potential customers who are interested in the benefits that the product provides requires an understanding of the consumer buying process and its relation to the marketing message that will be used in promotion. The creative entrepreneur must then decide on a targeting strategy. The final step will be to determine the characteristics of the consumers most likely to purchase the product. These steps will result in a segmentation strategy for the new organization. This targeting strategy is as critical to success as the production of the product.

What creatives have to say: Allison Lyke

Allison is a writer who also offers social media consulting services for startup brands, nonprofit organizations and performing artists. Not surprisingly, much of her work comes to her via social media. Alison took business classes in college, including marketing, and so thought that she had the skills she needed for success. Now she understands she needed to know even more.

1 Budgeting: As a creative she thought money would just arrive when it was needed, but then she learned she needed to plan her spending.
2 Negotiating/selling: Not all clients agree to the price; now she knows that persuading them to spend the money on something the client doesn't understand is key.
3 Business card: Only after launching her business did she know that even when all your work is online, there is no substitute. A card is informative, professional and long-lasting as it reminds potential customers of your pitch when you are no longer present.

You can learn more about Allison's company at www.facebook.com/LykeMediaCompany.

Targeting consumer segments

Most creative entrepreneurs believe strongly in the quality of the products they produce and also the benefits that the products provide to purchasers. They therefore might leap to the conclusion that everyone will want their product. Unfortunately this is not true because the wants and needs of people vary. Some creative entrepreneurs understand that this is true, but because they do not know who is most likely to buy their product, they still try to promote their product to everyone. However, this is not an effective or efficient strategy. First, it is not effective because it is unlikely that the targeted consumers will hear the message unless it is specifically communicated via the media they are most likely to use. Second, it is not efficient as the business needs to spend a great deal of time and money to try to communicate the marketing message to everyone.

A fundamentally different approach has been practiced since the mid-twentieth century, which is to develop a targeting strategy (Smith 1956). First, creative entrepreneurs decide whether to focus on developing marketing depth or breadth. Second, creative entrepreneurs must understand the connection between the marketing message and segmenting consumers. Creative entrepreneurs can then decide upon the segmentation strategy and the characteristics of their potential consumers.

Even an established business still needs to continually promote to new potential customers. This is true even if the organization is content with the level of revenue it is receiving, as there is a natural attrition of customer numbers. Organizations continually lose customers because they change product loyalty, move away or have reduced discretionary income available to spend, which results in the purchase of fewer products. For these reasons of attrition, all businesses must always be adding new customers. The question is whether they will do so by developing market depth or market breadth.

Market segment depth – fishing out of the same pond

The first approach to finding additional potential customers is to increase market depth. With this strategy the creative entrepreneur seeks to find more customers from the same geographic location, having the same personal characteristics and with similar purchase motivation as the business's current customers. This is an easy strategy as creative entrepreneurs already know how to attract these customers. The disadvantage of this "more of the same" strategy is that many of the non-purchasing consumers already know about the business as they have already been targeted with the promotional message. For whatever reason, they had already decided not to purchase. For example, an entrepreneur who produces customized perfume targeted at local college students can simply send out more tweets to college students. However, if the college women have not responded in the past, there is little likelihood they will do so now. It takes more than a promotional message to change consumption behavior and motivate purchase for an already targeted segment.

Market segment breadth – spreading the net wider

Rather than targeting the same type of people, a more productive strategy is to develop market breadth. With this strategy, the creative entrepreneur seeks to attract a new customer segment that may not currently be purchasing the product. They may not currently be purchasing as they are unaware of the product because a promotional message has not been targeted at them. Or, they may be aware of the product but do not believe it will provide benefits of interest to them. To successfully motivate purchase from new consumers, the creative entrepreneur will need to develop a new promotional message that communicates the benefits desired by this new segment. While the development of the new message will require time and effort, the advantage of developing marketing breadth is that it will provide a new group of consumers who have not been targeted in the past.

If creative entrepreneurs are developing market breadth by targeting an additional consumer segment, they will need to create a separate marketing message for both the existing and new segments. The organization will communicate more effectively and motivate more purchases if they channel each communication about the product's benefits to a receptive specific market segment. The members of the group may, or may not, share similar demographic characteristics such as age, income or gender. They also may not live in the same geographic area. However, each individual in the segment will feel a shared need for the specific benefits that the product offers. Once creative entrepreneurs have determined the new market segment they wish to target, they can then design a marketing message that communicates the benefits directly to this segment. With the example of customized perfume, the creative entrepreneur could target professional women with a message that they deserve a scent as unique as themselves. This new message should be developed with a communication style, wording and visuals that will be attractive to the targeted segment of professional women.

When consumers are constantly bombarded with promotional messages, it makes sense for creative entrepreneurs to focus the message on a new consumer target market that will be most attracted to their product. However, the message must accurately reflect the product's benefits. For example, if the creative entrepreneur wishes to develop market breadth by attracting a new younger segment of consumers, an exciting promotional message communicating the product benefits can be developed. However, if the product then does not provide the benefits, the brand image will be damaged.

Questions to consider: Why should I develop either market depth or breadth?

Targeting strategies

There is an old saying: "there is no business until something is sold." No matter how wonderful the product, without a customer there will be no revenue, resulting in no profit and, therefore, no business. It is not uncommon for creative people to fall in love with their artistic creation. After all everyone's new baby is the most beautiful in the world. Unfortunately, as a result, creative entrepreneurs will believe that everyone will be interested in purchasing, if only they knew about the product. As a result, the first impulse of the new creative entrepreneur is to immediately start to promote the product using a message designed to communicate to everyone. However, this is a serious error as it will waste both time and money.

Instead, the first step must be to determine a strategy for finding and targeting the people who are most likely to buy the product. In business terminology consumers are thought of as groups of potential customers called segments. These segments share characteristics that result in them having similar needs and therefore desiring similar products. One of the first questions that entrepreneurs need to answer is whether to have an undifferentiated, concentrated, multi-segment or niche-targeting strategy.

Targeting strategies

- Undifferentiated: all potential customers seen as having same product desires.
- Concentrated: single customer segment with similar desires.
- Multi-segmented: more than one distinct segment targeted.
- Niche: small group with similar interest targeted using technology.

Undifferentiated – everyone will love me

The choice of targeting strategy is determined by the size of the business and its available resources. A common mistake for small businesses is to assume that everyone in the marketplace is the same and, therefore, to use an undifferentiated targeting strategy, whereby the entire public is treated as one large consumer

market segment that wants the same product. Even a product that is bought by almost everyone, such as soap, will vary greatly based on the needs of consumers. While everyone needs to be clean and therefore needs soap, individual segments of consumers might desire soap that is floral, hypo-allergenic, shaped like an animal, or anti-bacterial. Each of these types of soap is aimed at a specific segment: those who like scents, have allergies, with children, or who worry about germs. Each of these groups will respond to a different promotional message, so the words and the visuals used in each promotional message for the four groups mentioned will need to be unique. Even purchasers of soap cannot be treated as one undifferentiated consumer segment.

Concentrated – someone will love me

Most small businesses start with a concentrated segmentation approach, where only one segment of the consumer marketplace is targeted. With this strategy, creative entrepreneurs carefully analyze the benefits that the product offers to potential customers. By determining the group of consumers who are most likely to want the product, the chances for business success are increased. This is critical as a newly formed business does not have an unlimited amount of money to fund promotional efforts.

By concentrating on a specific market segment, the business can better ensure that it can provide a product that meets the needs of the group that is targeted. The current trend in business is towards targeting smaller groups. While fewer potential customers will be targeted, there is a higher potential that each customer will purchase (Lesonsky 2007). It is especially true that small businesses cannot be all things to all people. If a small creative business focuses on the needs of a specific market segment, such as families or an ethnic group, they are better able to provide the services and benefits best suited to that segment. This strategy allows small businesses to more effectively compete with larger organizations. The promotional message of the small business may not be heard if broadcast generally, but will be heard if targeted carefully.

Multi-segment – with so much to offer more than one person will love me

Targeting more than one group is a multi-segmented approach. The challenge with this approach is that it will take a separate promotional message for each group. A business may start with a concentrated strategy but, as it grows, it may adopt a multi-segment strategy and target more than a single market segment. This can be done by modifying the existing product in some way, such as color, style or size. Or, the business might develop an entirely new product for a segment currently not being served. For a performing artist this might be a change in the musical or theatrical material that is presented. For example a musical performance might have been developed for entertainment at corporate events. The same musician may then decide to develop a performance to target children's parties. The challenge is that the organization's carefully developed brand image may be confused in the

mind of the public (Millman 2012). One way around this difficulty is to have a separate brand name and promotional campaign when targeting very different groups such as corporations and families. Having more than one segment can result in additional revenue, but it will also incur additional expense.

Rather than change the product, another approach when targeting to multiple segments is to keep all aspects of the product the same, but to vary the message to promote different benefits. Even creative entrepreneurs who do not wish to change their product can use this approach. Because creative products provide a variety of benefits, the entrepreneurs can communicate different marketing messages that promote the benefits most sought after by each target market segment. For example, a creative entrepreneur who produces hand-woven wall hangings may promote them as a decorating idea to women and to men as a gift idea.

Businesses should be aware that, if they market to multiple segments, they must continually reassess the marketplace to ensure that their choices are still correct. With today's fast pace of social change, many market segments change quickly and as a result so do their needs and desires.

Niche – there is one right person for everyone

Niche marketing is the final strategy for finding and targeting a consumer segment. Technology has now provided organizations with an opportunity to micro-segment to the few people that may share an interest in a more obscure art form or craft (Verdino 2010). While people with very specialized interests have always existed, before technology there was no economical means to reach them as a consumer segment. With technology, even if they are geographically distant, the creative entrepreneur can not only find and communicate with the targeted customers but using social media can also form a community around the product.

Another approach to niche targeting is totally individualized products. In this process unique products are produced for each customer. While this might be thought to be the process of most art, as a single unique product is produced and then sold to a single customer, there is a difference. With this approach there is a basic product that then is customized to meet the specific wishes of a customer.

Question to consider: Is my product of such specialized interest that I should consider a niche targeting strategy?

Targeting strategy process – product first, then customer

A for-profit company will start the segmentation process with either a product or a target market segment. They may start with a product idea and then determine which consumer segment would be most likely to purchase. Or, they may start with a consumer segment and design a product that they would find appealing. However, creative entrepreneurs almost always form their business idea around the product that they are already producing (Schaller 2013). While this simplifies the process because the product is a given, the challenge for creative entrepreneurs is to

ensure that the target market segment that they choose is distinct enough to qualify as a market segment.

Creative individuals have spent years analyzing schools of art, genres of music and styles of writing. They have not spent much time analyzing who might purchase their work. When they do start thinking about the purchasers, they may generalize. For example, a creative entrepreneur may decide to focus on providing the benefits sought by younger consumers. However, this segment is too broad to be workable. The segmentation process would be more effective if the creative entrepreneur divided young consumers into segments such as well-educated, upper-middle-class singles or less-educated, lower-middle-class parents. Also, young consumers may be from the dominant ethnic group or from a minority group. The only common characteristic that the young share is age. Alone this is not sufficiently distinctive to effectively target them as a segment. The benefits sought by all young people will be too diverse for the organization to be able to meet all their needs with a single product. Therefore the next step in the segmentation process is to identify which segmentation bases should be used to describe the creative entrepreneur's target market segment.

Question to consider: Do I have enough product lines that I can develop a multi-segment strategy?

Understanding your community as customers

If you are thinking of moving somewhere else to market your art, the first step is to learn as much as you can about the artists who are already living and working in the new community. If they have been successful at making a living, there must already be a consumer segment of art purchasers. In addition, creative place making means creating art and culture that responds to what the community desires, which local artists will already understand. There are two ways to learn about the local artistic community:

- Artist inventory: Be sure you know all the artistic organizations, networking groups and individual artists in your new neighborhood. Start with the ones with which you are familiar and then ask them for advice on with whom to speak.
- Dialogue: Ask these artists about to whom they sell their art. Don't bring assumptions, but instead ask with an open mind. There may already be customers waiting for your work.

When moving to an artistic community, you don't need to start building a customer base from scratch.

Jenkins 2013

Segmentation characteristics

The creative entrepreneur can choose to segment the marketplace by any characteristic that makes sense. For example the consumer marketplace for clothing can be segmented by style choice, with some consumers preferring classic styles, while others prefer fashionable trends. The clothing marketplace can also be segmented by size, with some companies catering to people who are petite, while others target those who are tall. In addition a specific geographic location can be targeted, as people in Florida may be more likely to buy brightly colored clothing than people in New York City. The choice will be up to the creative entrepreneur, but there are a few standard methods of dividing the consumer marketplace. One way to get started on this process is to use someone whom the creative entrepreneur personally knows who is representative of the anticipated potential customers (McKeever 2008). After describing this person, the creative entrepreneur can than analyze the description using demographic facts, geographic location and psychographic characteristics. Segmentation of the customers by demographic and geographic segment is most useful when designing marketing strategy, while psychographic segmentation is most useful when considering product development.

Segmentation characteristics

- Demographic: based on gender, age, ethnicity/nationality, income.
- Geographic: based on location.
- Psychographic: based on values and lifestyles.

Demographic – who are you?

Demographic characteristics are defined as those that are easily quantifiable. They include characteristics that are commonly used in segmentation such as age, gender and ethnicity. Demographic characteristics also include occupation and education, both of which correlates closely with income. Family life cycle is also used when segmenting for some types of product. However, certain demographic characteristics are not easily determined and can be considered matters of privacy such as religion, nationality and social class. Sensitivity must be exercised if these characteristics are used in segmentation.

Gender: Gender may be one of the first characteristics that comes to mind when people are described. Of course, most products are not gender specific and there certainly is no rule that says that consumer wants and needs do not cross over the gender divide. However, even if the product is of equal interest to both genders, segmentation might still be used. Creative entrepreneurs might decide to develop a brand image focused on a specific gender by the ambience of the retail store, where the product is sold or the visuals used in the marketing message. However, for some products, gender is the basis of segmentation. Handmade articles of clothing and decorative items may be produced in colors, sizes and styles to specifically appeal to one gender. Even for products that have no gender bases for

segmentation, such as a musical performance, the benefits provided by the product can be designed to attract a specific gender. If the promotional campaign is targeted at males, the benefit of watching the technical skill of the performers might be stressed, while for women the campaign may stress the emotional benefit of a "girl's night out."

Age: The age of the potential consumers can also be used to segment the market if this characteristic is useful when describing the purchasers of the product. However, there is an important caveat for the creative entrepreneur to remember. A person who creates fanciful wall hangings may target them at younger customers. However, the hanging might be exactly what a grandparent might buy for a grandchild. As a result, the creative entrepreneurs must remember that the targeted purchaser of the product may be different from the user of the product and promote accordingly.

There is another factor to remember when considering age. Just as the strict stereotypes of what males and females want and need have broken down, the stereotypes of age are no longer as relevant. As people are living longer, healthier lives, their purchase of products is no longer the same as previous generations. Older people are active, are interested in trends and, in addition, have the money to purchase products. Likewise, just because a potential customer is young, this does not mean they are automatically interested in cutting-edge art.

Ethnicity/nationality: Ethnicity and nationality can also affect the purchase of products as different ethnic groups may celebrate different holidays, hold different values and have different purchase patterns. Creative entrepreneurs can use this type of segmentation if they decide to produce a product that can be used to celebrate a holiday. They do not need to change the product, but instead use promotion to remind an ethnic group that their product makes an excellent gift. Values are also necessary to understand when targeting an ethnic group. These values might include an emphasis on the time families spend together. For example a creative entrepreneur who produces a performance-based product might learn that certain ethnic groups value entertainment that appeals to the entire family. Therefore if a production suitable for families is being planned, the promotional message can be targeted at this ethnic segment. Finally purchase preferences may vary. To target a specific ethnic group may mean using a different distribution channel for the product as some groups are more likely to purchase in person than online. However, targeting a different ethnic or national group may require no other changes than changing the promotional message and media.

Income: Income is a consideration when targeting any consumer group. There needs to be more than just a desire to buy the product; there needs to be the ability to pay for the product. Spending time and money promoting a product to a group that cannot afford to purchase is not only a waste; it also means that sales are being lost from the customers who should have been targeted. Again, this does not mean that, even if a product is expensive, someone with a lower income will not decide to splurge and purchase the product. However, a business cannot be sustained over the longer term by targeting a segment that can only afford the occasional splurge purchase.

Income is rarely used alone to segment a consumer group. Just because people share a similar income level does not mean that they all desire the same products. However, income should be combined with other segmentation characteristics when describing a target market segment.

Geographic – where do you live?

Geographic segmentation should also be considered when determining a consumer segmentation strategy. Using geographic location as a characteristic, the product will be promoted where there is a concentration of the targeted consumers. Just as with income, it is rarely used alone, but in conjunction with other characteristics.

Because of ecommerce, products can be bought and sold from anywhere in the world. If a product is sold online it might be thought that geographic distinctions for targeting customers are no longer relevant. After all, an artist can easily sell globally using a website. However, geographic distinctions will still impact the targeting strategy. For example there may be additional challenges when sending products to some countries in terms of transportation logistics, cost, packaging considerations and paperwork. For this reason a creative entrepreneur may decide not to sell to particular countries. In addition, even if the product has global appeal, most creative entrepreneurs cannot afford to promote globally.

Geographic segmentation for performance-based art provides unique challenges as the product must be performed by the creative entrepreneur. The reputation of the performers will determine the reach of their brand. If there isn't a sufficient customer base where they are located, then the decision must be made as to whether it is personally and economically feasible for the performers to travel to the location where more people live who would be attracted to the performance. Economically feasible is a consideration, because travel costs money not only for personal transportation but also for the transportation of equipment. In addition to being economically feasible, the creative entrepreneur must decide if it is personally feasible because the time involved in transportation takes time that could be spent on other aspects of the business and also the performer's personal life. If the creative entrepreneur decides to produce the performance in a geographic area where they are unknown, then they must plan to spend additional time and money on promotion to build brand awareness.

For most performers, the decision will be made to target the geographic region where they are located. Then the issue is how far potential customers will be willing to travel to attend the performance. It is a waste of resources to spend money on promotion outside of this range. Rather than think about miles, it is more useful to think about time. Travel time can differ for the same amount of miles if rural areas are compared with traffic-packed cities. In addition, the time for public transportation would be considered if this is how the targeted market segment travels. For example a theatre company may decide that people will be willing to travel up to an hour for the performance. They know that in their city an hour gets someone 30 miles; they then have a geographic range for their segment.

Psychographic – what are you like?

Psychographic characteristics, although more difficult to determine, are more critical to a successful segmentation strategy as they allow the entrepreneur to group people by internal characteristics rather than demographic and geographic external facts. While demographic and geographic segmentation are suitable first steps in analyzing the potential consumers for a product, psychographic segmentation, which focuses on factors such as attitudes, values and lifestyles, is a more powerful segmentation tool as it focuses on the motivation for purchase. When analyzing the business's potential consumers, psychographic characteristics may not be as easily discernible as demographic or geographic factors, but they are the factors that actually motivate the consumer to purchase a product (Demby 1994).

Psychographic segmentation attempts to understand and group consumers based on attitudes, which are a favorable or unfavorable view of a person, object or idea. Attitudes, which are usually formed by both past and current experiences, differ from values and lifestyles as they can be easily changed. A consumer may have an attitude that original art, since it costs more, is a waste of money. To change that attitude, the promotional message must explain the benefits of purchasing original art. Some consumers may have the attitude that where a product is produced is of little importance, while others have the attitude that it is the deciding factor when making a purchase because they recently read an article about inferior materials being used in some countries.

Values differ from attitudes in that they are deeply held beliefs on how life should be lived. They usually develop from exposure during childhood to the values of families, churches, educational systems and other social groups. While values affect critical life decisions, they also play a role in purchase motivation. For example, someone who values a simple lifestyle with limited consumption will want products that are useful and well made. Lifestyle is another psychographic segmentation characteristic and refers to how values are expressed in daily actions. Lifestyles can range from people who are religious and want their products to express their faith, to skateboarders who want their products to express a style of youth and freedom. It is easier to target and promote to lifestyle groups as they often express and share their lifestyle using specific social media sites and attending similar events. All of these can be used as venues to promote the marketing message.

VALS: It is true that psychographic market segments are not immediately apparent. As a result, focus groups and interviews of current customers may need to be conducted to discover the psychographic factors that motivate the various groups to purchase. However, once this information is obtained, and it is correlated with demographic and geographic factors, it can be used to design a market segment that can be efficiently targeted.

There are many sophisticated segmentation tools that describe psychographic market segments that can potentially help the creative entrepreneur. These tools, which are designed by research companies that have spent considerable resources on interviewing consumers, can be expensive as they are designed for and sold to marketing professionals. The VALS (values, attitudes, lifestyles survey) is an example of a

well-known psychographic segmentation system (Strategic Business Insights). Using survey results, consumers are grouped by both their inner motivation and their resources, both internal emotional and external financial, that they have at their disposal. VALS has eight categories of consumers, including two that are of interest to creative entrepreneurs. Innovators are consumers who have both the external resource of money and the internal resource of high self-esteem that motivates them to purchase artistic products as a sign of status. Experiencers are described as young and enthusiastic consumers without much money but who are motivated by the internal need for self-expression. They would be interested in purchasing inexpensive creative products that they can then display to express their sense of identity.

Question to consider: Are demographic, geographic or psychographic characteristics most important when describing my targeted customers?

Why people buy art

What is the motivation for people to buy art? Below are 13 reasons:

- Emotional connection: association with personal history.
- Story: emotions, experiences and feelings of the artist.
- Form of expression: tells the owner's story.
- Freedom: brings the lifestyle of the artist into the owner's home.
- Luxury: good feeling to buy something that is not a necessity.
- Fresh and different: breaks the owner out of the routine.
- Patronage: helping the artist.
- Place: where it depicts or where it is bought has meaning.
- Empty walls: functional object used to decorate.
- Investment: bought to resell.
- Collection: to demonstrate status and taste.
- Gift: impress with originality.
- Fashion: trendy to buy art.

All of these motivations can be used to define a psychographic consumer segment.

Aljena 2013

Specialized segmentation approaches

Besides the traditional methods of segmenting consumers into groups based on their characteristics, technology now allows specialized methods of targeting customers with the exact product they desire. These include one-to-one marketing

and mass customization. In addition, a segmentation strategy for targeting business customers follows a different approach.

One-to-one segmentation – every product unique

Small companies that produce original creations or provide individualized services can offer a product that is completely customized to the individual consumer's needs. Previously this could only have been done with personal consultation between the producer and the customer. However, now these conversations can take place quickly and cheaply via technology. Therefore musicians can develop individualized play lists for an event, while visual artists can produce a work of the style, size and cost desired by the consumer. In the past such individualized products would only have been possible for the few artists who were connected with a patron. Now using social networking sites customers can be communicated with online and the exact product desired produced. Individualized approaches such as one-to-one marketing can be implemented at the same time as the organization uses segmentation by the standard characteristics to target other customers (Bailey *et al.* 2009). The creative entrepreneur will need to use sales data to determine which customers provide significant revenue to the business and then offer them the added value of original products. Unfortunately a small organization cannot afford to offer this level of service to all customers and still have sufficient revenue to cover all costs.

Mass customization – start with the same core

One of the current consumer trends is the desire to have products customized as much as possible. Consumers are willing to pay more for a product that will express their own unique identities. While seemingly similar, mass customization differs from one-to-one segmentation in that the core product remains the same, with only one or a few elements of the product individualized. Therefore mass customization is a less expensive option than a fully individualized product. For example a creative entrepreneur might promote that the product may be customized with a symbol or words that the customer chooses.

Customization of a product takes effort on the part of the consumer as they must read about the choices that are available. They then need to design the different alternatives of interest. Finally they must input the information into a website or in person to the creative entrepreneur. While customizing takes more customer time than buying an existing product, customers are willing to pay more for the customized product (Moreau *et al.* 2011). This is particularly true when the item is to be given as a gift.

Business segmentation – sell more, but at a lower price

Some creative entrepreneurs may sell products to other larger companies for use as gifts for employees or customers. In addition creative entrepreneurs who produce performances may sell directly to schools or other institutions.

Besides segmenting by type of organization, these business markets can also be segmented by benefits sought. For corporations seeking items for gifts, the benefit sought will be whether the product expresses the image of the company. However, equally important will be the price of the product. Since the company will be purchasing a large quantity of the product, they will expect a lower price.

For institutions such as schools, hospitals and prisons that might be purchasing a performance, quality and price will be considerations. However, here the most important criterion will be if the performance accomplishes the task. These performances will not just be purchased for their entertainment value, but rather to meet an educational or emotional need. While most business purchase decisions are rational, under certain situations the decision has an emotional component. This is true when the mission of the organization aligns with the mission of the purchasing organization (Bellizzi 2009). The business purchaser will use this alignment to build a stronger relationship with their customers. This can be easily seen in businesses that promote that they only purchase supplies from companies that meet certain ethical standards.

Question to consider: What business markets could I target?

Consumer purchase process

In order to successfully promote to a target market segment, creative entrepreneurs need to understand the consumer buying process. There are five steps in the process that involve not only deciding upon the need for a product, but also deciding on which competing product to purchase, how to purchase the product and where to purchase. Understanding the steps of need recognition, information search, evaluation of alternatives, purchase decision and post-purchase evaluation will assist creative entrepreneurs in communicating a persuasive marketing message at the correct point in the process.

Need recognition – I feel a need coming on

In marketing, the term wants and needs is often used to describe consumer motivation. Needs are products that consumers must have. Besides food, clothing, shelter and perhaps transportation there are few absolute needs. In fact most people eat more food, have many more clothes, live in larger houses and drive more cars than they need. Instead they may want new products for a variety of reasons. For example consumers may want new shoes because the brand provides status, they are a new fashion trend, provide comfort after a sprained ankle or because they are depressed and purchasing a new pair of shoes lifts their spirits.

Consumers can easily identify their need; if they are hungry they need food. However, most creative products do not meet consumer needs but instead meet their wants. For this reason marketing plays a key role in making potential consumers aware that there is a product that can fill their wants, such as for beauty, fun or status. In addition their wants may be to support a social cause or to provide economic development opportunities to people or groups in need.

Information search – is there anything out there?

After consumers have recognized that they have a need or want, they will then search for information on products. Consumers trust information from personal sources more than direct marketing messages. This is one of the reasons for the popularity of social media and product review sites. People can express their views of products and these product reviews are then used by others to gather information. Not only are people's purchase decisions affected by the information they read online in product reviews, it has been found that these reviews are so influential that they will even cause product users to doubt their own experience if it differs from the majority online opnion (Sridhar and Srinivasan 2012). The amount of time and effort that a consumer will invest into the information search will depend on the type of product under consideration for purchase. People are most likely to rely on reviews when researching the purchase of intangible services.

The more expensive the product, the more time consumers will spend conducting research. In addition, the more complex the product, the more time will be spent on research. Both product cost and complexity add to the risk if the wrong decision is made. An inexpensive product that is well known to the consumer will require little research. For example most people do not conduct research on toothpaste as they will usually buy the same brand they always purchase. If consumers do buy new toothpaste they do not like, the risk is minimal as the tube can be simply thrown away.

However, expensive or complex products will be researched more carefully. Potential customers will not only gather information from social networking and product review sites, they will also carefully read promotional material and view the business's website. If possible they will also spend time in the store examining the product and asking for information on how the product is produced. The time is spent because a wrong choice can be an expensive mistake that the consumer cannot afford to make.

Evaluation of alternatives – how will I choose?

At this point in the purchase process, consumers will have narrowed their choices to a few products. These will then be evaluated by how well they match with the consumer's purchase criteria. During the information search stage, the consumer will have decided on specific criteria as to price, size, style or other features that the product must meet. The products that meet the criteria and come to mind when the consumer considers purchasing the product are referred to as the evoked set. However, because each product under consideration is actually a bundle of benefits, the decision will be made on more than simply the benefits offered by the core product. Creative entrepreneurs should carefully design their products so that they will not only be part of the evoked set, but also the final product choice of their target market segment.

Purchase decision – I'm going to buy it!

At this point in the process, consumers will make their decision on which product to purchase. Despite this intention, several factors can result in the process coming to a stop. The first factor is simply the inability to purchase conveniently. The consumer must be able to find an employee to handle the purchase and also accept the form of payment the consumer wishes to use. For example, if there is no helpful employee or the business does not accept credit cards, the purchase process might stop. If a product is expensive, the consumer may not purchase unless some form of financing is available. In addition, if the purchase is of a size and type that makes it difficult to carry, delivery options must be provided. Online purchasing, while convenient for the consumer, can also be stopped by a poorly designed or malfunctioning website. If the purchase is not completed, the consumer is unlikely to initiate the purchase experience again and the regret felt at not purchasing the product will be fleeting (Abendroth and Diehl 2006). Fortunately for creative entrepreneurs, the limited availability of a product leads to consumers being more likely to complete a purchase.

Post-purchase evaluation – am I sorry?

The purchase process is not done once the product is paid for. Instead consumers will now evaluate the product to determine if the benefits that the product produces meet their expectations. Rather than assume that this is true, creative entrepreneurs must create some way to gather feedback on consumer post-purchase evaluation. This could be using social media, contacting purchasers through email or monitoring online review sites. All of these methods can be used to determine if consumers are pleased with the purchase. If not, problems can then be corrected.

Impulse purchase – I see it, I buy it

Impulse buying is a purchase that is made without all the steps outlined above. The consumer may simply see the product and immediately decide to purchase. To encourage impulse buying creative entrepreneurs need to display their products in visible locations, such as the window of their storefront, as the visual display of merchandise can strongly influence whether people enter a store. However, it is displays that include information regarding product availability that lead to a purchase (Oh and Petrie 2012). If the product is sold in stores not belonging to them, creative entrepreneurs will want to ensure that their product has good visibility. In addition, booth placement at craft fairs should be considered as traffic flow can either hinder or help impulse purchasing. The type of placement of products on websites can also encourage impulse buying.

Question to consider: How would I describe the purchase process of my customers?

Summary

While creative entrepreneurs may have an instinctive understanding of their product, this is rarely true of understanding potential customers. Instead they will need to analyze whether they should develop market depth or market breadth. Market depth would focus on targeting more of the current consumers while a market breadth approach would mean targeting a new market segment. In addition a targeting strategy, usually concentrated for small business and multi-segment for larger, must be decided upon. Some creative entrepreneurs will start their business with a niche strategy by focusing on a single dispersed group of customers that can be reached using technology. These strategies will help ensure success by having the marketing message carefully targeted at those most likely to purchase. The creative entrepreneur will need to define their potential customers using demographic, geographic and psychographic characteristics. By doing so they can then develop a marketing message that will speak directly to this group by describing the benefits they desire. An understanding of the product purchase process will further develop the creative entrepreneur's understanding of how customers make the decision to purchase from many different alternatives.

References

Abendroth, Lisa J. and Kristin Diehl. "Now or Never: Effects of Limited Purchase Opportunities on Patterns of Regret over Time." *Journal of Consumer Research* 33, no. 3 (December 2006): 342–351.

Aljena, Agnese. "13 Reasons Why People Buy Art." *Take It Easy Business*. Business Blog for Artists, March 18, 2013. http://takeiteasybusiness.com/13-reasons-why-people-buy-art. Accessed August 10, 2014.

Bailey, Christine, Paul R. Baines, Hugh Wilson and Moira Clark. "Segmentation and Customer Insight in Contemporary Services Marketing Practice: Why Grouping Customers Is No Longer Enough." *Journal of Marketing Management* 25, no. 3/4 (April 2009): 227–252.

Bellizzi, Joseph. "Using Non-Utilitarian Factors to Encourage Business-to-Business Purchases." *Journal of Global Business Issues* 3, no. 1 (2009): 121–126.

Demby, Emanuel H. "Psychographics Revisited: The Birth of a Technique." *Marketing Research* 6, no. 2 (1994): 26–29.

Jenkins, Meri. "Getting to Market: Part 1." *Tools and Resources*. National Arts Marketing Project, September 5, 2013.

Lesonsky, Rieva. *Start Your Own Business: The Only Startup Book You'll Ever Need*, Irvine, CA: Entrepreneur, 2007.

McKeever, Mike P. *How to Write a Business Plan*, Berkeley, CA: Nolo, 2008.

Millman, Debbie. *Brand Bible: The Complete Guide to Building, Designing, and Sustaining Brands*, Beverly, MA: Rockport Publishers, 2012.

Moreau, C. Page, Leff Bonney and Kelly B. Herd. "It's the Thought (and the Effort) That Counts: How Customizing for Others Differs from Customizing for Oneself." *Journal of Marketing* 75, no. 5 (September 2011): 120–133.

Oh, Hyunjoo and Jenny Petrie. "How Do Storefront Window Displays Influence Entering Decisions of Clothing Stores?" *Journal of Retailing & Consumer Services* 19, no. 1 (January 2012): 27–35.

Schaller, Rhonda. *Create Your Art Career: Practical Tools, Visualizations, and Self-assessment Exercises for Empowerment and Success*, New York: Allworth Press, 2013.

Smith, W. R. "Product Differentiation and Market Segmentation as Alternative Marketing Strategies." *Journal of Marketing* 21 (July 1956): 3–8.

Sridhar, Shrihari and Raji Srinivasan. "Social Influence Effects in Online Product Ratings." *Journal of Marketing* 76, no. 5 (September 2012): 70–88.

Strategic Business Insights. "VALS™ | About VALS™ | SBI." www.strategicbusinessin sights.com/vals/about.shtml. Accessed August 4, 2014.

Verdino, Greg. *Micromarketing: Get Big Results by Thinking and Acting Small*, New York: McGraw Hill, 2010.

Tasks to complete

Answers to these questions will assist in completing the Customers section of the business plan.

1 Customer segments

 a List five demographic, geographic and psychographic characteristics of your potential customers.

 b Use the above characteristics to describe at least three possible segments to target.

 c List the product benefits that would motivate the largest of the three segments.

 d Describe a business segment you could target.

2 Purchase process

 a Describe how customers will find information about your product.

 b Give five criteria that you believe customers will use when purchasing.

Visualization exercises

1 Draw pictures of three different potential customers showing their demographic characteristics.

2 Draw activities that show their lifestyle.

3 Add the geographic area where they live.

4 Draw dollar signs over their heads to show how much money they will spend on your product.

5 Draw a comic strip that shows a customer going through the process of buying your product.

6 Mastering the numbers

Introduction

For creative entrepreneurs, selling their product isn't all about making money. Instead they are driven by their desire to be creative and to share their creativity with others. However, without knowledge of finance, the creative entrepreneur will quickly find that the business will not be able to stay solvent. The failure of the business could be caused by a misunderstanding of revenue vs. profit, pricing errors, inability to get a loan or simply because there is more money going out than coming in. To avoid future problems there are a number of financial concepts that must be learned before the business begins. First the creative entrepreneur must understand the relationship between revenue and profit. In addition the creative entrepreneur must learn the various pricing models so as to correctly determine the product's price. Understanding how to budget for income and expenses will help the creative entrepreneur keep track of finances. Finally, sources of startup capital must be identified.

What creatives have to say: Chelsea Moore

Chelsea is an artist who sells her handmade "goodies" as she calls them, on Etsy. She creates crochet accessories, jewelry and art prints. In addition she does freelance photography and video for weddings and other events. Being a true creative entrepreneur, she also gives lessons in photography. She is hoping to open a studio shop as she believes people want to feel it/try it on/ see it before they buy. Chelsea has advice to share with other creatives:

1 Pricing: At first her prices were too low, which not only hurt her, but also other artists as it conditioned customers into believing handmade equals cheap.
2 Branding: She waited too long before she started using the name MountainThings which now communicates her image of nature-inspired art created with eco-friendly materials.

> 3 Targeting: You may start in business by selling to friends, but that does not mean they are your target market. She learned that she needed customers who could afford her products.
>
> You can learn more about Chelsea's work at www.etsy.com/shop/mountainthings and www.mountain-things.com.

Relationship between price, revenue and profit

Many businesspeople, not just creative entrepreneurs, misunderstand the relationship between price and revenue – if they think of it at all. Everyone knows that price is what is charged for the product. If price is multiplied by the number of items sold, total revenue is calculated. Often revenue figures are quoted both by individuals about their own business or in the business news about a well-known company. A high revenue figure may be used positively to show the success of a company or a high revenue figure might be quoted negatively to demonstrate the greed of a company. The belief is that, if a business has a high level of revenue, then it must be doing well. In fact, the revenue total is evidence only that the product is being sold; it is not evidence of the financial health of the organization. Rather than revenue, it is the level of profit that demonstrates if the business is doing well.

Profit is calculated by taking the revenue, money received from customers, and subtracting the expenses incurred by the business. The resulting number, if positive, is the business's profit. If the number is negative, this is the business's loss. It is possible to have a loss even when a significant amount of product is being sold and, as a result, revenue is being received. Everyone probably knows someone who makes a good income but is still broke at the end of the month because he or she has spent too much money; the same is true of businesses. It is only the money that is left after paying the expenses that is a profit.

When a business does not make a profit, the answer may seem simple. After all, if the creative entrepreneur simply raises the price of the product, the total revenue will be increased. Unfortunately this simple solution is not necessarily effective as the rise in price may be offset by fewer products being sold as some people refuse to purchase at the higher price. It may then seem that a reduction in price is the best way to increase profit as it would raise revenue because more people would purchase. However, the creative entrepreneur needs to be careful using this strategy because, while more products may be sold, any increase in product sold will be offset by less revenue being received as all the products are now being sold at the lower price.

Rather than change prices, the other approach to increase profit would be to cut expenses. This strategy is certainly something a creative entrepreneur should consider. However, cutting expenses may adversely affect the business. For example, if the business is a retail store, moving to a new lower-cost site may lose customers who are not willing to visit the new location. If less expensive raw materials are substituted to produce the product, it might result in a lower quality product, for which people are not willing to pay the same price. Pricing to generate the

maximum revenue while keeping expenses to a minimum so as to generate a profit is more difficult than it might first appear.

Basic finance concepts

- Price: what the customer must pay for each product.
- Revenue: total stream of revenue received by the business from products.
- Profit: revenue left after all production and business expenses have been paid.

Non-price competition – don't say what it costs

One way to avoid relying on low price to motivate purchase is to position the product based on its quality and value rather than price. There is a common mis-understanding on how business uses the word, value. In business it does not necessarily mean inexpensive; it means that the product is worth the price paid when customers compare the price with the benefits received. Determining how much people will pay for the product benefits can be difficult, but pricing a pro-duct too low means that revenue that would have been paid stays in the customer's pocket (Bala and Green 2007). A low-priced product can be good value, but so can a high-priced product if it delivers more benefits than other products.

Non-price competition is a common practice for businesses that provide speci-alty products that have few substitutes. Because the consumer cannot find other similar products with which to compare the price, they usually accept the stated price as correct. Creative products can be promoted in this way because they are almost always unique. In fact, lowering the price of creative products may not inspire purchase but have the opposite effect, as it sends the psychological message that the product is of lower quality.

Pricing of art – can I resell it?

Not all prices for art are connected to the immediate value received from a product. Sometimes the purchaser calculates price based on what the product will be worth in the future. During the 1980s there was a boom in the price of visual art brought about by two connected factors (Horowitz 2011). First there was the emergence of the super-rich who had the money to invest in risky assets such as art and were willing to pay the exorbitant prices for art as an investment. In fact, in a world undergoing rapid economic change, art was seen as a product that would keep its value. Because art prices were rising steeply, it was felt that a person could make a profit on reselling the work. In fact the variability of prices is greatest for high-priced works of art produced by artists with brand names (Scorcu and Zanola 2011). As a result, there is still more investment risk in purchasing artworks than other types of financial instruments. However, you can't hang a stock certificate on the wall.

There was a second reason for the rise in prices, which is the status value of art. Super-rich individuals in countries around the world have so much money that they have run out of things to buy. If everyone in their circle is ultra-wealthy,

having money is not enough for status. Instead the purchase of a rare commodity, such as art, shows that they are beyond being concerned with the price of products. Therefore the increased wealth of individuals plus art's value as a status symbol both drove the price of art higher.

Question to consider: Can I give an example from my personal life that proves I understand the difference between revenue and profit?

Determining a product's price

Even if the business is not expected to provide enough profit to cover all the living expenses of the owner, it is important to generate as much revenue from sales as possible. If more profit is received from selling the creative product, there will be less need to obtain income from a day job. This frees the creative entrepreneur to focus more on the production of the product. However, pricing a product is much more difficult than creating a product. On the one hand, creative entrepreneurs are excited to share their product and, therefore, may price the product too low just so it will be purchased. On the other hand, creative entrepreneurs feel so strongly about the value of the work that they may price it too high and it may not be sold at all. In addition, artists tend to take either a craft approach or a fine art approach to pricing. They either price based on the expense of production for crafts or priced based on prestige for fine art (O'Neil 2008). To find the right price, the entrepreneur must understand the basics of the three approaches to pricing, which are cost, competition and prestige.

Pricing approaches

- Cost: priced to cover costs, with remaining revenue as profit.
- Competition: priced based on the cost of competing products.
- Prestige: priced high to indicate quality.

Cost pricing – cover costs and add a little profit

When deciding on the price of a product, one of the first issues that must be considered is the actual cost of producing the product. To be profitable, the price charged for a product must at least cover the variable costs of production. In addition, the creative entrepreneur must also price the product to cover all the fixed costs associated with the expenses of running the business. Any profit that remains can be used by the creative entrepreneur for personal expenses, reinvested in the business, or set aside to cover any future business losses. The first step in determining the cost of a product is to calculate the fixed costs of running the business and the variable costs of producing the product.

Fixed costs: The fixed costs of any business are the costs that would be incurred even if no product is produced. For example, a business must still pay rent for its

premises even if it does not have any sales. Fixed costs will also include the cost of any payments for equipment, whether purchased or rented, that is necessary to produce its product. For example any office equipment, such as computers, along with specific production equipment, such as special lighting for a showroom, is a fixed cost. Having to cover high fixed costs is the reason why small businesses should think carefully before renting expensive premises or investing in high-cost machinery.

Another fixed cost that must be covered is salaries for employees. The employees of a business must be paid even when no product is sold. The only other choice is to lay off employees, which is difficult for both the creative entrepreneur and those who must be laid off. Therefore the smaller the staff, the less dependent the business will be on generating a high level of revenue to cover salaries.

Variable costs: Once the business has determined its fixed costs, the next step is to calculate the variable costs. Variable costs are directly related to the production of the product. The more creative product produced, the higher the total variable costs will be. For a business that produces tangible goods, variable costs would be the cost of raw materials, because, with each product being produced, more material is required. Variable costs for services are more difficult to determine. In the case of a band that provides music for events, it would include transportation costs to the specific event. It would also include the rental of any specialized equipment and perhaps the salary of additional musicians. These costs are variable as the more events that take place, the more costs are incurred. For a gallery, the variable costs would include the cost of mounting a specific show. Variable costs will differ for every business and for each type of product within each business.

Break-even point: If a business can work out the amount of all fixed and variable costs they can use the break-even formula. This formula calculates the break-even point (BE), which is the amount of products that would need to be sold at a certain price to cover all costs. The calculation is simple:

$$FC/(P-VC) = BE.$$

First the variable cost (VC) of producing each product or event per person is subtracted from the price (P). The fixed costs (FC) are then divided by the remaining revenue from the sale of each product. The resulting number is the number of products that must be sold before the creative entrepreneur will start generating a profit. Even then the profit is only the revenue of each item minus the variable costs for each item. The profit is not the entire purchase price. If the creative entrepreneur decides that they would be unable to sell this amount of products during a specified time period, but still want to break even, they have two choices. They must either raise the price of the product or lower their fixed or variable costs of production.

Competition pricing – what do other products cost?

Unfortunately, because of the difficulty in calculating the actual costs of producing a product, and especially services, some creative entrepreneurs believe that the only other alternative method for deciding a price is to just choose a number based on

how they value the product. However, there are other pricing methods that can be used. One of the simplest is to use the business's competition as a guide.

However, it is not always easy to find the appropriate product for comparison. In the case of a handmade craft object, the competition may be a product that is mass manufactured. Such a product would certainly be available more cheaply because it is machine made. Even when creative entrepreneurs cannot compete on price, they still need to understand what consumers are paying for competing products.

Even when using the competitive pricing approach, the creative entrepreneur must still also consider the business's costs. The lower the price that it charges is from the theoretical price that would allow the business to cover all costs, the break-even point, the more reliant the creative entrepreneur must be on having another source of income.

Prestige pricing – let them pay

Because the creative business can rarely compete directly on cost, or meet the prices of competitors, there is a third method of pricing. For some specialty products, for which there is no easily obtained substitute, the business can price high and still attract customers. Consumers are willing to pay high prices for specialty products because they know that they will be given the opportunity to consume a product that is rarely available. Besides obtaining the product, they are also purchasing the status of having such an object.

Question to consider: What method will I use to price my products and why?

Learn the lessons before you price

There are numerous interesting blog posts online about the pricing mistakes made by other creative entrepreneurs. It is a good idea to learn from others and save the expense of your own pricing mistake. Here are five excellent lessons:

1　Resentment: You have put hours of work into the product. If after you are paid you feel resentment toward the purchaser, you are charging too little. The price for the product should be fair exchange, where both parties feel they got a fair deal.
2　Don't get defensive: You know what you are worth. If the customer complains about the price, stay friendly but stand firm.
3　Some customers aren't worth it: You might be better off without a customer who always complains about the price.
4　Shut up: Give a price, not a price range. Of course, the customer is not going to ask for the most expensive product.
5　You're worth it: If someone is willing to pay a high price, it is the correct price. You cannot overcharge for your own work.

Dinwiddie 2012

Budgeting for control

Budgeting is part of the day-to-day management of a business. Budgets are used to project both future revenue and expenses and to track current revenue and expenses to see if the actual numbers vary from what was projected. Using a budget is not an optional activity but rather the only means of controlling the business's finances.

Managing cash – don't let it slip through your fingers

Businesses are often surprised by the amount of cash that must be spent before a business is even started. Even after a business is in operation there will be a need for working capital. Working capital is the cash that is used to run the business on a day-to-day basis until it can make a profit and become self-sustaining. Many businesses that could have been successful end up closing before they have the chance to become profitable simply because they run out of cash. There are three rules to managing a business to help ensure this does not happen: limiting inventory of materials and finished goods, collecting money as quickly as possible and paying only when required to do so.

The first rule is to limit the amount of inventory in raw materials that is purchased by the business. It may be tempting to purchase the material needed to produce the product in bulk because doing so will result in a lower price. However, doing so will also take cash that may be needed later for a more critical expense such as a lease payment. In addition, having too much inventory of finished goods is a problem, as the purpose of a finished product is to be sold to obtain cash. Although inventory does have value, it cannot be used to pay the bills. If too much inventory builds up, it might be a sign that prices must be reduced so that cash is obtained.

The second rule is to collect receivables, money due the business, as quickly as possible. If the business is selling relatively inexpensive items, creative entrepreneurs should run it on a cash basis, with payment due when the product is sold. There is no reason to sell a product on credit as it can take time and effort to collect payment from a reluctant payer. As a result, the creative entrepreneur does not have access to money that the business needs, and the time spent trying to collect would be better spent producing more products. The last issue is to pay bills as late as possible. It may be worthwhile to negotiate with suppliers to pay on a 30-, 60- or 90-day delay, even if there is an additional fee for doing so. Particularly at the beginning of a business, the most critical issue is having enough cash to pay the bills on time.

Income accounts – tracking what is coming in

The above section looked at the business from the perspective of having enough cash to finance day-to-day operations. A way to ensure the long-term financial health of a company is to track its sources of income. Each organization's list of income sources will be unique because the products offered will vary. The creative

entrepreneur needs to estimate and then track not just the total amount of revenue received but also the sources of revenue. If the business offers more than one type of product, the revenue of each should be tracked separately. This information will help determine what activities or products are bringing in the most money. Only in this way will the creative entrepreneur know which product is producing the most revenue. As a result of having this information, the decision might be made to discontinue some products to make time for producing better-selling items.

There need not be a separate account for every type of product based on features such as color or style. Instead the products should be grouped by product lines. For example, a musician may wish to track income from playing at corporate events, parties and clubs as each of these will be priced differently and have different expenses. As a result the musician will know which type of event is producing the most profit. This is just as critical a piece of information as the number of bookings. After examining the budget, the musician may decide to have a smaller number of higher priced corporate events that produce more profit than numerous low-cost private parties that produce little profit.

Diversification is a term used in business for the idea of not putting all of one's eggs in one basket. Having more than one source of revenue doesn't just increase total income, it also helps protect the creative entrepreneur by lessening the risk if one source of revenue is lost. If for some reason one product line, such as prints, does not sell well, there are still others, such as photographs, to bring in revenue. For example, if a musician books fewer corporate events because of a decline in the economy, then there is still the income from playing at clubs.

If income is insufficient to cover costs, creative entrepreneurs may consider diversifying by adding entirely new product lines. These might be adding revenue from teaching adults at an educational institution, or fees paid by students for lessons taught by the artist. The creative entrepreneur might also decide to start providing consulting advice to government organizations or for-profit businesses to further diversify. Another idea would be to rent out the studio space to other groups for events. Finally the creative entrepreneur might share their expertise by demonstrating their skill at events for a fee. While bringing in additional revenue, these ideas also help to publicize the creative entrepreneur's core art product (Smith 2013).

Setting revenue projections – how much do you need to make?

One of the most difficult tasks when starting a new business is determining the amount of revenue needed and from where this revenue will be obtained. Most creative entrepreneurs will start with an estimate of how many products can be sold and then decide that they must live on the resulting profit.

Another approach is to first start with a goal of how much monthly profit is needed (Lesonsky 2007). This income goal would be enough to cover the costs of the business and the living expenses of the business owners. When calculating living expenses, creative entrepreneurs should include every item that must be paid each month, which would include fixed expenses such as rent and car payments and also include any discretionary expenses such as entertainment. Any yearly

expenses should be divided by twelve and then added to the monthly expenses. Once a monthly figure for expenses is calculated, any income from regular employment that will be maintained while the business is being established should be subtracted. The remaining figure will be the profit the business must make each month so that the creative entrepreneur can pay to cover both business and personal expenses. The next step would then be to determine how many products need to be sold to generate this level of profit.

Most businesses will have more than one product line that they sell. To both project future and track actual revenue, each of these product lines should have a separate account that includes both the number of products sold and the resulting revenue. For yearly budgeting purposes, creative entrepreneurs will need to estimate monthly revenue over the next year. This is very difficult for a new business as they do not having any historical sales figures on which to rely. In addition, trying to estimate the amount of product that can be sold in a year can be difficult for most new business owners as there is simply not enough experience to make an accurate estimate. However, one way for this to be accomplished is for creative entrepreneurs to start with an income goal for each product line and then use this to determine the number of products that must be sold.

Over the weeks and months, actual revenue will be tracked and then compared with budgeted revenue. Some creative entrepreneurs might think there is no purpose to this exercise as they will "make what they make." However, much can be learned from comparing budgeted and actual revenue. There might be weeks or months when revenue exceeds budgeted estimates but also months where it falls short. The creative entrepreneur will then know that these are the time periods when more effort needs to be put into marketing.

Expense accounts – tracking what is going out

Of course revenue is not the same as profit, as expenses will first need to be paid. For budgeting purposes, expenses also need to be divided into categories that are tracked separately. If expenses are too high, it is not enough just to say less money must be spent. There needs to a tracking of where the money was spent so that an expense critical for the running of the business is not cut. How to categorize expenses will be unique to each type of business. However, the creative entrepreneur should have a separate account for each type of expense, such as raw materials, salaries, rent or lease payments and marketing.

Only by using this type of budgeting will creative entrepreneurs know what product generates the most profit, not just revenue. For example if creative entrepreneurs travel to other locations to perform for organizations or private groups, they need to know the expenses used to generate the resulting revenue, such as transportation, materials and lodging. After a comparison of income to expenses it may be decided that the performances are actually losing money. In this situation, either the expenses incurred must be lowered or the prices raised, or, if neither of these is possible, the performances should no longer be given.

There are also expenses that are necessary to pay that are not directly related to production of the product. These are called general and administrative expenses and they include lease or rent payments, utility bills and vehicle maintenance expenses. Other issues not directly related to production would be insurance costs, tax payments, licensing and legal expenses. Marketing expenses might be tracked as a single fixed expense for the entire business or they might be tracked by the amount of money spent promoting each individual product line.

Analyzing variances – did I get it right?

It is not enough just to create and keep a budget. The budget must be analyzed on a regular basis. Each month, quarter and year, the actual revenue, expense and profit amounts will be compared to what was budgeted. In some situations the creative entrepreneurs will learn that the budgeted amount was unrealistic. For example the cost of utilities might be much higher than anticipated. If there is not a means of significantly lowering the cost, then the next time a budget is constructed the numbers must be revised to more accurately reflect reality. If revenue figures are higher than anticipated, this is certainly good news for the business. However, if revenue is lower than budgeted, then the reasons why this is so need to be ascertained. It may be that the creative entrepreneur was too optimistic and the figures in future budgets need to be lowered. Or, it may be that more attention must be paid to marketing so that sales will increase and the actual revenue numbers will match the budgeted.

Questions to consider: What will be my projected yearly revenue and yearly expenses and on what information do I base these numbers? When will my business break even?

Choosing your bank

Creative entrepreneurs may spend more time shopping for the latest cell phone than shopping for their bank. In fact it may not have occurred to them to do anything other than just open an account at the most convenient location. However, having a good relationship with a bank may mean the difference between staying open or having to close the business. When shopping for a bank, there are five issues to consider:

1 Loan approval: Ask who has the authority to approve a loan. It is better for your business if the loan can be approved locally.
2 Local knowledge: Community banks will have knowledge of local market conditions that regional banks may not have. In addition the local bank may know you personally.
3 Rates: Larger, regional or national banks are often able to give better interest rates than community banks.

4 Government programs: Regional or national banks may have more familiarity with various government programs that guarantee small business loans.

5 Account extras: Banks compete by providing extra services, which may be online banking, collections of accounts receivable and payment of bills.

When making the decision to establish a relationship with a bank, you should envision business success and ask yourself what services you will need as you grow, rather than just what is needed now. Once the decision on a bank is made, you should meet with your banker even when the business is going well. By establishing a relationship when times are good, you are more likely to be able to secure funding when times are bad.

Wall Street Journal 2014

Sources of funding

Getting the cash to start a business is a challenge for everyone except the independently wealthy. The days when a prospective small business owner could easily get a loan from a bank or a grant from a government agency are gone. Banks blame the lack of business loans on fewer businesses applying for money because of the weak economy, while business owners blame the banks' reluctance to give out loans because of the risk (Tozzi 2012). However, even when loans were more readily available, it was still difficult to obtain funding because of the inherent risk of a new small business. It is now even more difficult for several reasons. First, because of the economic recession starting in 2007, banks have stricter qualification requirements. In addition, creative people who may wish to start their own business may have substantial personal or student loan debt. Artists might also have no credit history or a less than perfect history. Stricter requirements, a high level of debt and low credit scores will make it very difficult to get a traditional business loan. This situation of not being able to obtain funding not only affects the business before it is started, but also on an ongoing basis, as money may be needed in the future to fund new equipment, move to a new location or get through a period of low sales.

The creative entrepreneur might be prepared to fund the start of the business with personal savings. If this is not the case, the traditional source of financing for small businesses includes friends and family. However, there are now new online funding sources such as peer-to-peer loans (Wack 2014). These are independent investors or financial companies offering to make business loans online. Individual investors can invest in loan investment funds, for which they are paid interest. Businesses can then apply for loans from this fund. This type of loan company may have lower interest rates than traditional banks because of their low fixed overhead

costs. However, business loan interest rates will vary widely based on the assessment of the credit risk of the creative entrepreneur.

Commercial loans – just go to a bank

Before a creative entrepreneur can obtain a commercial loan, there are certain restrictions that a lender will impose. First, the lender will require that the funding only be used for the purposes for which the loan was requested. For example, if a creative entrepreneur requests a loan to purchase raw materials in order to fulfill a large product order, the lender will want to see the resulting paperwork to verify the purchase. Second, there may be restrictions on using any of the loan funds as salary for the creative entrepreneur. Such salary security may be welcomed by the business owner, but does not increase the profitability of the company. In addition, the lender may ask for collateral for the loan. The collateral, a tangible asset that can be taken and resold if the loan is not repaid, might be raw materials or completed work inventory. It would be rare that a creative entrepreneur had other business assets free and clear that could be used as collateral. Therefore, the lender may ask the business owner to pledge personal property such as a car or truck.

Likewise, there are conditions for which the creative entrepreneur should ask when negotiating a loan. They should ask for the option to repay or refinance before the due date of the loan, if the creative entrepreneur has surplus cash, as this will lessen interest payments. On the other hand it might be that the business starts even slower than expected. Therefore the loan contract should allow for a grace period of 30 or 60 days for payment. In this case, if the payment is made by the readjusted due date, the bank cannot take any action to recover the loan collateral.

Loan requirements – money is not free

Besides evaluating the product, the banker will evaluate the borrower. After all, if the product is great, people will buy, so the borrowed money can be repaid. However, it is not the small business that will be receiving the money, rather it is the individual who is running the business. Therefore the bank will look just as closely at the borrower as at the business idea. When obtaining a bank loan the individual will be assessed on what are called the five 'Cs' of credit: character, capacity, collateral, capital and conditions. An understanding of these will greatly increase the chances of receiving funding (Barrow *et al.* 2008).

First the lender will assess the character of the individual requesting the loan. Even if the business does make money, this does not guarantee repayment, as the borrower could simply choose to spend the revenue and not repay the loan. Therefore the lender will verify if the borrower has repaid all past loans. In addition they will look for proof that the borrower has a reputation for honesty. For a larger lender, this analysis is a critical part of the decision-making process as the institution may not know the borrower personally. For a small community bank these questions will be easier to answer.

Capacity is the ability to repay. Even if willing to repay, if the business's revenue is too low, repayment will be impossible. This is why the loan request must be supported by projected budgets that demonstrate that there will be enough cash flow to support the payment schedule. Without this information, the borrower's statement that the loan will be repaid is only a hope.

Collateral is almost always required. A banker is not lending his or her own personal funds; rather, the money of other people who have deposited in the bank is being lent. The bank has a fiduciary responsibility to not lose their money on loans that will not be repaid. However, sometimes, even with the best business plan, things go wrong. A major flood takes out the storefront right before opening or the creative entrepreneur receives a serious medical diagnosis. Collateral is the promise that, if the bank cannot get repaid from the business's revenue, they will be able to own something of value to compensate them. The bank does not want the collateral, but it is a way at least to recover part of the financial loss if the loan is not repaid.

If the bank is satisfied with the character of the borrower, has been assured that the business will generate enough cash flow for repayment and there is collateral if the loan cannot be repaid, an additional issue is capital. The more money that is requested, the tougher will be the requirements for character, capacity and collateral.

Finally external conditions will affect the ability of the bank to provide a loan. If the bank's own balance sheet is weak, the bank may not have enough money to fund all loan requests. In addition, for some banks, small loans do not make business sense as the overhead costs associated with providing the loan will not be covered by the future interest payments.

Loan application: Before applying for a loan the creative entrepreneur should speak to someone knowledgeable about the process. This could be an advisor at a government agency, such as the Small Business Administration (SBA) in the United States, a volunteer organization of retired executives or the loan officer at the local bank. It is recommended that a new creative entrepreneur should start the loan application process at a local rather than a national financial institution (Tabaka 2013). The local financial institution is more likely to know the applicant and will put more of the decision emphasis on character. Most large banks are only interested in lending to already successful companies that need funds for expansion.

While a business plan may impress a lender, it is not a substitute for a loan application. Most banks analyze a loan request of under $250,000 based on collateral and credit score, with larger loans receiving much more scrutiny. Most small business loan requests will fall well under the $250,000 category. The topics that a bank will want covered in this type of loan application include the purpose for which the loan is sought and how the loan will be repaid. They will also want information on the expertise of the people involved in the company. After all, the best opportunities will not be successful if the business owners are not competent. Finally the loan application will require a list of assets that the creative entrepreneur owns that are available to act as collateral for the loan.

Government-secured loans – who can argue with the government?

In the United States the Small Business Administration is a government agency that guarantees loans made by banks. Other countries have similar programs to encourage economic development by supporting the growth of small businesses. The reason an agency such as the SBA exists is to encourage small business startup and growth by encouraging bank lending. The SBA's application procedure is similar to that of a bank. Documentation of the business's structure and finances is required, not just a good product idea. Both the government agency and a bank will require creative entrepreneurs to put some of their own money into the business. Loans are never made for 100 percent of the startup costs for two very good reasons. First, if creative entrepreneurs do not have any money saved or do not have any other personal sources of funds, it is thought they may not have any future as a business owner. Second, the business owner must also have "skin in the game." If owners do not have any money at risk, it is thought they may not work as hard to succeed and may simply walk away if the business gets into financial trouble.

A bank may require the guarantee of a government agency for a loan to a business, particularly if the amount is large and it is long term. However, in the case of the SBA, it guarantees that the lending institution will be repaid only 75 percent of the loan amount if the creative entrepreneur is not able to do so. This does not totally eliminate the risk to the bank, but does make them more willing to make a loan without sufficient collateral. Even the best businesses can fail before they have paid back their loan, sometimes through no fault of their own. Using a government agency loan guarantee, the bank will be assured that they will receive back most of the money that was lent.

Loans from friends and family – just ask Mom and Dad

One option for creative entrepreneurs is to ask for financial assistance from family or friends. It is critical to remember that receiving money from friends or family is not a gift, but a loan that must be repaid. However, the type and timing of repayment can be more flexible as the family member or friend making the loan has a personal relationship with the creative entrepreneur. In addition, because they are risking their own money, not someone else's, friends and family can be more generous on interest rates and repayment terms. Of course, by borrowing money from friends or family, creative entrepreneurs risk ruining the relationship if the money is not repaid.

Therefore borrowing money from family and friends should be approached just as seriously as money borrowed from banks. This means that creative entrepreneurs should provide documentation that demonstrates the loan can be repaid. Creative entrepreneurs might be able to get more lenient terms than they could from a bank, but there should still be a written agreement on the amount of the loan and the repayment time period. This agreement should also describe clearly the obligations of the borrower. However, friends and family may be willing to accept other benefits than cash for payment, such as free or discounted products that will make up for a lower interest rate or a no-interest-rate loan.

Barter – just like a swap meet

If a creative entrepreneur has no funds to pay for needed goods or service, bartering, where something else of value is exchanged instead of cash, might be used. The creative entrepreneur can use barter as a standing arrangement. For example, a building owner might agree to a smaller lease payment in exchange for some maintenance work on the building. It is also possible to barter product for a service on a one-time basis. The creative entrepreneur may be able to barter for services, such as tax preparation, in exchange for a product. The advantage is that the product does not cost the creative entrepreneur the full retail cost but only the variable cost of the materials. Meanwhile the tax preparer has a product that normally could not be afforded. Use of barter is growing, even in international business deals (Kouremetis 2012). Types of barter include direct, where products/services are exchange simultaneously, or indirect, where a product is received from one party with the other to be received later. There is now even an online group, International Reciprocal Trade Association, for companies that do barter exchanges.

Question to consider: From where will I be able to get startup funding and how much will I need?

Summary

It isn't necessary for creative entrepreneurs to be skilled financial analysts. A basic understanding of the relationship between revenue, expenses and profit will help them to avoid costly business mistakes. New business owners may feel that they are financially successful because they are selling products and receiving revenue. However, any revenue received must first be used to pay for expenses. Only after these have been paid will there be a profit. Therefore the pricing of the product is critical. The price may be based on cost of producing the product or be chosen to be comparable to the price of competing products. In addition, the creative entrepreneur may use prestige pricing when the product is so valued by a segment of consumers that price is not an issue. Learning budgeting skills will help to ensure that the creative entrepreneur will always have the cash to pay bills. While traditional bank loans may not be available to the creative entrepreneur, loans from friends and family may be available. However, such loans should still have written agreements that clearly spell out each party's obligations.

References

Bala, Venkatesh and Jason Green. "Charge What Your Products Are Worth." *Harvard Business Review* 85, no. 9 (September 2007): 22.

Barrow, Colin, Paul Barrow and Robert Brown. *The Business Plan Workbook: The Definitive Guide to Researching, Writing up and Presenting a Winning Plan*, London: Kogan Page, 2008.

Dinwiddie, Melissa. "5 Art Pricing Lessons I Learned the Hard Way." *The Abundant Artist*, November 13, 2012. http://theabundantartist.com/5-art-pricing-lessons. Accessed August 12, 2014.

Horowitz, Noah. *Art of the Deal: Contemporary Art in a Global Financial Market*, Princeton, NJ: Princeton University Press, 2011.

Kouremetis, Dena. "Bartering for Survival – 'Have I Got A Deal for You'." *Forbes*, October 22, 2012. www.forbes.com/sites/denakouremetis/2012/10/22/bartering-for-survival-have-i-got-a-deal-for-you. Accessed August 4, 2014.

Lesonsky, Rieva. *Start Your Own Business: The Only Startup Book You'll Ever Need*, Irvine, CA: Entrepreneur Press, 2007.

O'Neil, Kathleen M. "Bringing Art to Market: The Diversity of Pricing Styles in a Local Art Market." *Poetics* 36, no. 1 (February 2008): 94–113.

Scorcu, Antonello E. and Roberto Zanola. "The 'Right' Price for Art Collectibles: A Quantile Hedonic Regression Investigation of Picasso Paintings." *Journal of Alternative Investments* 14, no. 2 (2011): 89–99.

Smith, Constance. *Art Marketing 101: An Artist's Guide to Creating a Successful Business*, London: ArtNetwork, 2013.

Tabaka, Marla. "4 Tips for Getting a Business Loan." *Inc.com*, January 21, 2013. www.inc.com/marla-tabaka/4-ways-to-get-a-business-loan.html. Accessed August 5, 2014.

Tozzi, John. "Weak Banks Drag on Small Business Lending." *Bloomberg Business Week*, August 28, 2012. http%3A%2F%2Fwww.businessweek.com%2Farticles%2F2012-08-28%2Fweak-banks-drag-on-small-business-lendinghttp%3A%2F%2Fwww.businessweek.com%2Farticles%2F2012-08-28%2Fweak-banks-drag-on-small-business-lending. Accessed August 4, 2014.

Wack, Kevin. "Small Business Loans Emerge as New Frontier in P2P Lending." *American Banker* 179, no. 75 (May, 2014): 1.

Wall Street Journal. "How to Shop for a Bank." How to Guide Funding. *Wall Street Journal*, n.d. Accessed July 22, 2014. http://guides.wsj.com/small-business/funding/how-to-shop-for-a-bank.

Tasks to complete

Answers to these questions will assist in completing the Finance section of the business plan.

1 Revenue and profit

 a Give examples from your own life where too many expenses caused problems.

2 Pricing the product

 a Which of the pricing approaches makes most sense for your product?

 b Find ten competing products and compare their prices to your own.

3 Budgeting

 a What is your projected yearly revenue and profit?

 b Write a stern note to yourself about your overspending.

 c Find a supplier for any equipment you will need and find the prices.

4 Funding

 a How much money can I contribute to the business?
 b Fill out a loan application that you find online.

Visualization exercises

1 Draw what you will look like when you have achieved business success.
2 Draw your home and car.
3 Draw a pile of dollar bills that represent how much money will be needed for startup expenses.

7 Distributing your product

Introduction

While most entrepreneurs understand the need to develop a plan to produce, price and promote a product, many are unaware of the importance of a distribution plan. Distribution refers to how the product gets from the producer to the consumer. The issues that must be considered for the distribution plan include whether creative entrepreneurs will sell their production through direct or indirect methods. They must also decide if their products are going to be distributed exclusively, selectively or intensively, while the unique distribution issues for performance-based products include finding venues. Production-based companies will need to determine the best location for their business.

Direct distribution can be achieved through creative entrepreneurs having their own storefronts. The creative entrepreneur might also have their own website or they might sell their product using an existing online marketplace that is hosted by another company. Direct distribution can also occur at craft fairs, pop-up stores and entertainment events. In addition, creative entrepreneurs can distribute indirectly through other retailers.

What creatives have to say: Leenda Bonilla

Leenda is another example of a creative entrepreneur who has more than one product that she produces. She creates jewelry called "cultural bling" from upcycled bottlecaps. When creating this jewelry she utilizes her photography, drawings and graphic design. While she has an etsy shop, most of her sales are through word of mouth and commissions. She also sells fine art, but not as much as she would like. In addition, Leenda provides project management services to large arts- and cultural-based events. Leenda, even with an excellent education in cultural management, still feels she could have known more about:

1 accounting;
2 access to do more direct research for online selling; and
3 licensing.

You can see Leenda's work at www.leendabonilla.com.

Methods of distribution

Distribution includes all the processes and steps of getting the product from where it is produced to the purchaser's home. The various ways that a product can be distributed to a consumer are referred to as channels. Creative entrepreneurs might use a direct distribution channel where they sell directly to the consumer either in their own studio or storefront. Direct distribution can also take place through selling the product on a website. Direct distribution has the advantage of providing the creative entrepreneur with personal contact with the customer. Creative entrepreneurs can also sell using an indirect distribution channel. Using this method they sell to a retailer who then sells to the ultimate purchaser. Indirect distribution has the advantage of reaching many more potential customers. Some creative entrepreneurs distribute both directly and indirectly using a multi-channel system.

Direct distribution – directly from me to you

Direct distribution is when the producer personally sells the product to the consumer. This could take place at the creative entrepreneur's studio where the work is produced. It could also be at a separate retail site owned or managed by the creative entrepreneur. While it is true that opening a retail establishment involves increased risk, many small retail establishments are finding opportunities in economically reviving small towns (Palma 2006). Other methods of direct distribution are selling at craft fairs and entertainment events. In addition, direct sales can be through a kiosk at another retail location, such as a mall or urban street site. Pop-up stores, which are open for operation for only a short period, can also be run by the creative entrepreneur as a means of direct distribution. Pop-up stores, which often open in a vacant storefront, have become so popular that there are now businesses that will match creative entrepreneurs with available space (*Promotional Marketing* 2013).

There are disadvantages to direct distribution, as the creative entrepreneur must incur both the cost and effort of maintaining a retail space or website. Even when the same space is used for production of the product and retail selling, therefore saving costs, the creative entrepreneur must understand that dealing with customers will take time away from creative production. A final disadvantage of direct distribution is that creative entrepreneurs will need to do all their own marketing.

However, there are significant advantages to selling directly. First, because the creative entrepreneur sells directly to the consumer, all the revenue is retained by the business. Besides keeping all the revenue, one of the major advantages of selling directly to customers is that it allows creative entrepreneurs to learn more about their customers' product preferences. This type of personal contact is not available when the product is sold through another retail operation. Although the creative entrepreneur may have access to online reviews, it is more difficult to get product improvement ideas from online comments that simply either praise or condemn the product. The personal conversations that occur through direct distribution can generate ideas for improvement of the current product and even new product ideas.

While many people shop online because of the convenience, these same people may also prefer to buy unique products directly from the producer. These consumers believe that interacting with the creative entrepreneur is part of the experience of the product. The purchasers not only want to understand how the product was created, they also want to know the values of the creator. By purchasing the product directly they feel that they have also then embraced these values.

Other consumers prefer to buy directly as they believe the cost will be lower. They understand that, if the same product is sold through a retail store other than one owned by the producer, the price will be higher. Because there isn't a separate retailer that must also make a profit, the consumer anticipates a lower price.

Indirect distribution – from someone else to you

Another method of distribution is indirect, where the product is sold through an intermediary. Retail stores or galleries owned by someone other than the creative entrepreneur would be examples of intermediaries. These retailers will pay the creator for the product and then resell, keeping all the profit. These retailers may have physical stores, online sites or both. When the intermediary pays the producer for the product, they then take ownership. This is an advantage for creative entrepreneurs as they then receive revenue immediately without having to wait for the product to be sold to the customer.

However, there are disadvantages to using intermediaries for indirect distribution. Also being businesses, they will need to make money from the sale of the product. Therefore either the creative entrepreneur has to accept a lower price or, if they do not, the price of the product will be much higher at the retail location. The standard markup for many retail establishments is to double the price of the product. For mass produced goods this is usually not a problem, as such goods are produced cheaply by machines. For individually produced creative goods, this does create a problem. If the price of the product is doubled, it may become too expensive for the targeted market segment to purchase.

Distribution strategy

Before deciding where to distribute their product, creative entrepreneurs should first decide as to what type of distribution strategy – exclusive, selective or intensive – should be pursued. Exclusive distribution would be through a single channel, such as a retail store or only on one website. Selective distribution allows for a few carefully designated distributors for the product, such as the creative entrepreneur's own website, plus art fairs. An intensive distribution strategy gets the products into as many potential purchase locations as possible.

Distribution methods

- Intensive: product distributed widely to maximize sales.
- Selective: several outlets chosen based on customer location preference.
- Exclusive: single distribution location that supports the brand image.

Intensive – you can find it everywhere

The first method of distribution is intensive, where the product is distributed as widely as possible. This type of distribution method is mostly used with inexpensive convenience products, which must be distributed widely as the sale of each item results in very little profit. To maximize total profit, as large a volume as possible of the product needs to be sold. Because these products are sold cheaply and in volume, they usually are mass manufactured. Products produced by creative entrepreneurs are rarely, if ever, intensively distributed.

Selective – available here and there

Selective distribution means that the producer of the product decides to sell through more than one distribution channel. This decision is usually made due to geographic, target market or shopping preference. The creative entrepreneurs may choose to pursue selective distribution because they need to reach more geographic areas. For example gift shops in different locations might be used so as to reach both urban and suburban locations. It might also be that the distribution outlets each reach a different consumer segment. A retail shop might reach older consumers while younger consumers can be reached through pop-up stores. Finally, selective distribution is used when the target market segment likes to shop with multiple methods, such as both in person and online.

While it might seem that having more distribution outlets would always be better, there are difficulties with selective distribution. Having more than one distribution channel will require more time to be spent either providing the product to a physical location or getting the information online. In addition, packaging and shipping issues need to be considered. Finally, while having more than one means of distribution may lead to more sales, the creative entrepreneur needs to be able to supply sufficient product to each outlet. Despite these challenges, selective distribution is probably the norm for all but the smallest or most exclusive businesses.

Exclusive – you can find it only here

When a business decides to use exclusive distribution there is only one means to acquire the product. While it might be thought that this is the natural situation for a creative entrepreneur, there are large companies that also pursue this policy. This is because exclusive distribution is used to develop an image of exclusivity, as few people will have access to the product. Exclusive distribution can also be implemented because the product is complex and, when sold to a consumer, needs to be explained. In both situations, the location where the product can be purchased is carefully chosen to support the brand image.

Some retailers will carry a product only if the producer agrees to an exclusive distribution arrangement. This allows the retailer to charge a higher price as no other competitor can charge less. In addition, an exclusive arrangement allows the

retailer to attract customers by promoting that it is the only location where the product is available. Such exclusive arrangements with a retailer are usually only possible when the creative entrepreneur already has an established brand name.

If the product is only offered for sale at the creative entrepreneur's studio, this would also be an example of exclusive distribution. Creative entrepreneurs may decide to have their own retail stores that are located in a trendy area of a city if this fits the brand image. The creative entrepreneur may also decide to distribute via a single retail store, which is chosen because of the other types of products offered. Finally the product might be distributed exclusively online if it is determined that this is where the market segment being targeted is already shopping. When using exclusive distribution, the creative entrepreneur should analyze if this will result in sufficient sales or if selective distribution should be implemented instead.

Question to consider: Will I distribute my product selectively or exclusively, and why have I made this choice?

Distribution intermediaries

If creative entrepreneurs have their own studio or shop with a sufficient number of customers who live nearby, it will be easy to follow a strategy of direct distribution. However, they may face the issue of not having enough local customers to provide sufficient revenue. If creative entrepreneurs need to increase the number of customers, they can increase their distribution channels by also selling on their own website or directly to customers at craft or art fairs. However, if these methods do not produce sufficient sales, or creative entrepreneurs do not wish to deal directly with customers, they may distribute indirectly through an intermediary. An intermediary, who takes on the task of selling the product, may be a brick and mortar or online retail store, a wholesaler or an agent or broker.

Retail intermediaries – let a store sell it

Creative entrepreneurs may decide that they do not wish to have the responsibility of selling the product to the consumer. They want to focus on the production of the product and let someone else worry about the marketing and sales. If this is the case, the creative entrepreneur will need to find a retail outlet that is willing to carry the product. It does not matter if the retailer sells through a physical location, an online presence, or both: the intermediary process is the same. The retailer will purchase the product, mark up the price and then promote to consumers.

Retailers understand that they are selling products to a specific target market segment. Therefore, they are only looking for products that will be of interest to their already existing customers. While creative entrepreneurs understand the quality and unique features of their product, the retailer's question will only be if it will sell. This does not mean that retailers are uninterested in such issues as the production

process and sources of the raw materials. It does mean that these issues are relevant only if these are benefits sought by their customers. After all, if the product does not sell, the retailer cannot pay the bills and keep the establishment open.

The second issue of concern to retailers will be price. Because a retailer must price the product a percentage higher than the price paid to the creative entrepreneur, the initial price must be low enough to allow for this markup. The percentage of markup will vary by establishment, but must be high enough to cover the costs of running the business including lease payments, utilities, taxes, staffing costs and marketing expenses. Many retailers keystone the price by doubling the amount paid for the product. For this reason, unless the creative entrepreneur already has a reputation that allows the product to be sold at a higher price, it can be challenging, but not impossible, to find a retailer willing to carry the product.

Before entering an agreement with a retailer, the creative entrepreneur should ensure that the match will benefit both parties. Creative entrepreneurs should only sell to retailers whose staff has the expertise to sell the product (Reece 2010). If they do not, the creative entrepreneur will need to educate the staff on the production process and the mission of the organization. In addition, the brand of the retailer should complement the creative entrepreneur's brand. Both an educated staff and alignment of mission will increase sales.

Agents and brokers – they'll find a buyer

Another type of distribution using an intermediary is the use of an agent or broker. Although the terms are often used interchangeably, there is a distinction. An agent works for a client to find a distribution outlet, while the broker works independently to put sellers and buyers together for a fee. An agent would work for the creative entrepreneur to find a distributor for the product and, if the deal is arranged, the creative entrepreneur pays a percent of sales for this service. A broker service would be unusual for creative entrepreneurs, while the use of agents is quite common for performing and visual artists.

Wholesaler – let them worry about finding a retailer

A wholesaler purchases the product from the producer and then resells the product to retailers. Selling the product directly to a wholesaler relieves the producer of the responsibility of finding the correct retail distribution outlets. It also relieves the producer of risk, since, if the product does not sell, it is the wholesaler who is left with unsold product. However, because the wholesaler bears this risk and responsibility, they will pay significantly less for the product. The wholesaler must make a profit when they sell the product to the retailer, who then must also make a profit when they sell to the ultimate consumer of the product. For this reason, wholesaling is rarely an option for creative entrepreneurs who wish to handcraft their products, as the final retail price will be too high.

Question to consider: What intermediaries could I use to distribute my product?

Living the artist lifestyle

Some cities encourage artists to work and live in the same location by having zoning that allows both residential and commercial development. These specially zoned areas often contain unused or underused industrial buildings. In Cleveland, the Community Partnership for Arts and Culture (CPAC) maintains Creative Compass, a listing of spaces available to artists. Some, like the Waterloo Arts Studio, rent out spaces that can be used for creating, showing and selling work, but cannot be used as residences as they have no bedrooms. Along with the loft space for creating and selling work, the artists share a kitchen and restrooms. However, the owners understand that artists need to be surrounded by a creative community. Therefore they stress that there are galleries nearby and monthly art walks. In addition each summer an annual arts fest is held to attract tourists to the area.

Another option is to live and work in the same space. While this choice is more costly, the creative entrepreneur does not need to pay rent for a separate residence. The Tower Press live/work artist spaces each have a loft bedroom along with a full kitchen and bathroom. The rent is below market rate because the owners received a tax break to develop the project. Therefore the owners need to ensure that only practicing artists can take advantage of this arrangement. As a result, artists must submit a portfolio of their work with their rental application. However, if accepted, not only do they have an opportunity to live and work in the same space, they also get to enjoy the on-site café and galleries along with a courtyard and gated parking.

Who said being an artist has to be tough?

My Creative Compass 2014

Production location

The product that is sold by creative entrepreneurs is a product that they produce themselves. This results in a unique issue for creative entrepreneurs of where the production should take place. For most businesses, production occurs at a separate location, perhaps even in a separate country, to where the product is sold. In addition, it is assumed that the owners and employees of the company have their own separate homes.

Creative entrepreneurs who produce tangible products face the decision of whether and how to combine where they produce with where they sell their work. However, for performing artists, product production must occur at the same location where the product is sold. Performing artists are presented with the issue of whether they should have their own venue or perform at venues owned by others.

Visual artists – eat, work, sleep

While it saves money, it is often difficult for someone producing a tangible product to live, work and sell at the same location due to government restrictions. Areas that are planned for residential use may not allow someone to produce and sell a product from a home. The reason for this restriction is to protect neighborhoods from the nuisance of production noise and excess traffic. In addition residential neighborhoods rarely have sufficient parking for customers. If they wish to live, produce and sell at the same location, creative entrepreneurs must find somewhere that will allow both residential and commercial activities.

There is a solution to this problem which is to live in an area that is planned for both residential and commercial use. Some of the buildings in these areas are being developed specifically for use by creative entrepreneurs (Borrup 2006). These buildings are often reused industrial sites or located in downtown areas undergoing economic revitalization. Cities often support the establishment of these developments because the energy and innovation brought to a community by creative entrepreneurs can attract other businesses.

Some creative entrepreneurs will live at home in a residence and then have a separate location, such as a studio, where they can both produce and sell their product. The last option is to have a home, a workspace and a storefront. However, to do so will be more costly as it will require more staffing. While the artist is at the production space, staff will be needed to sell to customers at the store.

It will be easier for creative entrepreneurs who provide services to combine work and personal life, as they do not produce a tangible product. Services, such as giving voice lessons, are more often allowed out of the home as they do not result in production noise that neighbors might find objectionable. In addition they usually serve a single customer at a time, so traffic is not as significant an issue.

Performing artists – the venue is the issue

Creative entrepreneurs who provide a service of theatrical or musical productions face similar issues. However, there is a significant difference, as creative entrepreneurs who provide performances rarely can produce their product at their own venues. Instead, to escape the fixed cost of maintaining a venue, the performances will take place in other locations. These locations might be established performance spaces such as theatres or nontraditional spaces such as retail sites, restaurants or public parks. Even if they do not have their own venue, these creative entrepreneurs will still need a performance practice space. This space could be in a home if the number of people is small and noise is not an issue. If this is not possible, rehearsal space can often be rented on an as-needed basis rather than leasing and maintaining a space full time. In addition, residential buildings designed for working performers are available in some cities.

Questions to consider: What would be my dream location? How would I like to combine my creative with my personal life?

Choosing a retail location

Creative entrepreneurs may decide to have their own retail space. Producing and selling the product from the same location by combining a studio with a shop can save money and time as there is only one lease or rent payment that must be made. In addition there is the efficiency issue. If a studio is combined with a storefront, when there are no customers, creative entrepreneurs can use this time to produce their product. However, there are also drawbacks. First, if quiet is needed to produce the product, having the same space used as a storefront can be disruptive.

If it is decided to have a location for production and sales the question of where to locate needs to be addressed. Of course, the cost of the premises is of critical importance. In addition, target market segment factors, such as the willingness of customers to travel to the location, the ambience of the setting and the availability of transportation and parking, must be considered. Other considerations, including the neighborhood and nearby competitors, should also be analyzed.

Factors to consider when choosing a retail location

- Costs: lease/rent, insurance, utilities, maintenance.
- Target market: nearness, transportation, parking.
- Neighborhood: convenience, ambience.
- Competitors: similar stores, similar products.

Costs – can I afford it?

When considering the cost of renting or leasing property, creative entrepreneurs must understand that the cost will be more than the monthly payment. One cost that needs to be considered because it can seriously impact a budget is utility payments. A space in an older building may cost less, but it also may have high ceilings, drafty windows and little insulation. As a result the monthly heating bill might make the rent of a newer unit actually less expensive. Locations in neighborhoods with a high crime rate may not be objectionable personally, but insurance rates will be higher, again impacting the budget. Taxes on the property will probably be paid for by the owner of the building. However, the higher the building's property taxes, the more rent that the owner must charge. In addition many municipalities may tax business revenue. This cost can be substantial and must be considered into the total cost of the unit as it will directly affect the creative entrepreneur's budget. If there are any landscaped or parking areas, it should be clear who is to pay for the mowing, raking and plowing before the lease is signed, as these expenses can be significant.

Target market considerations – will they come?

Before a location decision is made, creative entrepreneurs need to have already determined both their target market segment and a distribution plan. If it is decided that most sales will happen from the storefront, then it must be located within traveling distance of where the target market is located. If the work of the creative entrepreneur is well known, customers may be willing to travel a considerable distance to purchase the product. However, if the creative entrepreneur is just starting out, the business needs to be at a location near where the target market currently shops. Once this community is decided upon, the choice of an individual site will depend on the ease of public transportation to the area. If it is anticipated that most potential customers will drive, then parking must be available. While creative entrepreneurs need to be happy with the location where they produce and sell, the issue of convenience for potential customers must also be considered.

Neighborhood – will they like the neighbors?

The neighborhood where the business is located can either attract or repel customers. There is an old saying that the three most important criteria for business success are location, location and location. If the creative entrepreneur is depending on customers traveling to the retail location, then the neighborhood must not only be convenient, but it must also have the desired ambience. While the most loyal customers might come to the store no matter where it is located, for the rest the location is part of the brand and the product experience. Only the creative entrepreneur knows if potential customers will be attracted to an eclectic area in a city center, a trendy spot near upscale nightlife or a place in a suburban strip mall.

In addition, creative entrepreneurs should consider if the location will be supportive of both their business and mission (Barrow *et al.* 2008). College or university towns often have districts that cater to students that might be a natural fit for the entrepreneur. Not only would the students be potential customers, the creative entrepreneur might find the intellectual life stimulating. Newly emerging arts districts can also be environments where creative entrepreneurs can support each other by providing advice and encouragement.

Competition – keep them close

If may seem that it would make sense for a business to be located far from businesses that sell similar products in order to minimize competition. In fact the opposite is often true (Speader 2014). Businesses can gain new customers by locating near their competition and benefiting from their marketing efforts. While a current loyal customer will come directly to the creative entrepreneur's store, others may be in the market for a product but not have made the decision on type or brand. These potential customers may be attracted to an area where there are a number of similar stores for them to shop so that they can compare products before their purchase decision is made. Therefore being in an area with stores with similar

types of products can result in customers who find the product while originally shopping elsewhere. Of course the product must have a unique competitive advantage and not simply be a copy of one that is sold at a nearby store.

Question to consider: What type of retail space would be a good fit for my product? What would be the best location?

Distributing through websites

While most people might think of a website as part of the business's promotional efforts, if the creative entrepreneur is using the website to sell the product, it is also part of the distribution strategy. The business might sell solely online or do so as part of a multi-channel distribution system. Even if the business is not relying on online sales for a major portion of their revenue, distributing online may be worth the effort. Some potential customers, who find the product online, might not be able to obtain the product in any other way because they are not geographically located near the business.

A creative entrepreneur might sell using their own website or sell their product through a website marketplace owned and managed by others. The use of online selling has been said to democratize the art world as it can reach consumers who do not go to galleries or shows (Latimer 2011). In addition, artists use online sites to sell different product lines. A well-known artist might sell expensive original artworks in galleries and also inexpensive prints online. Whether it is the creative entrepreneur's own website or an online marketplace owned by others, the pages belonging to the artist should combine information on the business and product, media content of interest to the potential customer and ecommerce ability.

Design – make it look good

Creative entrepreneurs can design their own websites or use a company that offers an online template that can be customized. There are also companies that specialize in designing websites for artists and musicians. A separate issue is whether the creative entrepreneur's ecommerce site will be independent or part of an online sales marketplace. Online marketplaces that host a variety of artists, musicians or crafters provide a matchmaking service. Rather than hoping that the online shopper finds the creative entrepreneur's ecommerce site on their own, linking their website with other artists can increase sales. Of course, this linkage and matchmaking service is not free. However, while the creative entrepreneur must pay a percentage of revenue as a fee, these companies also provide additional services, such as marketing advice, social media content, blogging assistance or even more. Etsy, a well-known online marketplace, is even helping its best-selling artists, crafters and designers to also distribute through retail outlets (Indvik 2014).

Content – make it interesting

The creative entrepreneur will need to ensure that the finished site reflects the correct brand image. Choices will need to be made as to URL name, color, layout and features that should be included. Whether the site is being designed personally or with the assistance of others, it is a good idea to examine as many of the creative entrepreneur's competitors' websites as possible. This will provide ideas on not only design but also what information to include. Included on the website should be a short biography of the creative entrepreneur, a history of the business and the business's mission statement. While the site should include high resolution photos of the artistic product, it should also include photos or video of the creative entrepreneur and the creative process. Links to the creative entrepreneur's other social media sites should be prominently displayed.

Payment systems – don't forget to get the money

The creative entrepreneur has many options, which continually change as new services are introduced, of systems for handling online payments for online sales. If creative entrepreneurs have their own website they will need to decide upon the payment service provider. One factor for the creative entrepreneur to consider is if they want a flat fee system or a pay per sale. With a flat fee system, a monthly charge must be paid for the payment services. This can be a reasonable cost if sufficient sales are made. Other payment services charge per sale, which will be a percentage of the cost of the purchase. If the creative entrepreneur is using an established online marketplace, it will provide the payment system.

Choosing an online marketplace – where will you feel at home?

Rather than relying on potential customers to find their website, creative entrepreneurs have the choice of using an established online marketplace. These are companies that host websites that can be used by creative entrepreneurs for displaying and selling their products. They range from marketplaces that sell inexpensive handcrafted items to ones that sell major works of art to collectors. A quick online search will provide an up-to-date list of choices. These sites vary as to the types of products that are sold and the types of customers targeted. Some are for any type of creative product, while others specialize in an art form. The sites will also vary by the services they provide to the creative entrepreneur, with some providing only a basic software page that is then customized by the creative entrepreneur. Other sites offer additional design services and a community of fellow artists that can be asked for advice. The creative entrepreneur may be charged a flat fee, a listing fee per item, a percentage fee on each sale or any combination of these charges. Creative entrepreneurs must not simply use the first online marketplace they find but follow the same selection process they would follow when considering a retail site. These online marketplaces vary as to price, quality of products, customers targeted and brand image, just as do brick and mortar stores.

Such sites are not meant to replace other means of promoting the creative product and should be combined with personal selling (Grant-Peterkin 2014). Creative entrepreneurs who use online marketplaces to sell their work should also still maintain their own web and social media sites as it is on these sites that creative entrepreneurs build their reputation.

Questions to consider: Do I have the skills to design a website? Do I want to sell online? Is there an appropriate online marketplace to sell my product?

Distributing through craft and art fairs

Another means of direct distribution is for creative entrepreneur to sell at craft and art fairs. The advantage of such fairs is that they do much of the marketing to attract people. If it is a well-organized and marketed fair, creative entrepreneurs will be able to sell to customers who were previously unfamiliar with their products. When choosing which fairs to attend, creative entrepreneurs need to consider the cost of the fair, which may be a flat fee, a percent of sales or both. In addition, the cost of transportation to the fair along with the value of the time spent manning the booth must be considered. These expenses must be weighed against the potential sales that will occur. Another consideration is whether the fair appeals to the target market segment that will be most attracted to the creative entrepreneur's product. After each fair the expenses must be compared to the revenue to determine if the fair was financially successful.

Trade shows

Trade shows differ from other fairs in that trade shows are aimed at intermediaries and not the ultimate consumer. Only people "in the trade" can attend these fairs. Product producers pay a fee to have a booth at the show where they can display their product to potential retail intermediaries. People who attend trade shows must register that they have a business and will not be purchasing the product for personal use. Trade shows are organized by product type, with a show for almost every kind of product. Probably the most relevant for creative entrepreneurs are gift trade shows. The advantage of trade shows is that they provide exposure to many potential retailers who may be interested in purchasing the product. The disadvantage is that, if a retailer is interested, they may want to place an order for a larger number of products than what the creative entrepreneur may be interested in producing, or even able to produce.

Question to consider: What craft or art fairs or trade shows should I use for distribution?

Indirect distribution through retailers

Creative entrepreneurs may decide that they do not want to sell their product directly to consumers. This may be because they are not geographically located where their customers live or they may lack the interest, financial ability or skills to operate their own retail store, maintain an ecommerce site or attend fairs or shows.

Therefore the correct distribution choice for some creative entrepreneurs may be to distribute indirectly through retail stores.

Selling through a retail distributor presents a pricing challenge to the creative entrepreneur. If the retailer purchases the product, they will expect to purchase it at a lower price than the individual customer. The product's price will then be marked up significantly so that the store owner makes a profit. Therefore creative entrepreneurs will need to price their products lower. However, the financial advantage is that the retailer will purchase multiple products, while consumers typically only purchase for themselves. In addition, the retailer will promote the product and provide visibility to many more potential customers.

Types of retailers – a right store for every product

Creative entrepreneurs should chose a retailer, which vary based on ownership, level of service, product assortment and price, that is best positioned to sell their product. Stores may be either individually owned or be part of a chain of stores. The individuals who own their own stores will have more discretion about the types of products they wish to stock. If the store is owned by a corporation and a manager is in charge of the store, they may need to get permission to carry a new product.

Stores will also vary based on the level of service provided. A store may be basically self-service where the only assistance is at the checkout counter. Or a store may hire well-trained staff who take the time to inform customers of the products that are stocked. In addition, a retailer may specialize in a particular type of product, such as visual art or handcrafted items. The staff at these specialized stores will have a deep knowledge of the product. Customers are willing to take the time to find and shop at specialty stores because they know that they will have the best selection and product knowledge.

Other types of stores will have a broad range of products, but less selection of each type. Customers will patronize these stores because of the convenience of finding many different types of products at the same location. Retail stores will also vary by the prices they charge. Some will be known for high-priced items. These stores will have the ambience and décor designed to attract these customers who are willing to pay more. At the other end of the spectrum are stores that carry low-priced items.

Stores that carry specialized lines with well-trained staff tend to charge more for products. Stores that carry shallow but wide varieties of product lines tend to charge less. However, they make up for the low profit margin by selling more products. Because creative entrepreneurs are unable to create their product in large volumes, they will most likely sell to stores that carry specialized lines of products.

Multi-channel distribution

Creative entrepreneurs may decide upon multi-channel distribution, where the product is distributed by more than one method. The product may both be distributed in stores and available online. In addition, it may be sold at craft or art fairs or other special events. It should be kept in mind that, when using multi-channel

distribution, prices should be kept comparable. A retail outlet will not be interested in carrying the product if the creative entrepreneur also sells it online for a significantly lower price. Many people routinely check prices online while out shopping. The retail store knows that, if the online price is much lower, they will lose the sale. As a result there is no incentive for them to carry the product.

Question to consider: What retailer would be interested in carrying my product?

MakeWork in Chattanooga

Artists are 3.5 times more likely to be self-employed than other people. However, many also have "regular" jobs in order to pay the bills. The city of Chattanooga, Tennessee decided that artists needed help in growing their businesses so that they could earn a living. In addition, the city needed more businesses in their downtown core. As a result, the MakeWork program was established. Artists and other creative entrepreneurs could apply for grants to be used to cover expenses that would allow their business to grow. A competitive juried process was used to choose the grant winners. The grants have been awarded to chocolate makers, graphic designers, musicians and portrait artists to fund projects, studio assistance and other business needs. For example, a local sculptor used grant funds to purchase metal-cutting and welding equipment.

However, the program does more to help creative entrepreneurs be successful than just giving out money. In exchange for the grants, the recipients can attend meetings to share ideas on marketing, budgeting and networking. They are also encouraged to share their work via a blog and exhibit publicly.

Did it work? The program ran from 2008 to 2013. During that time 63 percent of grant recipients reported on average 15 percent higher annual incomes. In addition, 53 percent can now rely on their creative work as their sole source of income.

Don't think 15 percent is much? Ask anyone with a regular job if they would like a 15 percent raise!

WRCBtv.com 2012

Finding performance venues

Creative entrepreneurs with performance-based products, from traditional musical entertainment to multi media puppet shows, have unique issues when dealing with distribution. Performance-based creative entrepreneurs may choose to have performances at their own location. In this case, leasing a venue would require the same types of decisions as choosing a storefront or studio.

However, creative entrepreneurs could also decide that they will not have their own venue. In this situation it would be perfectly acceptable to have an office in their home to handle the booking arrangements and other engagement details. There would be no issues with neighbours as no customers would be coming to the office to purchase. The question then is whether the performances will be held at a specially rented venue or at other business locations.

Some creative entrepreneurs have performance-based products, such as entertainment for parties, that will be scheduled at people's homes. When creative entrepreneurs make this choice they need to be sure that they handle the transaction properly. When making the booking, a contract should be signed that specifies payment amount and terms. However, creative entrepreneurs should also ensure that the home or other location where the performance will be held meets their performance needs. If at all possible, a site visit should be made before the performance or event. If this is not possible, the contract should specify any needs such as the amount of space, electrical outlets and available lighting. It is often too late to correct these problems once the performer has arrived at the venue. Not having the needed equipment may affect the quality of the performance.

Another option is to book a professional venue for the performance. In this case there is less concern that the venue will meet requirements. While the creative entrepreneur would need to pay a rental fee, having the performance at a well-known venue can assist in attracting an audience to the performance. If the venue has a brand image of providing quality entertainment, it will make tickets easier to sell.

Instead of a traditional venue, performances can be held at established businesses such as at a restaurant, bar or hotel. These venues are often looking to book talent at a reasonable price. If the audience is known to tip, this revenue can be added to what is paid by the business. Other businesses, such as large office buildings, might be interested in having entertainment in their lobbies. Another alternative would be retail establishments. Not only does entertaining at such public businesses provide revenue, it also helps in building public awareness for the creative entrepreneur.

Question to consider: What performance venue should I use?

Summary

Distribution of the product is often overlooked in business planning. However, it is just as critical to success as having the right product, price and promotion. Creative entrepreneurs can sell their product directly to customers or indirectly through intermediaries. As part of the business planning process, they will need to consider whether they wish their product to be distributed exclusively, selectively or intensively. Creative entrepreneurs face the challenge of how to combine where they live, produce their work and sell to customers, and will need to find the situation that best meets their needs. They may wish to sell from their own production space, in which case they need to ensure they have chosen an advantageous location. Or, they may decide to distribute through established retailers. If

they choose to sell online, they can create their own website or use a company that provides an existing online marketplace. Distribution is a more complicated part of the business plan than it may at first appear.

References

Barrow, Colin, Paul Barrow and Robert Brown. *The Business Plan Workbook: The Definitive Guide to Researching, Writing up and Presenting a Winning Plan*, London: Kogan Page, 2008.

Borrup, Tom. *The Creative Community Builder's Handbook: How to Transform Communities Using Local Assets, Art, and Culture*, Saint Paul, MN: Fieldstone Alliance, 2006.

Grant-Peterkin, Chris. "Selling art online and reaching new markets: 5 tips for artists."*The Guardian*, January 28, 2014. www.theguardian.com/culture-professionals-network/culture-professionals-blog/2014/jan/28/selling-art-online-tips-artists. Accessed August 4, 2014.

Indvik, Lauren. "Etsy Wants To Get More Sellers Goods In Brick-and-Mortar Stores." *Fashionista*, August 5, 2014. http://fashionista.com/2014/08/etsy-wholesale. Accessed August 7, 2014.

Latimer, Joanne. "Would Picasso Have Sold Online?" *Maclean's* 124, no. 10 (March 2011): 56.

My Creative Compass. "Guide to Cleveland Artist Communities." *My Creative Compass*. mycreativecompass.org/space. Accessed May 15, 2014.

Palma, Dolores P. "Ten Myths About Downtown Revitalization." In *Main Street Renewal: A Handbook for Citizens and Public Officials*, Jefferson, NC: McFarland & Company, 2006, pp. 374–380.

Promotional Marketing. "The Pop-up Shops Broker." *Promotional Marketing*, December 5, 2013. http://lyco2.lycoming.edu:2048/login?url=http://search.ebscohost.com/login.aspx?direct=true&db=buh&AN=92950173&site=ehost-live&scope=site. Accessed August 6, 2014.

Reece, Monique. *Real-time Marketing for Business Growth: How to Use Social Media, Measure Marketing, and Create a Culture of Execution*, Upper Saddle River, NJ: FT Press, 2010.

Speader, Karen E. "How to Find the Best Location: A Guide to Scouting out a Location for Your Food or Retail Business, Sizing up Demographics and Getting the Help You Need." *Entrepreneur.com*. www.entrepreneur.com/article/73784. Accessed August 6, 2014.

WRCBtv.com. "MakeWork to Award $75,000 in Arts Grants." *WRCBtv.com*, January 4, 2012. www.wrcbtv.com/story/18692785/makework-to-award-75000-in-arts-grants-this-year. Accessed July 7, 2014.

Tasks to complete

Answers to these questions will assist in completing the Distribution section of the business plan.

1 Distribution channels

 a Describe the distribution channels that you will use.

2 Direct distribution

 a If you have your own storefront, where would it be located?

 b Find the rental or lease costs for storefronts in the preferred location.

 c List the products you will be selling online.

3 Indirect distribution

 a List three retailers that could potentially carry your products.

 b Find three online marketplaces that you could use to sell your product.

 c Find five craft or art fairs in which you could participate.

4 Performance-based product distribution

 a Describe your ideal venue.

 b Find three different types of venues you could use in your community.

Visualization exercises

1 Design the signage for the front of your building.

2 Draw a floor plan for your ideal retail or performance space.

3 Draw a map of your block, labeling the neighboring businesses.

4 Create a display of your products.

5 Design the look of the home page for your website.

8 Promoting the creative product

Introduction

Creative entrepreneurs produce products that are an expression of their own personality and values. Because they so firmly believe in the excellence of their product, it may be difficult to grasp that, to the potential customer, what they produce is just another product among many. The reality is that the marketplace is full of competing creative products. Furthermore, because of technology, people are not only aware of these many available products, but they are also able to easily purchase the products from around the world. As a result, creative entrepreneurs must differentiate their product from competitors'. They then must position an image of the product in the mind of the consumer.

While creative entrepreneurs understand that there is a need to promote their product, in fact more than a simple promotional message is needed. Instead, the creative entrepreneur needs to develop a brand image that communicates the mission and values of the organization along with the product's features and benefits. This image and message should be communicated using the promotional methods of advertising, sales incentives, personal selling, public relations and social media. In addition, a successful communication of the marketing message will depend on an understanding of the AIDA process of gaining the consumer's attention, developing interest in the product, creating desire and moving the consumer toward the action of purchasing the product.

What creatives have to say: Hillary Frisbie

Hillary is a Renaissance woman educated in communication and media studies, cultural organizations and facilities management. What ties all these fields together is her work in managing cultural facilities, where she is responsible for scheduling musicians and events. In addition, she is a co-founder of an international conference for facility managers, FM Docs. The organization creates educational tools that are then sold to facility management programs at universities. A woman of many skills, she still wishes she had known more about:

1 helping the client to understand their needs so that their plans become a reality;

2 understanding her own strengths and weaknesses, which will help her manage those who work for her and also manage her managers;

3 understanding how to market a product face to face without sounding like a sales person.

You can learn more about Hillary at www.linkedin.com/in/hillaryfrisbie.

Branding

Branding is the process of creating a message and a visual symbol or logo that together communicate to a potential purchaser the values of the company along with the features and benefits that the product has to offer. While the words and symbol used together are simply thought of as a brand, the term, brand name actually refers to the words, while the term, brand mark refers to the symbol or logo.

A well-developed brand image communicates an emotional message to the customer that provides a preview of what they will feel when they consume the product. Creative entrepreneurs should understand that, while the marketing message communicates how the product benefits the customer, the brand communicates what the product means to the customer (Millman 2012). Therefore the brand should not just focus on product attributes. Instead, the purpose of the brand is to become an expression of the aspirations of the consumer. For example, consumers may care deeply about poverty in economically underdeveloped countries but feel that as individuals there is nothing they can do. However, by buying a product from an organization that provides employment in such countries, they now can think of themselves as someone who not only cares, but also takes action to alleviate poverty. Both a marketing message on the product benefits and a brand image that speaks to the aspirations of the consumer are necessary to sell a product in a crowded marketplace.

Because the development of the message and image of a brand is a creative process, creative entrepreneurs have a natural advantage. Despite the time and effort required, creating a brand message and visuals that will come to be identified with the product is a worthwhile use of resources as the brand will be used in all of the creative entrepreneur's promotional material. In fact, even the packaging of the product can be designed to express the brand image. If creative entrepreneurs have a studio or storefront, the exterior signage and interior design should also reflect the ambience of the brand. This is also true of the company's ecommerce website. Even small details, such as the price tags on the products, should incorporate the brand image.

The brand image is even more critical to the success of a performance company. Because the product is intangible, the brand image communicates the type of experience that the product will provide. It is part of the guarantee that the product will be as it is represented in the promotion. There is an old saying that you

can't know a book by its cover. In branding of intangible experiences, this idea is turned on its head. It is the cover, or brand image, that quickly and accurately informs the customer of the contents.

A means to start creating a branding message is to think of the adjectives that describe the company's mission and product (Reece 2010). The company might be thought of as durable, trendy, safe, fashionable, exciting, calming, healthy or any combination of these or other words. Brands have emotional connotations with consumers, so the words should also be emotional. To get design ideas, there are many websites that show brand logos. Of course, these should not be copied, but they can be used to spark inspiration.

One new method of developing a brand image is to co-create the brand with current customers (Ind *et al.* 2013). One simple way to do so is to ask customers what the product both does for them and means to them. This can be accomplished best by using an online community but can also be done using personal communication. Customers can be asked for their memories of the product, stories on how they currently use the product and emotions about the business. People feel closer to and more supportive of brands that they felt they have helped create.

Questions to consider: What will be my brand image? Where will it be used?

Brand success

Simply looking at the brands available in stores and online quickly demonstrates that brands vary greatly. There are no guidelines that state that successful brands consist of a specific visual or verbal design. So what does make brands successful? Here are seven principles that need to be followed for a successful brand that have nothing to do with design.

1 Know your audience: You cannot successfully communicate unless you understand to whom you are speaking.
2 Be unique: If there is nothing unique about you, your message cannot be unique.
3 Passion: Customers cannot become passionate about a business unless that business demonstrates internal passion on a daily basis.
4 Consistency: The product needs to be as consistent as the brand.
5 Competitiveness: Creating the brand is easier than the ongoing effort of building a brand.
6 Exposure: Using the brand in multiple ways is necessary.
7 Leadership: Brands don't succeed alone; company leadership is the key.

When it comes to branding, more is involved than just a cool design!

DeMers 2013

Differentiating the product

Deciding on the appropriate brand message should take into consideration how the creative entrepreneur's product is different from competing brands. This is referred to as differentiating based on competitive advantage. Creative entrepreneurs must first decide on their competitive advantage and then determine how to use it to position their product in relation to the competition in the mind of the potential consumer. While some businesses may focus only on brand equity, which is what the brand is worth monetarily, a better model is to value brands based on their ability to create a competitive position (Burke 2011). Creating a competitive position starts with understanding the needs of the target market segment. The creative entrepreneur compares the benefits that the product provides to the targeted segment with the benefits provided by competing products. However, the value of the brand also results from the business delivering what it says it will provide. Integrity, then, is part of the competitive position of the product.

The competitive advantage for mass produced products can result from low pricing, efficient distribution and patented technology. However, the competitive advantage of products developed by creative entrepreneurs results from the values of the people who create the product and run the company, along with the unique quality of the product.

Positioning the product – it's all in the eye of the beholder

The positioning of the product is the process of matching a unique product benefit to the needs of a specific target market segment. A product can have more than one position in the marketplace if it has more than one bases for differentiation. For example a handcrafted toy created for children can be positioned against other toys as being educational. This positioning would be developed into a marketing message aimed at parents. If the toy was produced in a rural village with little employment opportunities, the same product can be positioned as ethically produced for people concerned about social issues. In this case the marketing message would explain that purchase of the product helps to alleviate poverty. Finally the same handcrafted toy can be positioned as a piece of folk art that can be used as display. This opens a new target market of collectors who are not looking for children's toys but rather decorative objects.

Bases for differentiation: There are many bases for differentiation of a product, including production methods, raw materials or the producer of the product. Differentiation can be based on the production methods used to create the product, such as the creative entrepreneur's use of a new digital printing process. If this process results in prints that are more vibrant, this could be the basis of differentiation. The resulting marketing message might state that the vibrant colors bring the subject matter to life. The differentiation can also be based on the material used to produce the product, such as using fabrics dyed with natural plant extracts. The creative entrepreneur who produces clothing dyed naturally might have a marketing message aimed at parents that the clothes are as pure as a mother's love. In

addition, differentiation can be based on the producer of the product. The fact that the creative entrepreneur is a local resident, college student or employs recent immigrants may be the differentiating factor. In addition, actual product attributes can be used in differentiation such as emphasizing personalized service or unique product packaging. Finally, the differentiation can be based on ancillary attributes such as the mission of the organization. Whatever the differentiation is based upon, it is the foundation of the promotional message aimed at the target market segment.

Positioning strategy: Once the business understands their competitive advantage and has defined their differentiation, they can then choose a positioning strategy. This process involves the creative entrepreneur developing a positive brand image in the minds of its consumers. The first option is to strength their current position by emphasizing the positive attributes of the product. With this option, the company will use its competitive advantage to create a unique positive image. However, there is another strategy which is to reposition the competition. In this positioning strategy, the creative entrepreneur emphasizes the deficiencies of the competitor's product. For example, the creative entrepreneur may state that buying goods mass produced in other countries takes jobs from local residents.

Competitive grid: A means of helping the creative entrepreneur develop a positioning strategy is to create a competitive grid. The grid will consist of two lines intersecting at 90 degrees, thereby forming four quadrants. The two lines represent what creative entrepreneurs consider to be two of the product attributes that are most desired by consumers. For example, for musical groups one line might represent the level of personalized service, from no service to the ability to totally personalize a play list, and the other line the cost of performance, from low to high. The creative entrepreneur's product and all other competing musical groups are laid out on the grid based on their level of service and price. From this grid it might be determined that there are many bands with personalized services that charge a high fee. There are also bands that provide no option to personalize that charge low fees. If the creative entrepreneur's band can use technology to provide a means of personalizing services without having to charge high fees, they have found a competitive position where they will have minimal competition. Another example would be prints of city landscapes where the intersecting lines would be price and framing service. This grid could demonstrate that there are no low-cost providers that also provide an on-site framing service. In this case, the creative entrepreneur of low-cost prints might decide to add a framing service as their competitive position.

Questions to consider: How is my product different from my competition? How do my customers view my product?

Communicating the marketing message

Creative entrepreneurs must communicate a single marketing message to a target market segment that explains their competitive advantage and position. If creative

entrepreneurs use inconsistent promotional messages, they will simply confuse the potential consumers as to the features and benefits that the product offers. To avoid this confusion, the entrepreneur can use branding to build the association between the product's name and its benefits. However, building name recognition among potential consumers using branding will take time and effort.

Just because a marketing message is communicated does not mean that it will be heard. One of the most challenging tasks in developing a marketing strategy is to write in a few short words a marketing message that will catch the attention of the potential customer. It has become increasingly difficult to get consumers' attention as they are constantly exposed to an enormous number of promotional messages. Besides the usual traditional sources of broadcast and print, consumers now see promotion on websites, attached to emails, on buses, posted on construction hoardings and even in toilet stalls. In addition, social media sites also contain promotional messages. Consequently it is not surprising that people 'tune out'. Therefore creative entrepreneurs must develop a message that will be heard over the constant 'noise' of competing messages.

Communication strategies – do you use facts or feelings?

The promotional message for the product can be created to communicate either explicitly or implicitly. The marketing message is communicated explicitly when the product's features are described directly in simple words that are easy for everyone to understand. An explicit message is used when the purpose of the message is to provide factual information. For example, a creative entrepreneur who paints murals would use an explicit message stating that a mural in a home adds to its resale value.

On the other hand, an implicit message communicates persuasively using the emotional benefits that result from the purchase and use of the product. These implicit messages communicate information indirectly using emotional words and images. For example, an implicit message that the creative entrepreneur might develop would show a couple relaxing on a sofa at the end of the day while enjoying their mural. The implicit message being communicated indirectly is that consumers will enjoy the benefit of relaxation from having a mural in their home. A second picture might show two serious art devotees comparing their mural to art in books. This implicit message would communicate the message that the mural will be enjoyed by those with an appreciation of art.

Push vs. pull: Two other terms used when discussing communication strategy are push and pull. A pull strategy is the usual form of consumer promotion, where the producer of the product communicates the promotional message directly to consumers to 'pull' their attention away from competing products. For example, creative entrepreneurs can promote their musical performance to potential audience members in an effort to pull their interest away from other entertainment opportunities. A push strategy is when the creative entrepreneur promotes to intermediaries, such as retail shops, in the hope that they will then in turn promote or push the product to their customers. For example the creative entrepreneur can

provide retail shop managers with promotional material about the product, such as brochures or postcards that explain how the product is produced, to encourage them to 'push' the product to their customers.

If creative entrepreneurs only distribute to customers through direct channels, they will only need a pull strategy. However, if the creative entrepreneur also distributes indirectly using an intermediary, they will also then need a push strategy to effectively promote. In this situation both the pull and push strategy will communicate the product benefits that the purchaser will receive. However, another type of marketing message is aimed directly at the intermediary. This is a business-to-business message that stresses how having the product in the store will increase sales. This type of message is only used to communicate to intermediaries.

Communicating features, benefits and values – what it is, what it does, what it means

Creative entrepreneurs will use the marketing message to communicate information on what the product offers in an effort to motivate purchase. Three types of product knowledge can be communicated to potential consumers to assist them in making a purchase decision. The marketing message should contain information on all three: features, benefits and values. In addition, the message should communicate both rationally and emotionally.

Information about product features will be communicated rationally to create awareness of the product as a possible choice. Features are factual attributes of the product and are directly stated. For example, a marketing message might state that all scarfs are wool, handmade, and come in multiple colors. This lets the potential consumer know that the product is available and its tangible features. However, this rational message is rarely enough to motivate purchase unless potential customers have already decided that they want to purchase a wool handcrafted scarf in blue.

The marketing message on benefits will be communicated emotionally to build preference for the scarf over competitors. This message will not be about what the product 'is' but rather what it 'does' for the consumer. For example, the marketing message will state that the handcrafted scarfs keep consumers warm while also being fashionable. Another benefit message might be that the purchase of the scarfs helps to promote a social cause. In addition, the benefit promoted might be that the scarfs can also be used as furniture throws to decorate the home. The emotional marketing message will also be used to appeal to the potential consumer's own values and sense of identity. This part of the message can be thought of as a story about not just the product but also the mission of the company (Sachs 2012). This story will create an emotional connection between the potential customer and the organization. For example the marketing story may state that all scarfs are handmade by textile study students from a local college. By purchasing, the customer not only receives a product, a student is also provided with a means of funding their education. By communicating the features, benefits and values, the marketing message will motivate the potential consumer to move from awareness, to preference to actually purchasing the product.

Analyzing the product

- Features: what the product is.
- Benefits: what the product does.
- Values: what the product means.

Question to consider: How will my marketing message communicate my product's features, benefits and values?

Promotional methods

Once creative entrepreneurs have decided upon a promotional message, it must be communicated to the target market segment. The traditional methods of communicating a marketing message include advertising, sales incentives, personal selling and public relations. Now added to this promotional mix is social media. While there may be some who believe that traditional methods of promotion have been replaced with social media, this is not true. What has happened is that social media incorporates and enhances the ability to communicate via traditional methods (Kabani and Brogan 2012). This use of social media will be discussed in detail in the next chapter.

Promotional methods

- Advertising: communicates impersonally one-way to build awareness.
- Sales incentives: provide motivation to purchase immediately.
- Public relations: gets other media to tell your story to establish credibility.
- Personal selling: communicates two-way to overcome objections.

Advertising – it is still around and it still works

Advertising is defined as one-way, impersonal communication. It is probably what most people think of first when asked about promotion. In fact, the words promotion and advertising are often used interchangeably. However, advertising is only one way to communicate a promotional message. The best use of advertising is to build product awareness. Its purpose is not to stimulate immediate sale but rather to motivate the consumer to find out more about the product. Advertising is best used to communicate the product name and a marketing message that describes the competitive advantage. The advertisement will also contain information about the availability of the product by directing the potential customer to a retail location or an online site. Because people are inundated with advertising messages on a daily basis, the words and visuals used must be both creative and succinct. The words and visuals must grab the attention of the consumer and communicate its message in a matter of seconds.

Advertising can be expensive, especially if the company is using national or even regional media campaigns. However, it also can be inexpensive using methods such as flyers and posters. The marketing message can also be placed on business cards, coffee cups and the back of ticket stubs. Creativity is needed to think of how the potential target market can be reached with the message using advertising.

Types of messages: Advertising messages can be categorized as being pioneering, competitive or comparative. Pioneering advertising is used when a new type of product is being introduced to the marketplace. If a product is new, the marketing message must be used to explain the product to the target market. A new form of digital artwork would need this approach, so that the public can appreciate the benefits provided by this new form of art. New styles of music would also need to use this approach to describe how they sound. Competitive advertising is used when the type of product is well known to the marketplace. In this situation, the marketing message would communicate the advantage of the product over competitors. Finally, comparative advertising is used when the product is positioned directly against competitors. In this type of message the product's advantages against specific competitors is compared. Creative entrepreneurs might need to use a comparative message to describe the advantages of buying a locally produced product versus one shipped in from another country.

Types of media: The major categories of advertising media are broadcast, print and internet. In addition nontraditional media can be used. Broadcast advertising includes both television and radio. Television advertising may not be possible for creative entrepreneurs because of both the expense of production and cost of media time. However, newspapers are a medium that should be considered. Newspapers have been losing paper subscribers but increasing the number of online subscribers. While advertising campaigns using leading newspapers with broad reach can be costly, creative entrepreneurs should not forget that many people still check the local paper for both news and advertisements. In addition there are free newspapers, which are often widely distributed, which are possible sites for the placement of advertisements. Newspapers have the advantage that most are specific to a geographic area. If the creative entrepreneur's product is sold directly to a retailer, part of the negotiated agreement might be that the retailer place advertisements promoting the product.

Magazines are often produced in both print and online. The advantage of using magazines is that many are targeted narrowly at very specific lifestyle or special interest groups. The creative entrepreneur's target market segment may be defined by psychographic characteristics including lifestyle. If this is true, there is most likely a magazine being targeted at this same consumer segment. If it is affordable, placing an advertisement may be a wise investment.

Online advertising should also be considered. The website of the business is a form of advertising. However, in addition, advertising space can be bought on other websites. Using analytics, creative entrepreneurs can know if their ads are being clicked on.

Alternative media are all the other methods that can be used to display the advertising message. While some alternative methods, such as ads on social media,

are the focus of much attention, other methods continue to be effective (Blakeman 2014). The simple flyer and brochure can catch the attention of the target market segment if strategically placed where they will be noticed. Posters for events and performances are also effective methods for communicating a marketing message to attract an audience. These methods are low cost and successful if the message and visuals are targeted at a specific segment.

Sales incentives – everyone loves something for nothing

Sales incentives are combined with other promotional media to build interest in buying a product by providing a reason for immediate purchase. While the ideas can be considered simple and are certainly not new, they continue to work because they respond to a basic human desire for a 'good deal.' They can be particularly helpful in getting interested consumers to purchase during economically challenging times (Findlay Schneck 2010). Sales incentives are usually limited-time offers that are targeted either at current customers so that they purchase more frequently or to attract new customers.

Sales incentive methods can be tailored to the desires of the target market segment. An incentive that works for one group may not work for another. In addition, the cost of the incentive needs to be scaled to the cost of a product. For example, a small gift that is included with the purchase of an inexpensive product is appropriate. However, as the cost of the product increases, the cost of the gift that is provided must also increase.

The advantage of sales incentives is that they can be crafted to help sell a specific product or any product during a specific time period. If a product is not selling as anticipated, the use of a sales incentive can increase purchases. Of course, there is a cost to sales incentives as the profit on each item is slightly reduced. However, this may be preferable to not selling any product at all. In addition, if there are slow times of year, the sales incentives can be seasonal to give consumers a reason to purchase when they might not have thought to do so.

Of course, the public needs to be made aware of the available sales incentives. This can be done using advertising such as online ads or low-cost flyers. Information on sales incentives can also be seamlessly added to the creative entrepreneur's social media campaign. In fact, they provide content that can be written about for the social networking site, blog entries and tweets.

Types: Some sales incentives are financial, such as a temporary reduction in price, a coupon that can be used to reduce the price, or a rebate that can be received after purchase. Other sales incentives offer a free gift, such as an additional product that customers receive with their purchase. For example, the premium might be related to the creative entrepreneur's product such as a free carrying case for jewelry or an unrelated item, such as a sample of a new product. Finally, some sales incentives involve contests where the purchaser can win a prize. Contests have the advantage of collecting information on the customers that can then be used to send future promotional messages and offers.

Some types of sales incentives, including discounts, gifts and contests, are easy to understand and implement. Others, such as loyalty programs and sampling, may take more thought. Loyalty programs encourage repeat purchases by providing a gift or discount after a purchasing goal is met. They may be based either on the number of individual purchases or by the dollar amount of product purchased. The simplest is the punch card that is punched after each sale. Of course, there are now online versions of the punch card that keep track of purchases. A current customer may also be rewarded when a friend is referred and purchases the product.

Sampling is usually associated with easily consumed products such as food. However, sampling can be effectively used by creative entrepreneurs who perform. Taking a small sample of the performance into a public place can expose potential customers to the product in a way that even an online clip cannot provide. The sample not only displays the performance, but it also introduces the performer. The performance-based creative entrepreneur can provide samples using public places such as a park, local festivals or even the lobbies of corporate offices. Not only does this give the chance for the public to hear the performance, the performer can provide information on how a performance can be booked.

Public relations – say something good about me, please

The purpose of public relations is to maintain a favorable public image. It is a necessary tool when countering negative information that may appear in the news media about any type of organization. While countering negative news is an important function of public relations, it is not how it is usually used by creative entrepreneurs. Instead, creative entrepreneurs need to focus on the publicity component of public relations. Publicity is the creation of affirmative information on the organization in the hope that it will be published by the news media. However, rather than merely hope that the news media will write an article that will reflect positively on the organization, the creative entrepreneur will supply information to the media such as actions that the business is taking to improve the community. The purpose of the information that is provided is to generate news articles or blog postings that will then be read by the public who will, hopefully, be motivated to purchase the creative entrepreneur's product.

Tools: The principle tools used in generating publicity are news releases, photographs and feature articles. The most common use of public relations is when the creative entrepreneur's business is involved in contributing to community welfare. All organizations need to consider how they impact their communities. Of course, businesses provide a needed product and by doing so provide employment and pay taxes. However, they should also be philanthropic by doing what they can to improve their community. This might be getting involved in existing organizations or it might be holding an event in support of a cause. When they do so, it is appropriate that information on their actions is provided to local news media using press releases, photographs and articles. In addition, such actions should be well covered by the creative entrepreneur's own social media.

Some forms of public relations that might be specifically useful to small creative businesses are charitable giving, sponsorships and consumer education. Creative entrepreneurs can donate directly to charitable causes. When they do so, they should choose charities of interest to the targeted customer segment. The most popular forms of sponsorship by businesses involve sports, music and arts. By contributing to a fund to support these events, the creative entrepreneur's name and logo will be displayed. This not only creates awareness in the public that the company exists; it can also be used to enhance the brand image. For example if creative entrepreneurs are selling a product aimed at children, they may wish to consider sponsoring a local children's sports team or a local children's music festival. If the creative entrepreneur sells a food product that is targeted at customers who are health conscious, they might consider having a consumer education event on healthy living. An artist that sells watercolor paintings may wish to hold an event where potential customers can learn to paint. Performing artists should also consider educational events. For example, musicians can have an event that introduces children to music by letting them try instruments.

Use: Of course these events should be communicated to a larger audience than only the people who attend. First, creative entrepreneurs should send a short press release describing the event to any media outlets, informing them of the upcoming date. Because the event is focused on community education, the media outlet should provide coverage for free. After the event, a press release should be written and sent along with photos of the community having fun while raising money for charity. All of this information can also be used in the creative entrepreneur's social media promotion (Scott 2013).

Public relations is not a substitute for other forms of promotion. It is simply one of the many tools that should be used. It is free in the sense that no media needs to be purchased. However, time and effort will go into hosting the event and writing the press release. If creative entrepreneurs are not already involved in the community because it is the right thing to do, they should consider doing so, as communicating community involvement using public relations will increase sales.

Personal selling – let me explain face to face

The fourth traditional form of promotional method is personal selling. This is selling products with two-way communication, where the purchaser has the opportunity to voice concerns or objections to which the sales person responds. Before the advent of technology this meant only face-to-face communication. Because it was expensive to dedicate staff to the task of selling, only products that were expensive or ones that needed to be explained, because either the product or its competitive advantage were difficult to understand, used personal selling. This has changed with the use of social media. Every time creative entrepreneurs respond to an online request for information or to an online complaint, they are using personal selling.

If creative entrepreneurs have a storefront, everyone with whom the potential customer comes into contact is a sales person. Therefore everyone who visits the

storefront should be treated with interest and respect. Even if they decide not to become a customer, they may recommend the product to a friend. It is a delicate balance to be friendly and helpful to customers without becoming annoying. One way to do so is to focus the first interaction on the customer, rather than the product. Asking about where they are from, commenting on something they are wearing or even just mentioning the weather are ways to start conversations without seeming only interested in a potential sale.

Networking: In addition, the creative entrepreneur is always selling the product even when they are not talking to a potential customer. This is why networking within the community is critical. Getting out to events where creative entrepreneurs can introduce themselves and their business can make people curious enough to check out the company's website, visit the store or find the creative entrepreneur at a craft fair. While networking with other creative entrepreneurs is a critical means for inspiration and artistic knowledge, community networking is different. This networking is with groups that are potential customers. This might at first not seem a very attractive opportunity for creative individuals who would rather spend time with other artists. However, not only will the company name and products become better known through networking, creative entrepreneurs will learn more about what their potential customers desire in a product and what motivates them to purchase. Creative entrepreneurs should think of every event that involves the public as a networking and personal selling opportunity (Zack 2010).

Question to consider: What are some ideas for using advertising, sales promotion, personal selling and public relations to promote my product?

Using online marketplaces

New means of selling art have always emerged. In the nineteenth century, art was sold through salons that were hosted by the cultural elite. In the twentieth, art was sold through commercial galleries. Now increasingly it is online marketplaces that are being used. Etsy may be the first such platform that comes to mind, but some of the new entrants to the field are Artspace, Paddle8 and Amazon Art.

Now everyone is talking about social media and online selling. As a result there is confusion between social networking sites, websites with ecommerce ability and online marketplaces. Creative entrepreneurs will have their own social networking site to communicate with the public about the product. However, selling the product online will occur on the creative entrepreneur's website, where an ecommerce function can be added. There is another choice for ecommerce, which is to use an online marketplace, which is a company that hosts 'shops.' If a creative entrepreneur choses to use this model, here are five points to remember:

1 Don't get confused: Online marketplaces find new customers, while social media manages current relationships.
2 Keep working offline: Use online marketplaces to complement other distribution methods, not as a replacement.
3 Spread options: Use more than one online site as they serve different audiences.
4 Still sell face to face: Most people still want to see art in person before they purchase.
5 Update information: There are no sales people on online marketplaces, so the buyer only has the information posted by the artist with which to make a decision.

Online marketplaces are one piece of the puzzle, not the entire picture.

Grant-Peterkin 2014

AIDA model

Creative entrepreneurs must understand that motivating a customer to purchase a product is a process, which is why the consumer purchase process model was discussed in an earlier chapter. Another useful way to think of the purchase process is to consider how promotion can be used to move consumers along the continuum from initial interest to final purchase. The AIDA model is useful in describing how a promotional message and method can be used to move consumers from attention (A) to interest (I), to desire (D) and, finally, to action (A) by purchasing.

Before consumers can purchase a product they must first become aware of its existence. With so many products in the marketplace, consumers are constantly bombarded with marketing messages. As a result they tend to ignore all but the most interesting. Advertising can be used to develop this product awareness. It can be difficult to gauge if advertising is effective in gaining attention, which is why creative entrepreneurs should always ask customers when they purchase how they heard of the product.

However, simply gaining the attention of consumers through advertising is not enough. The creative entrepreneurs must develop the interest of the consumer by communicating how the product will benefit them directly. Therefore, besides just informing the customer of the product's existence, the promotional message must communicate the competitive advantage. Personal selling and social media are very effective in communicating benefits to gain interest. Social media can provide customers with reviews by people who have already purchased the product. In addition, creative entrepreneurs can encourage current customers to upload photos taken while they were using the product. If these reviews are positive, and the photos attractive, the potential customer will become interested in the product.

While the consumer may develop an interest in the product, getting them to desire the product will take even more action by the creative entrepreneur. Sales incentives are very effective in getting the consumer to not just be interested in the product but also to desire the product by providing an additional purchase benefit such as a discount, gift or right to enter a contest.

Finally, getting the consumer to take action involves encouraging them to purchase the product. It might seem that, if potential customers desire the product, purchase is inevitable. However, many issues can keep the purchase from occurring. For example not providing detailed information on the store location and hours might result in the customer losing interest. If online sales are not easy to complete, again, the consumer might lose interest and abandon the purchase process. In addition, complete pricing information, including shipping, must be available. Therefore the creative entrepreneur must include all needed information on how the product can be purchased.

Question to consider: How will I create desire in my customers?

Using promotion effectively

There is an old saying in promotion that states that half of all money spent on promotion is wasted, but the problem is that no one knows which half. To not let this happen, creative entrepreneurs must track the effectiveness of their promotional efforts. This can be done using an ROI, or return on investment, model. The creative entrepreneur sets a goal for sales of a particular product or product line. This goal is based on past performance or, if the business is new, on estimates. The profit that will arise with this number of sales is then calculated by subtracting expenses from revenue.

The cost of the planned promotional activities will also be calculated. This includes the dollar value of time spent developing the promotional materials, if they are being created personally by the creative entrepreneur. If they are being developed by a separate company, the cost will be what they charge. It will also include the cost of any physical brochures and flyers that are produced, along with the cost of purchasing the newspaper, magazine or internet space. In addition, the cost of maintaining social media content about the promotion must be included.

At the end of the time spent on the promotional campaign, sales are again checked to see if they met the planned outcome, which was to increase revenue over the cost of the promotional campaign. If they did not, the promotional campaign did not meet its objectives and was not successful. At the least, the additional revenue received during the period should cover the cost of the promotion. While tracking promotional campaigns in this way can be time consuming, it is the only means of determining if the investment in a promotional campaign was worthwhile.

Question to consider: What is a method I could use to track if my promotion ideas are successful?

Summary

A brand is a promise that not just the product, but the mission, of the organization is actually what is stated. People buying a creative product are not just buying the physical product or the service, but also the values of the company. Therefore every communication that the company has with the public should express these values. In the past these values would have been communicated in the company's traditional media. Now they can be communicated continually using social media. The promotional message that is communicated to the target market segment should explain the product's advantages over its competitors. The product is then positioned at a specific target market segment by having a message that will speak directly to their needs. It should be the goal of creative entrepreneurs to use the types of promotion that will be most effective in reaching their potential audience. The traditional methods include advertising, sales incentives, personal selling and public relations. Social media is not a substitute for traditional media, but rather an extension that allows the creative entrepreneur to focus their message on individual consumers. By understanding the AIDA model, creative entrepreneurs can use the type of promotional method that will move consumers from awareness to final purchase.

References

Blakeman, Robyn. *Nontraditional Media in Marketing and Advertising*, New York: Sage Publications, 2014.

Burke, Sandra J. "Competitive Positioning Strength: Market Measurement." *Journal of Strategic Marketing* 19, no. 5 (2011): 421–428.

DeMers, Jayson. "The Top 7 Characteristics Of Successful Brands." *Forbes*, November 12, 2013. www.forbes.com/sites/jaysondemers/2013/11/12/the-top-7-characteristics-of-successful-brands. Accessed August 8, 2014.

Findlay Schneck, Barbara. "Three Steps to Effective Sales Promotions." *Entrepreneur*, February 1, 2010. www.entrepreneur.com/article/204860. Accessed August 8, 2014.

Grant-Peterkin, Chris. "Selling Art Online and Reaching New Markets: 5 Tips for Artists." *The Guardian*, January 28, 2014. www.theguardian.com/culture-professionals-network/culture-professionals-blog/2014/jan/28/selling-art-online-tips-artists. Accessed August 23, 2014.

Ind, Nicholas, Oriol Iglesias and Majken Schultz. "Building Brands Together: Emergence and Outcomes of Co-Creation." *California Management Review* 55, no. 3 (2013): 5–26.

Kabani, Shama and Chris Brogan. *The Zen of Social Media Marketing: An Easier Way to Build Credibility, Generate Buzz, and Increase Revenue: 2012 Edition*, New York: BenBella Books, 2012.

Millman, Debbie. *Brand Bible: The Complete Guide to Building, Designing, and Sustaining Brands*, Beverly, MA: Rockport Publishers, 2012.

Reece, Monique. *Real-time Marketing for Business Growth: How to Use Social Media, Measure Marketing, and Create a Culture of Execution*, Upper Saddle River, NJ: FT Press, 2010.

Sachs, Jonah. *Winning the Story Wars: Why Those Who Tell – and Live – the Best Stories Will Rule the Future*, Boston, MA: Harvard Business Review Press, 2012.

Scott, David Meerman. *The New Rules of Marketing and PR: How to Use Social Media, Blogs, News Releases, Online Video, and Viral Marketing to Reach Buyers Directly*, Hoboken, NJ: John Wiley & Sons, 2013.

Zack, Devora. *Networking for People Who Hate Networking: A Field Guide for Introverts, the Overwhelmed, and the Underconnected*, San Francisco, CA: Berrett-Koehler Publishers, 2010.

Tasks to complete

Answers to these questions will assist in completing the Promotion section of the business plan.

1 Branding

 a Research online and find five websites whose look would fit your brand image.

 b Write a marketing message that describes your product and its benefits.

2 Promotion

 a What are three different media you can use to advertise the start of your business?

 b List three sales incentives that would motivate your customers to purchase.

 c What are five opportunities you can use to network to use personal sales?

 d Write a press release describing a charity event you will be sponsoring.

3 AIDA model

 a What would be the advertising medium you would use to attract attention?

 b What is one promotion idea that would move a consumer from desire to action?

Visualization exercises

1 Use all your senses to describe your brand image.
2 Create the words and visuals for an advertisement.
3 Draw yourself as a cartoon character with word balloons with what you would say at a networking event.
4 Draw the prizes or premiums you could give away.
5 Create an idea for a public relations event.

9 Building social media relationships

Introduction

Social media is now a part of any promotional strategy, whether it is a creative startup, a nonprofit cultural organization or a multinational corporation. A creative entrepreneur needs to use social media because it is an effective and yet low-cost method of building a relationship with customers. Nonprofit organizations need to use social media so that they can build support for their mission in the community. In addition, the public now expects to be able to communicate even with a multinational corporation and get a response, as they are no longer interested in merely being an audience for a promotional message. The development of social media has had such a profound change that it has resulted in a redefinition of media. Rather than being described as traditional versus new, media is now described as paid, owned or earned. The traditional forms of promotion are still used but are integrated along with social media into a cohesive strategy. A successful social media strategy will attract awareness, entice the public to interact and allow potential and current customers to add their own comments to the conversation. Besides providing a means of communication between the creative entrepreneur and the public, social media also can help in the decision-making process and product development.

> ### What creatives have to say: Jonathan Chang
>
> Jonathan is a multi-talented artist who not only paints but also photographs and designs objects. Having been a resident artist in Beijing and Taiwan and now living in New York, he has an international reputation. What makes Jonathan a true creative entrepreneur is that he applies his creative skills to the world of marketing. He has developed marketing strategies for young artists and also creative websites. He is now, in collaboration with other artists, developing a dinosaur figure that will be a blank canvas for artistic creation. Part of the proceeds from the sale of the product will be donated to animal rights organizations. Jonathan suggests to other creatives to focus on:

1 the ability to develop advanced marketing strategies;
2 web knowledge, as website development is a necessary part of business; and
3 not forgetting that marketing is part of any creative job.

You can learn more about Jonathan at www.chunghanchang.com.

Paid, owned, earned media

A new categorization of media has become popularized over the last few years. In the past, promotional media were categorized into the traditional methods of advertising, personal selling, sales incentives and public relations, and then a new fifth method of social media was added on. However, social media is not just another promotional channel: it has changed the way that the public consumes marketing information. Now promotional methods are more accurately being categorized as paid media, owned media or earned media (Burcher 2012).

Types of media

- Paid media: broadcast or print media purchased by the company.
- Owned media: company's own social media sites.
- Earned media: other social media promoting the company's product.

Paid media – we paid for it, so we can say what we want

Paid media is traditional advertising purchased by a company. Because the company is paying for the content, it can control the marketing message that is communicated. Paid media includes magazines, newspapers, billboards, television and radio. Smaller companies with limited marketing funds might use less expensive forms of paid media such as flyers and brochures. All of these paid channels are used to broadcast a controlled marketing message to the general public. Paid media does not guarantee that the target market segment will purchase the product. Instead, as a result of hearing the message, it is hoped that some potential consumers will seek out more product information by visiting the company's owned media.

Owned media – we say what we want, but welcome responses

Owned media is the use of communications technology to send a marketing message to both promote and build a community around the product and organization. Websites, social networking sites, photo- or video-sharing sites and other social media platforms are examples of owned media that belong to the creative entrepreneur. In addition, both blogging and microblogging sites, such as Twitter, are included in the owned media category. Owned media differs from paid media

in that it is not only a promotional message aimed at a specific target market segment, it also encourages a response. Owned media, while still communicating the company's marketing message, also asks for the public to respond with their own opinions and ideas about the product and organization. As a result, conversations are started where the public may agree or disagree with the promotional message. Because the creative entrepreneur will then respond to these comments, owned media takes more time and energy than traditional paid media. However, it is much more effective in engaging customer interest and building a community around the product than paid media.

Earned media – someone else's social media is talking about us

Earned media is outside of the control of the company. It includes comments about the product on social networking sites, bloggers who write about the product and customer reviews. An example of earned media is a video clip of people using the company's product that is made by a purchaser and then posted on YouTube.

Earned media can be favorable to the company or it can be unfavorable. While the company should monitor earned media and respond where appropriate, it in no way controls or even guides the content. Of course the company is pleased with positive earned media. If the earned media is not positive, the company must react either by countering negative information or improving the product if the complaints are valid.

Fan communities that develop around a product are another form of earned media. These communities will have their own websites and social media platforms that have no connection with the company that produces the product. Using these sites, the members of the community will share examples of how the product can be used and will even answer questions from potential purchasers about the product. These fan communities promote the product without any input from the company.

Product review sites are another example of earned media. Because these sites are not controlled by the company, they are trusted by the public. When individuals complain on the creative entrepreneur's owned social networking site, it is easy for a response to be posted. However, they may also complain on an independent product review site. There is a difference in how product review readers react to negative reviews that should be understood by creative entrepreneurs. When negative reviews of utilitarian or practical products meant for everyday use are read, they are likely to be believed. However, negative reviews of hedonic products, or products that are purchased because of the pleasure they give, such as creative products, are more likely to be dismissed by readers as resulting from the internal bias of the reviewer, not a problem with the product. Readers of this type of negative review are more likely to understand that beauty is in the eye of the beholder (Sen and Lerman 2007).

Question to consider: What forms of paid, owned and earned media do I currently use personally and professionally?

Integrating paid with social media

The creative entrepreneur must develop a marketing message based on positioning the product's benefits. Next, the creative entrepreneur must use traditional paid media to gain the attention of potential customers, engage their interest so as to develop a desire for the product and, finally, persuade the consumer to purchase the product. All of these actions must still be undertaken when the use of social media is integrated with the use of owned media. What is different is that the company no longer controls the marketing message. Instead, the company monitors and reacts to the message.

There is a misconception that social media has made traditional promotion obsolete (Handley 2012). Instead, what social media has done is transform the manner in which traditional promotion is used. The traditional promotional methods of advertising, sales incentives, personal selling and public relations can still be used to communicate the marketing message. However, rather than being used alone, they are now combined with social media. For example a small art supply store will still use inexpensive flyers posted about town to inform the public of the its upcoming painting night. They may still have coupons that give 10 percent off any purchase the night of the event. Personal selling will be used when the current store customers are informed about the event while making a purchase. In addition, because the crafts being created are being donated to an assisted living center, the store will still write a news release.

Adding social media – to reach more people, say it online

However, all of these promotional methods will be more effective if social media is added to the mix. The flyer will also contain information about the store's website, which will steer potential customers to the business's owned media Facebook page. This owned media site will provide more details of the event and messages from the public discussing their plans to attend. The availability of the coupons will now be tweeted to people on the store's Twitter feed. The personal selling is still done in the store but is now extended by using the store's blog, where questions about the event are answered. Finally, photos of the customers delivering the completed crafts to the assisted living center are posted on the Facebook page, Instagram and Pinterest. This is noticed by other bloggers who comment on the event.

Social media profile: To be successful with social media, creative entrepreneurs must develop a strong social media profile, which is similar to a brand image but promotes not just the product, but also the creative entrepreneur and the organization. Every communication that is online must accurately communicate product information but also reflect the business's values. In addition, the business should be humanized by providing information on the business's employees. The creative

entrepreneur's online brand is about the product, while the social media profile includes the business's values and its people. These three elements, product, values and people, identify the business to the public and are the basis of starting a community built around the product.

For the creative entrepreneur who already uses social media to communicate with friends and family, building a social media profile should be a natural fit (Harrah 2012). However, the creative entrepreneur should not assume that the social media platforms that work well with friends and families are the same sites that will be useful in communicating with customers. It may take some experimentation to determine which types of sites customers prefer. In addition, learning what type of content will be of interest will take trial and error. A successful strategy will not happen overnight, which is why it is a promotional task that needs to be implemented quickly.

Analytics: Some creative entrepreneurs may initially resist getting involved. This may be due to a belief that there is no way to determine the return on investment for the time spent adding content to the social media sites. However, social media has matured to the point where the three types of analytics, descriptive, predictive and prescriptive, can be used by small businesses even without the use of sophisticated software programs (Leone 2014). Descriptive reports will tell creative entrepreneurs how many people visited their sites, how long they stayed and from where they came. Predictive statistics notice a relationship between two separate occurrences. For example, when videos are posted on a site more people stay longer. Prescriptive reports take sophisticated software that is out of the reach of small organizations. However, the principle only needs common sense. If people stay on the site longer when videos are uploaded, then any new product launch should include uploaded videos.

Question to consider: How can I integrate traditional media with my use of social media?

Types of social media available

While new social media platforms are always being introduced, the types of social media remain fairly constant and can be categorized by the type of information that is being shared. Social networking sites, whether for personal relationships or for professional communication, allow for two-way conversations between members of the public. Other types of social media are platforms designed for sharing and viewing of videos and photos, rather than verbal communication. Some forms of social media are not site specific and include podcasting, blogging and microblogging.

Social media sites can be described using a creative product such as pottery. A general social networking site would be used to tell customers about someone's interest in pottery. A professional networking site would be used to tell the other potters that someone is in the business of making pottery. Blogging would explain

the process of making pottery and answer questions on specific styles. Microblogging would explain "I am making #pottery now." Photo-sharing sites would be used to post pictures of recently made pottery, while a video-sharing site would show videos of pottery while being made. Finally, podcasting could be used to share stories about the history of pottery.

Social commerce – let's create together

All social media methods allow people to do what people have always done, which is to communicate and share with each other. The difference is that now they can do so electronically without regard to distance or time. While social media started as a means for personal communication, businesses quickly realized its potential for communicating with both current and potential customers. Creative entrepreneurs can use social media not just to encourage comments but also to build a community around their product using social commerce (Liang *et al.* 2011). Social commerce is a term used to describe the relationship between buyers and a single seller. When creative entrepreneurs have their own ecommerce and social media sites, they involve the customers in the co-creation of value. This will involve shoppers making purchase suggestions to other shoppers. It will also include shopper-generated product preference wish lists that are shared with friends. No longer is the producer of the product the only person communicating a belief in what is being produced. Instead, social commerce means that the current purchasers promote to potential purchasers.

The process – let's get started!

Creative entrepreneurs do not need to incorporate all types of social media at once to build social commerce. Creative entrepreneurs should first develop a personal social networking site page for their organization. This site will be used to provide information and also to interact with customers. In addition, a professional social networking site, such as LinkedIn, can be created which will be used for communication with other professionals. Photo- and video-sharing sites can be added next to post pictures of the product but also videos of customers using the product and the product's production process. These sites allow members of the public to post comments to which the creative entrepreneur and other members of the public can respond. Such communication educates the public and builds an appreciation of the creative process.

An optional step would be adding podcasts, which are the creation of an audio file that can be downloaded and played at the convenience of listeners who can then post comments. Creative entrepreneurs can use podcasts to provide samples of the work of upcoming performances or information on the creative process. Blogging is a more advanced form of social media used by creative entrepreneurs as a means to share product ideas, personal views and organization updates. However, it can also be used to share general news that will be of interest to current and

potential customers. The customers can then comment or post questions about the creative entrepreneur's products.

Creative entrepreneurs can also use microblogging as a means of keeping in contact with others. Twitter, which is probably the best known microblogging site, is used not to get feedback but instead to get others to pass on the information. However, not all creative entrepreneurs have the time to microblog, as the posts must be both informative and interesting. Not everyone has the skill to continually write compelling or entertaining posts.

The creative entrepreneur should start with a well-designed webpage on which other social media can be linked. After the webpage, a social media site should be developed that includes photos and videos. These photos and videos can be added to specialized social media sites. Not all creative entrepreneurs will have the interest or time to develop blogs or podcasting, but if they do, these would be added. Finally, the creative entrepreneur can add microblogging.

Questions to consider: How can I use a social networking site, blogging, photo sharing, video sharing or podcasting to create or enhance my brand image? What percent of my business will be done by ecommerce?

Developing a social media strategy

While using social media may come naturally to creative entrepreneurs, they must think more strategically of how to engage customers so as to develop brand loyalty. Social media strategies should be designed around a three-step process. First, the social media site needs to attract the attention of the consumer. Second, it must get them to interact in some way beyond passive viewing by clicking through to a new page, opening a blog post or viewing a video. Finally, if the social media strategy is well designed, the site will so involve consumers that they will add their own comments or photos.

The creative entrepreneur's website may be where some potential customers start the process of engagement. The website will provide factual information on the company and links to social media sites. Hopefully customers will then click onto the creative entrepreneur's social networking site to learn more. It is critical that, once potential consumers are attracted to the site, they interact with the content and, finally, as they become more engaged, add personal comments and photos.

Social media strategy

- Attract: content of interest.
- Interact: video, blog and photo links that invite action.
- Add: enticing others to add own content.

Attract – come look at me!

The first task when creating a social media program is to attract people to the owned social media site. To do so there must be content that is both interesting and useful to the potential consumer. In addition, to attract, all of the information, both visual and verbal, must be well produced.

While consumers will use social media sites to learn factual product information, they also want to understand the values of the people who create the product. While some consumers are merely searching online for products to purchase, the market segment that is attracted to creative products is equally concerned with how and where and by whom the product is produced. Social media should be used to share the story of the creation of the product and the values of the creator.

Internal information: While the potential consumer is attracted to the social media to learn about the product and creative entrepreneur, additional information must be included that is useful. Useful information may be of upcoming events, whether they are sponsored by the creative entrepreneur or by another organization. Creative entrepreneurs should share information on any upcoming opening nights for performances. They can also post information on events held at the store where customers can come and try their hand at creating the product themselves. Posting this useful information on social media will encourage public comments. These are useful, as they let potential consumers know whether they too would also like to attend.

One way to provide useful information is to give away expertise. The creative entrepreneur can demonstrate how the public can create a product at home similar to what is being sold. While it may seem counter-intuitive, giving away the product will encourage sales, as it will help develop an appreciation of what is being created (Scott 2013).

External information: However, creative entrepreneurs should also share useful information on events sponsored by other organizations that they believe will be of interest to customers. A blog on the social media site could feature information not just on the creative entrepreneur's products. To be really useful, the blog could also give helpful hints on how to use products sold by other companies. In addition, creative entrepreneurs can share promotional offers from neighboring businesses that will be useful to the potential consumers. A short video tour of the local area including other stores and restaurants that customers might like to visit could be posted on the social networking site and then also uploaded onto a video-sharing platform.

Interact – click on me!

All of these photos, blog posts and video clips are created not only to attract the potential consumer but to get them to interact. The goal is for potential customers to not just find the sites but to read the posts and watch the video clips so that they become involved emotionally with the product. As a result, they will return to the site even if they have not yet purchased. This is why the site must be visually

appealing. In addition, the information cannot remain static. New photos, blog entries and video clips must be added so that there is always something new to click, view or read. Creative entrepreneurs can use analytics to determine what content is most successful in motivating action.

Add – comments, please!

Finally the goal of a social media strategy is to get consumers to add their own content. Potential customers believe the opinions of current customers much more than they believe what the producer of the product has to say. Customers can be encouraged to add comments by asking for answers to questions posed by the creative entrepreneur. In addition, customers could be asked to post their own photos or videos of themselves using the product in order to be entered in a contest. Even better is if users of the product post reviews online. Even if these reviews are on other sites, they can be linked to the creative entrepreneur's owned social media, blogged and tweeted. Positive reviews are critical, as potential consumers believe current customers more than they will believe the creative entrepreneur.

It can be difficult for a creative entrepreneur to keep the content updated and to respond to queries and comments on an ongoing basis as there will always be more demanding priorities. However, for the small creative business, social media is critical in gaining customers.

Questions to consider: How should my social media sites look so as to attract customers? How will I encourage customers to add their own content to my social media sites?

Sharing your brand on social media

A brand is more than just the words and symbol of a company. A brand is the story that embodies its mission, vision and values. But how do creative entrepreneurs communicate what their brand means? They can do so by telling stories like those listed below that illustrate their core philosophy in action.

Creative entrepreneurs: Why did they start the company? Why did they choose the product they produce? Who inspired them during their early struggles?

Company: Why did they choose the name? Why is it located where it is? What was it like in the beginning? What does the creative entrepreneur see the company doing in the future?

Product: How does this product embody the values of the creative entrepreneur? Where are the raw materials from? How does the packaging and distribution reflect the organization's unique mission?

Employees: Why do the employees choose to work for the company? What unique experiences or challenges have they encountered?

Customers: In what interesting ways has the product been used by customers? How are customers making the community a better place?

Just answering these questions provides interesting content that educates the public about the meaning of the brand.

Cohen 2013

Customer expectations of social media promotion

The expectations of customers should be taken into consideration when implementing a social media program. While each business is unique, and therefore the customers of each business will vary, there are still four guiding principles that apply to all organizations: full disclosure, authentic interactions, relevant information and response (Amos 2013).

Full disclosure – don't hide anything

Customers want full disclosure of who works in the company and who is doing the social media posting. In addition, potential customers want accurate information on the company's mission and values. Social media should never be used to develop a false brand for the company. If the creative entrepreneur is tempted to do so, it should be remembered that it only takes one person to notice the discrepancy and share the information with everyone, to destroy the business's credibility.

Authentic interactions – be yourself

It might be tempting to save time by having someone other than the creative entrepreneur write stories, blogs or tweets. While this might be acceptable for a large company, people expect authenticity from small businesses (Palter 2013). Potential customers should know the name and title of the company personnel who are posting online. If customers discover that postings are not the views and opinions of the creative entrepreneur, it will lead to a lack of trust and the loss of customers. Of course this is why social media is perfect for creative businesses, as it will most likely be the creative entrepreneurs who will be interested in doing the social media posting.

Relevance – make it useful

The information that is posted, tweeted or blogged must be relevant to current and potential customers. The information can be about the company so as to deepen the link with the customer. More importantly, information should be useful, such as how to do certain craft techniques. However, relevance means that the flow of

information is not just one way. When the creative entrepreneur blogs about a craft technique, customers should then be asked to also share their ideas.

Response – get back to them

Finally, social media is expected to provide a response to the customer. Not only will people post information about the product, they will also post what has gone wrong with a product that has been purchased. If one person communicates about a problem with the product, there are probably many more with the same issue. Customers expect that the company will join the conversation by providing information on how to correct or avoid problems.

Questions to consider: What style of writing will I use in my postings? What type of information would my customers find useful? How will I respond to customers with problems?

Social media and the purchase process

As explained in a previous chapter, the decision-making process is often described as need recognition, search for information, evaluation of alternatives, purchase and post-purchase assessment. While it has always been true that consumers do not always follow these steps in strict order, it was still a useful model for business owners to use when considering how to reach people through promotional communication. Now that people are using online technology as part of the purchase process, even when a product is purchased in a store, a simplified model has been proposed (Evans 2012). In this model the steps have been shortened to awareness, consideration and purchase.

Awareness – let them know it exists

Marketing has traditionally discussed product purchase as resulting from customers' needs and wants. However, at least in the economically developed world, most people have their basic needs already taken care of. The issue faced by creative entrepreneurs is that potential consumers are not able to want a creative product if they are not even aware of its existence. As a result, they cannot do an information search for a product that they do not know exists.

Therefore, it is the creative entrepreneur who will need to build awareness about the product using social media, rather than relying on the consumer searching for information. While traditional media can still be used to build awareness for a product, social media is ideally suited to build a wider awareness, as communication can be placed on sites other than the one owned by the creative entrepreneur. By responding to blog posts, customer reviews and photos on other sites, creative entrepreneurs can build awareness of their brand.

Consideration – tell them what they need to know

The consideration stage of the purchase process has also been heavily influenced by social media. In the past it was difficult for consumers to find information about a product except what was communicated by the company. Now there is an abundance of information that is easily assessable and also easily added to and shared.

Creative entrepreneurs must influence this consideration process by joining in the conversation. If they do not join the process by responding to negative information that may be posted, other people will control the conversation about the product. Silence on the part of the creative entrepreneur to negative comments will be taken as agreement to what is being said.

Purchase – doesn't matter how or from where

Of course the step of product purchase has been influenced by social media. The consumer no longer makes a distinction between on-site and online purchasing. They may view a product personally at an event or in a shop, but still decide to purchase online. Likewise, they may do all the research online but then travel to the shop to purchase in person.

Questions to consider: How can I use social media to build awareness of my product? How does my social media site make the purchase process easier?

Simple rules for social media success

Everyone thinks they know how to use social media. However, there are eight simple rules to remember, no matter what form of social media you are using.

1 It's not free: Social media posting takes time.
2 Listen, then talk: If you listen, you will hear people talking about your product and can respond.
3 Respond to everyone: No one wants their voice to be ignored.
4 Tell don't sell: Describe your product and company, and the right people will decide to buy.
5 Just be you: You are best at being you.
6 Advertise: Don't forget social media sites can be used for placing ads.
7 Give stuff away: Knowledge is free to give.
8 Be grateful: When people say good things about your company, thank them.

It's not about the technology but how the technology is used.

Fass 2013

Uses of social media

Social media is a low-cost method of reaching the target market segment for an organization that cannot afford to invest much money in traditional marketing media (Falls and Deckers 2012). Using social media, consumers can be both made aware of the product and motivated to purchase. However, social media can also be an inexpensive method for small businesses to conduct research and development, develop conversations about issues and create an online community.

Research and development – always ask why, what and how

In the past it was necessary to conduct formal research to gain information on customer's opinions about current products and their ideas for new products. While formal research is still necessary when companies are considering major changes requiring large expenditures, social media allows continual informal research. Creative entrepreneurs can gather information passively by reading postings and reviews. However, they can also ask current and potential customers about why they use the current product. In addition, customers are also an excellent source of information for what new products they may prefer. Besides asking for comments, the creative entrepreneur can also post a survey link that asks questions of how the product can be improved.

Conversational strategy – talk about issues

By having fans like the creative entrepreneur's page so that their friends see the link, like-minded people will be attracted to the creative entrepreneur's social media sites. However, once they are on the site, creative entrepreneurs must use posting on issues to start an ongoing conversation so that they return. Developing a conversation on social media sites begins with telling a story, rather than only asking questions (Sachs 2012). To be remembered, the story should link the creative entrepreneur's values with a social issue of concern to society. The public, which wants meaning and not just information, responds to brands that, while being something to buy, also provide something in which to believe.

For example, if the creative entrepreneur wants to start a conversation about customer privacy issues, a blog about a recent survey regarding the percentage of people who are concerned about the privacy of information could be posted. The creative entrepreneur would then discuss the relevance of the article to the company's own customer privacy policy. Finally, creative entrepreneurs would ask for feedback from customers on how their customer service could be improved.

If the creative entrepreneur is at a loss for words and can't think of anything to say about an issue, the method to get the conversation started is simply to ask the view of the social media site users. Once the question is asked and answered there should be sufficient content to keep the conversation going.

Creating a community – get everyone involved

One of the major advantages of using a social media strategy is the ability to create a community. Fans of any product or service have always discussed their likes and dislikes. However, in the past these discussions were out of the hearing of the company. Only if a customer directly spoke to the business owner was it likely that these opinions would be heard. Other than putting a telephone number on a product and hoping someone would call, there was no direct means of inviting comments. In addition, even if someone did call, the comments would only be about the company's existing products, rather than comments about ideas for new products. Now social media allows the creative entrepreneur to create and manage their own community where all ideas are welcomed. This community is a two-way relationship where the creative entrepreneur invites comments but then also provides information that is useful to the customer.

Social media sites are designed for exactly this type of consumer behavior. For example, information on performance events would include facts such as where to have dinner or drinks near the venue before or after the event. However, even better would be for the performers to ask fans where they would recommend dining or drinking, as people are eager to share their favorite places. Using this strategy does more than just give people a reason to post; it also gives the fans a chance to meet with each other before or after the event at the suggested venues. Community can further be developed if the performers stop by the suggested restaurant or bar to meet the fans in person.

Sharing creations: Community building can be accomplished by allowing customers to demonstrate how they create their own work. This will often lead to a better appreciation of the creative entrepreneur's skill as it is learned how difficult it can be to produce the product. However, just as everyone believes their own child is the most beautiful, everyone believes their own artwork worthy of being shared with others. This online sharing of the fans' creative work is a powerful means of building community.

Sharing the creative process is of interest even to those customers who do not wish to create their own work. To someone who has never struggled with the creative process, the resulting product may seem easy to produce. By viewing the customer-created work, others can feel that they too can become part of the creative process. This can also have a direct effect on sales, as, when the creative process is appreciated, there is a willingness to pay a higher price for the product.

Helping the community: Building community does not need to focus only on events and the creative process. The company's mission and values can also help build community. Creative entrepreneurs can suggest ways that customers can assist in social causes that are part of the company's mission. Rather than only focus on asking for donations for causes, the creative entrepreneur can ask fans how they would like to see the company assist the community. The company will then ask the fans to join them in the effort. For example, the creative entrepreneur can ask what issues affecting the community concern their customers. The customers may post on social media comments regarding the run-down condition of a local park.

The creative entrepreneur may then organize an event where together with customers the park is cleaned and flowers planted.

Questions to consider: Can I develop my own social media marketing strategy by encouraging the sharing of creative efforts? What events could I organize along with my customers that would help my community?

Social media quality

Information that is posted online, whether blogs, photos or videos, must be of the same quality level as the brand image that the creative entrepreneur has established. Of course, poor quality social media sites would negatively reflect on the product. However, a well-produced site does more than just look good. A quality site will increase trust in the organization, which will strengthen the customer's intention to purchase (Hajli 2014). While blog entries may be short, they still must be well written and free from errors. A quick note of apology for the errors because the creative entrepreneur is too busy does not make up for poor quality writing. The reader may wonder if the creative entrepreneur also takes short cuts when producing the artistic product.

Photos should also be of a quality in line with the brand image. The product photos need to be attractive while also showing the details of the product. If creative entrepreneurs lack the necessary skills, a professional should be hired to take the photos.

Video clips should also be posted with an eye to quality. However, the creative entrepreneur should also consider privacy issues if people other than the artist are in the videos. If the video is shot in a public place, it is acceptable to include people without asking permission. However, special care should be taken if children are shown. If a video is taken in a shop or studio, the people who are included should be asked for permission and then identified. This is not only professional behaviour, it is also good marketing as the friends and family members will click on the site to see the clip.

Creating an interaction calendar

Just as with personal relationships, online relationships must be maintained through ongoing communication. For some creative entrepreneurs this will be done naturally and spontaneously as they enjoy communicating and posting information. However, for many busy creative entrepreneurs it will take careful planning, especially if they do not have the time or inclination to be online. To ensure that social media content is updated on a regular basis, an interaction planning calendar should be created. The first purpose of the calendar is to ensure that something interesting is happening on the social media sites on a continuing basis. It is not necessary to have significant announcements each day, which may not even be possible for a small organization. However, at least once a week some interesting

story, blog, photo or video should be posted. Sharing small events, such as a posting with photos about the excitement caused by the arrival of a new order of raw materials, can be of interest to someone who does not work creatively. Passing on interesting stories told by customers along with their photos can make the members of the public feel more involved. Once the creative entrepreneur has formed the habit of regular posting, more ideas will occur.

Major events, such as opening nights or relocation of a storefront, should be handled differently. Once the date for the event is known, the creative entrepreneur works backwards in planning postings that will build up excitement. For example, plans for the opening night can be shared well in advance, but, as the date approaches, the frequency of the posts will increase. Store relocation can start with photos of the unoccupied space and then continue through the renovation process. By following the posts, the customers feel they cannot miss the grand opening.

If nothing of note is happening in the business, related content can be used as a posting. Therefore the creative entrepreneur must keep abreast of what is happening in both the creative community and also the wider world. First, when there are events that affect other artists, these can be posted and commented upon. Legal and ethical issues that the creative entrepreneur faces, such as difficulties in obtaining raw materials due to trade restrictions, can make for interesting posts. The fans of the site will then respond with their own comments. If world events affect the organization's customers, creative entrepreneurs should acknowledge and comment by either offering congratulations, such as for a sporting event win, or concern, such as when a natural disaster affects a community. Of course this should be done because the creative entrepreneur truly does care. Insincerity will be quickly spotted and can end the relationship.

Questions to consider: Do I have the skill to produce quality material? What will be my schedule for updating my social media content?

Summary

Rather than being referred to as traditional versus new, media is now categorized as paid, owned and earned. Paid, traditional forms of media, are combined with owned, the business's own social media sites, in the hopes of gaining earned media, which are mentions of the company and product on other sites. Traditional means of promotion such as advertising, personal selling, sales incentives and public relations are still used. What is new is that all of these methods are enhanced by the use of social media. Social media, whether done through social networking, video/ photo sharing, podcasting or blogging, is unique in that it allows two-way conversations. Social media programs need to first attract potential customers. Once they are on the site, they need to encourage them to interact by clicking on a link to view content. Finally, a successful social media program will encourage users to add their own content. Creative entrepreneurs should be aware that the public wants authentic interactions, relevant information and a response to postings. Social

media has resulted in a shortened customer purchase process of awareness, consideration and purchase. Besides selling a product, creative entrepreneurs can use social media to conduct research and development, start conversations and build communities. Once the social media is established, the creative entrepreneur needs to ensure that all content reflects the quality and image of the company. In addition, a calendar should be maintained so that the sites are continually updated.

References

Amos, James. *The Tasti D-Lite Way: Social Media Marketing Lessons for Building Loyalty and a Brand*, New York: McGraw-Hill, 2013.

Burcher, Nick. *Paid, Owned, Earned: Maximizing Marketing Returns in a Socially Connected World*, London: Kogan Page, 2012.

Cohen, Heidi. "Social Media: 35 Brand Attributes to Consider." *Heidi Cohen Actionable Marketing Guide*, January 17, 2013.

Evans, Dave. *Social Media Marketing: An Hour a Day*, Indianapolis, IN: John Wiley & Sons, Inc., 2012.

Falls, Jason and Erik Deckers. *No Bullshit Social Media: The All-Business, No-Hype Guide to Social Media Marketing*, Indianapolis, IN: Que, 2012.

Fass, Allison. "7 Simple Social-Media Moves That Work." *Inc.com*, April 25, 2013. www.inc.com/allison-fass/dave-kerpen-social-media-moves-that-work.html. Accessed August 24, 2014.

Hajli, M. Nick. "A Study of the Impact of Social Media on Consumers." *International Journal of Market Research* 56, no. 3 (July 2014): 387–404.

Handley, Lucy. "Promotional Pioneers Keep the Classics to Hand." *Marketing Week* 36, no. 1 (December 19, 2012): 25.

Harrah, Raquel. "Social Media Opens Doors for Young Entrepreneurs." *Profiles in Diversity Journal* 14 (2012): 18–20.

Leone, Chris. "Working the Web: Using Analytics to Transform Your Business." *Richmond Times Dispatch*, August 7, 2014. www.timesdispatch.com/business/learning-center/working-the-web-using-analytics-to-transform-your-business/article_0d6055b2-1d8c-11e4-bc30-0017a43b2370.html. Accessed August 8, 2014.

Liang, Ting-Peng, Yi-Ting Ho, Yu-Wen Li and Efraim Turban. "What Drives Social Commerce: The Role of Social Support and Relationship Quality." *International Journal of Electronic Commerce* 16, no. 2 (2011): 69–90.

Palter, Jay. "Never Hire Someone to Do Social Media For You." *Yahoo Small Business Advisor*, February 26, 2013. https://smallbusiness.yahoo.com/advisor/never-hire-someone-social-media-211000069.html. Accessed August 9, 2014.

Sachs, Jonah. *Winning the Story Wars: Why Those Who Tell – and Live – the Best Stories Will Rule the Future*, Boston, MA: Harvard Business Review Press, 2012.

Sen, Shahana and Dawn Lerman. "Why Are You Telling Me This? An Examination into Negative Consumer Reviews on the Web." *Journal of Interactive Marketing* 21, no. 4 (October 2007): 76–94.

Scott, David Meerman. *The New Rules of Marketing and PR: How to Use Social Media, Online Video, Mobile Applications, Blogs, News Releases, and Viral Marketing to Reach Buyers Directly*, Hoboken, NJ: John Wiley & Sons, 2013.

Tasks to complete

Answers to these questions will assist in completing the Promotion section of the business plan.

1 Integrating with traditional promotion

 a Provide one idea each for how advertising, public relations, sales incentives and personal selling can be integrated into your social media sites.

2 Social media use

 a Look at competing businesses' websites and find five postings of interest.
 b List ten subjects for blogging.
 c Research the options online and then choose appropriate photo- and video-sharing sites for your business.
 d What content could you use for podcasting?
 e Research online to find a payment system that could be used for online purchases.
 f Write a response to a customer complaint.

3 Logistics

 a Who will handle design and content on the sites?
 b How frequently will content be updated?

Visualization exercises

1 Design the look of your social networking site.
2 Use cartoon characters to write a conversation you hope your customers will have about your product.
3 Draw pictures of photo subjects that would be uploaded.
4 Sketch out a monthly timetable for posting.

Part 3

Growing your business to the next level

A business, just like a piece of art or music, can be as simple or as complex as you wish. Start small and stay small, or use your talent to take your business as far as you wish to go.

Chapter 10: Financial concepts for success
Chapter 11: Expanding the business
Chapter 12: Legal and management issues for growth

> You can never cross the ocean until you have the courage to lose sight of the shore.
>
> Christopher Columbus

10 Financial concepts for success

Introduction

Once the creative entrepreneur has produced a product and planned its pricing, distribution and promotion, the business is ready to start operations. However, there is still additional financial information that needs to be understood if the business is to prosper long term. Many of these are financial concepts such as understanding the reason for maintaining separate business and personal financial accounts. Without understanding the distinction between liabilities and assets it will be difficult to keep the business solvent. Even if the business accounts are handled by software or an accountant, an understanding of cash versus accrual accounting is helpful. Every creative entrepreneur needs to be able to read basic financial statements so that they understand the current financial position of the organization. Finally, additional sources of funding and the necessary types of insurance coverage will help the new company protect itself as it grows.

What creatives have to say: Mariko Tanaka

Mariko and fellow artist Isabel Lezcano started their multidisciplinary studio in 2013. They handcraft all of their designs including textiles, 3D paper models, candles and ceramics. Their designs are clean, modern and functional. They started selling through art fairs but then expanded and now distribute through their own website, Etsy and pop-up stores. Mariko has this advice to share with other creatives:

1 Be nimble and flexible: Have a plan but be ready to change as the marketplace changes and presents new opportunities.
2 Don't be shy: Reach out to other creatives for networking and advice. They may be using resources that may help you. Don't forget that there are also government resources you can use.
3 Set actionable goals: Tackle the big picture by setting bite-sized tasks. Give yourself daily or weekly markers so you can track success.

You can see Mariko's work at www.rabbitanddragon.com.

Business finances

Once the business is established, separating the creative entrepreneur's business financial transactions from personal finance becomes imperative. Creative entrepreneurs may see the production of the product as integral to their identity. However, to manage the business it is critical that the creative entrepreneur now make a distinction between their professional and personal finances.

Bank accounts – each in its own place

One of the tasks that the creative entrepreneur faces is to separate personal expenses from professional expenses. This is not a problem for most business people as there is a clear distinction between what is purchased for the business and what is purchased to be used personally. With creative individuals there is not such a clear distinction, as producing creative objects is part of their everyday life.

To maintain the separation of finances the entrepreneur should have different checking and savings accounts for business and personal use. The entrepreneur needs to know what is being purchased for the business so that the expenses of producing a product can be compared to the revenue received from selling a product. Creative entrepreneurs may decide to stay in business even though there is no immediate profit, but they should not fool themselves into believing the business is making a profit when it is not. The second reason for maintaining separate accounts is that business expenses may be tax deductible. Taxes must be paid on the profit earned by the business. However, profit is the business's revenue less the business's expenses, so taxes will be lower if all business expenses are tracked and subtracted from revenue.

Banking services – it's about more than money

Banking can be done at a physical bank location or a bank that is only online. Because of the ease of banking online it may be that a person never needs to enter into a bank. However, there is a reason for creative entrepreneurs to maintain a relationship with a local banker. A personal relationship with a business advisor at a community bank can provide the entrepreneur with expert advice on how to handle financial issues. In addition, community banks are now offering mobile banking applications that can help with keeping track of finances that were previously only offered by large banks (Wisniewski 2014). These mobile applications give creative entrepreneurs the ability to conveniently track expenses by category, send invoices and make payments.

The bank where the checking and savings accounts are held may also provide other software tools for categorizing and tracking expenses to help prepare financial statements. If they do not, they can suggest a commercially available software program that can be used. These programs will even help with budgeting, as they categorize business expenses as to type, such as materials or labor costs, and place the totals spent on the proper budget line. These tools will also help with tax preparation, although the advice of a tax professional may still be needed.

A bank-issued business credit card can also be useful in tracking business expenses. Of course, credit needs to be used carefully, as most credit cards carry high interest rates and fees. However, the advantage is that a detailed statement is available at the end of each month that can help with analyzing expenses to determine where money was spent.

Processing payments – the money has to get to you somehow

It is expected that by 2017 over three-fourths of all sales transactions will be by credit or debit card rather than cash (CommerceGate Online Payment Processing 2013). Since consumers have become accustomed to paying for most purchases with a card, creative entrepreneurs will need a means of accepting electronic payments. Large retail operations will use a bank or other financial institution that handles merchant account services and will handle all the issues involved in payments. The financial institution will provide the equipment needed to accept payments. After the sale is rung on a cash register and the credit card is swiped, the bank will send the payment request to the credit card company. When payments are received from the credit card company, they will be held in a merchant account before being transferred to the creative entrepreneur's bank account. There are numerous fees for equipment and statements and also a fee that is both a fixed amount and a percentage for each sale processed. The ability to do mobile credit card processing also can be added for an additional fee.

There are also payment service providers that only process online credit card transactions without using a merchant account. Instead, once the sale is processed, the amount of the sale, less fees, is deposited directly into the creative entrepreneur's bank account. These service providers work with mobile card readers that turn any smartphone into a terminal. Mobile credit card processing services have lower setup and monthly fees but do charge higher transaction fees for each sale.

The choice of service provider will depend on the number of transactions and the necessity for the mobile payment option. Creative entrepreneurs should research the possible companies and their fees. Just like any other product, there are customer reviews online that can assist with the choice.

Questions to consider: What bank will I use to handle my business accounts? How will I process credit card payments?

Research before you sign

Almost all creative entrepreneurs will need to process credit card payments, such as Visa and MasterCard. These companies do not process payments directly but instead work through merchant accounts at banks, which are called third-party processors. There are a wide variety of ways that creative entrepreneurs can connect with the credit card companies, all of which cost fees. Here are five issues to research:

1 Termination fee: Make sure it is a set amount and not a vague fee to be calculated at the time of discontinuation of services.

2 Shopping cart: Make sure the service provider understands the type of ecommerce you use, so that the systems are compatible.

3 Interchange-plus pricing: You will pay two charges when a customer uses a card: one to the credit card company and one to the merchant account service company. Make sure that each charge is listed. Some credit cards may be too expensive to accept.

4 Other fees: Be sure you understand how much you will be charged for monthly/annual fees, regulatory/compliance fees and statement fees. Once you have a total, then compare.

5 Customer service: What happens when a card's charges won't go through? Make sure there is 24/7 customer service support ready to answer any questions. You can't afford to lose a sale because the card can't be processed.

It is worth the time to research the possibilities, as the wrong choice will mean expenses are higher and profits are lower.

Clifford 2012

Personal finances

Once the business starts making a profit by covering all business expenses with revenue, the next issue to be faced is how much money should be taken out of the business to use for the creative entrepreneur's living expenses. Rather than just removing money randomly whenever it is needed, creative entrepreneurs should pay themselves a salary. This salary is then transferred each month to the business owner's personal account to cover personal expenses. These personal expenses are not tax deductible and so must be tracked separately. It is not unusual for it to take several months or even longer before a business is profitable enough to both cover business expenses and provide an adequate living. This is why many creative entrepreneurs need other sources of income. Having another source of income can be an advantage as creative entrepreneurs then have the freedom to produce products that may not have a strong market appeal (MacLeod 2009). The creative entrepreneur will need to make a decision as to whether the salary from another job will be used to cover only personal expenses or also to cover any financial loss incurred by the business.

As the business grows it may provide even more profit than is needed to cover the living expenses of the business owner. The creative entrepreneur is then faced with the decision of how to invest the money. It may be tempting for the owner to simply give themselves a raise. However, another option is to invest back into the business by purchasing inventory or equipment, or making expansion plans

(Steinkirchner 2012). The creative entrepreneur should also consider simply saving the excess profit. These savings may keep the business alive when sales are slow. If the money will not be needed for a while, the owner may choose to place the money in a savings instrument that pays more interest than a standard bank savings account. Another option is to pay down debt, which not only cuts monthly expenses but saves on interest payments.

Creative entrepreneurs can easily understand that they are responsible for the business's financial condition. They also understand that the financial condition of the business will affect their ability to get credit or loans. They may not know that the condition of their personal finances will also affect the business's ability to obtain financing, buy supplies on credit or find a service provider willing to process credit card payments.

Net worth – how much are you worth?

If a small business needs financing, any lender will want to know about the net worth not just of the business but also of the creative entrepreneur. The lender will believe that the way in which potential borrowers handle their own finances will be the way that they will handle the finances of the business. Therefore, creative entrepreneurs will be asked to provide a statement of their own financial worth that includes a list of assets broken down into cash, savings and physical assets. These assets will be balanced against the potential borrower's liabilities, which could be mortgages, credit card debts or student loans. The total liabilities are subtracted from financial assets to give the creative entrepreneur's net worth, which is hopefully a positive number.

Credit score – they know if you've been bad or good

Every individual has a credit score which is provided by credit rating agencies. These credit rating agencies track information about the use of any and all types of credit. Based on an individual's debt load, income and payment history, the agency will give a score that represents the person's creditworthiness. This score will then be provided to a bank or a company that is considering offering credit. Landlords and suppliers will also check credit ratings before signing a lease or contract.

Poor credit scores can result from late payments on any type of mortgage or loan. Even only being 30 days late will be recorded and reported. Poor credit scores can also result from having too high a debt load, even if payments are being promptly made. This is due to a concern that, if the borrower encounters any future financial problems, the monthly debt payments will not be able to be paid. Of course, if an individual has stopped making payments and defaulted on a loan, their score will be significantly lower as there would be concern that any new loan might also be defaulted upon. One final issue that might be a reason for a low score is if there is no credit history. If creative entrepreneurs have no credit history, the risk of default is unknown and, therefore, the agency cannot verify creditworthiness.

If creative entrepreneurs are considering getting a loan or signing any kind of financial contract they should investigate their own credit rating report for two reasons. First, to ensure that there are no errors that must be corrected. Second, so that they can improve their credit rating if needed. If the creative entrepreneur has a poor credit rating it will affect their ability to get any future funding. It will even affect their ability to get credit from suppliers and, as a result, they will be required to pay cash. Correcting a poor credit score will take time, but is simply a process of starting to make all payments in a timely fashion. After a period of time the poor payment history will recede. If the poor credit score is due to lack of credit history, creative entrepreneurs need to apply for credit, even if they could pay cash, so that they can make payments to establish a credit record of making payments.

Creative entrepreneurs may believe that focusing on the mundane aspects of financial management will dampen their creative ability. Even worse, some believe that, if they become financially secure, they will no longer be willing to take artistic risks. However, what is sometimes termed the innate precariousness of the artist's existence is not what leads to creativity (Vivant 2013). In fact, the opposite argument can be made, that freedom from financial worries allows the artist to focus on creative work.

Questions to consider: How much money do I need to take from the business each month for personal expenses? What do I estimate as my net worth and credit score?

How much is an artist worth per hour?

One of the most difficult issues facing the creative entrepreneur is how to value their time. The concept of subtracting the cost of raw materials used to produce the product from the sales price to calculate gross profit is easy to understand. But what if there are two products that cost the same to produce, but one product takes one hour of creative work and the other ten hours. The two products obviously should not have the same price. However, if artists don't track their time, this fact will not be taken into consideration when pricing.

One artist wanted to know if craft fairs, where she sold many inexpensive items, were worth her time or if she should stay in the studio and concentrate on producing fewer, but higher priced, items. When she calculated all the time it took to prepare for the fair, such as sending out emails, packing items for transportation, setting up the booth and taking it down, time sitting in the booth with no sales, and transportation time, she concluded that she would have been better off financially if she had stayed at home and focused her energy on a more profitable use of her time.

Rhee 2011

Accounting methods

When tracking revenue and expenses, accounting requires that the time period of when expenses are recorded correspond with the time period when money was earned from this expense. After all, the business is always interested in understanding the relationship between money spent to produce a product and the revenue received from a product. If the expenses are not recorded during the same time period when the sale is made, this relationship will not be clear. For example, a sculptor who works in metal might need to buy a large order of steel because of a commission received for new work. If the purchase of the material is recorded at the end of the budget year but the revenue is recorded at the beginning of the next, there will be no way to know why the business lost money in one year and made a big profit the next. This is the role of accounting, which is different from just keeping track of financial transactions. There are two methods of accounting for revenue and expenses, which are cash and accrual. If creative entrepreneurs have very small businesses with no accounts receivable or long-term liabilities, cash accounting will meet their needs. However, accountants will use accrual accounting.

In the past, if a creative entrepreneur wanted to do their own accounting, the only option was to purchase a sophisticated software package. However, thanks to the ability of software to now exist in the cloud, there are software choices that can be tailored to fit the exact needs of a business and then expand as the company grows (Traylor 2013). This keeps the cost low for a startup business. For a small business, software can be very simple as it only needs to track bills and send invoices. As the business grows, other functions can be added that handle everything from ecommerce to payroll.

Accounting methods

- Cash: Most common in small businesses; cash is accounted for when it is received.
- Accrual: Transactions are accounted for when they occur, not when cash is received.

Cash accounting – you can do this

Cash accounting records money as it is received from any sales, and all expenses are recorded as money is paid out. This system works fine for small businesses where customers pay at the time of purchase. In addition, this method works when the creative entrepreneur also pays immediately when supplies are purchased and other monthly bills are due. However, if major equipment or large amounts of supplies are purchased on credit so that payments are made by installment, or if customers are offered credit and make installment payments on their purchases, then the cash method is inappropriate.

Accrual accounting – let your accountant do this

If a business sells high-priced items, they may allow customers to buy on account. Customers may pay a percentage down and then make payments until the full amount is paid. In addition, the business may purchase equipment for which it will make payments over a long period of time. If cash accounting is used, the books will not accurately reflect how the business operates. Therefore accrual accounting adds another level of complexity by including accounts payable for money that is owed and accounts receivable for payments that are due to the business. Finally, depreciation needs to be calculated and recorded.

Question to consider: What software do I need to keep track of financial information?

Assets and liabilities

In order to understand the financial status of the business it is necessary to establish some system for keeping track of more than how much money is going out and coming in. In addition, it is necessary to track the source of the revenue and the reason for the expenses. By doing so less time is spent on worrying about money, freeing more time to be creative. Keeping track of finances does not ensure that there will be money to make payments, but it does mean that no time will be wasted on worry if the money is there. Likewise, if the money is not available it is better to know ahead of time, rather than when the bill is due. If it is known that there will not be enough cash, action can be taken, even if this means selling an asset, to raise cash.

Owned and owed

- Current assets: cash and other items of value that can be quickly turned into cash.
- Long-term assets: items of value that will be kept in the business for at least a year.
- Current liabilities: bills that must be paid off within a year, most common for small business.
- Long-term liabilities: bills that will take more than a year to pay, usually for major equipment and buildings.

Assets – what you own

The finances of the business can be divided between assets and liabilities. Assets are what the business owns that are cash or could be easily sold for cash. Assets are necessary for a business to operate, as cash is needed to pay for daily and monthly expenses. Besides cash, the business may also own assets in the form of equipment that is used for production of the product. Raw materials used to produce the

product are also assets, along with larger assets such as an automobile, truck or van. All of these assets can be funded in only two ways. The first is the money that the owner puts into the business, which is invested capital. This money might be from the owner's own savings, loans from family or friends, or a loan from a bank. The second source of assets is revenue that comes from selling the product. Unlike a nonprofit organization, there is no category of contributions. People do not contribute to a business, they buy its product.

Assets are divided into two categories; current and long term. This is a critical distinction as it helps to understand how the business operates. There must be current assets, defined as those that are either cash or can be turned into cash quickly, to pay upcoming bills. Long-term assets such as inventory and equipment are needed for the business to operate. If a business must sell assets used to produce the product to pay the utility bill, the business is in serious danger of becoming bankrupt and ceasing to exist. Not all new businesses will have every kind of asset. Yet, it is useful to understand what types of assets exist, so that the creative entrepreneur can start thinking about what assets are needed and how they will be funded. While the entrepreneur already has the creative talent, the assets are needed to turn talent into a product that can be sold.

Current assets: Besides cash, current assets include checking and savings accounts, money owed as receivables, raw materials and finished inventory. While items such as cash, and checking and saving accounts, are easy to understand as assets, the other items are also part of the value of the business. For example, if a customer has purchased a product and has not yet paid, this is an account receivable. Even if the money is not yet in the account, there is still value in the promise to pay that should be recorded. This is particularly true if the business is selling high-priced items. Of course the entrepreneur might be thinking that they would surely remember someone who owes them a lot of money. However, if the business owner needs to prove that they are a successful business to a banker or other investor, they need to have these transactions recorded.

Inventory is another valuable asset that is owned by the business. This could be inventory of raw materials that will be used in production of the product. Of course, there is no plan to sell the raw material inventory as it is needed to produce the product, but it is still a valuable asset. Work in progress and completed products are another valuable asset that the business owns. Taking into consideration all of these assets gives a quick picture of the value of the business.

Long-term assets: Long-term assets are ones that will be kept in the business for at least a year. Most small businesses will not have many long-term assets as they are usually expensive to purchase. However, creative entrepreneurs may be creating a product that uses production equipment such as a kiln, lathe or welder. Creative entrepreneurs who give performances may have lighting or sound systems which are classified as long-term assets. If the creative business owns its own building, store or vehicle, these are also long-term assets. Long-term assets need to be depreciated, which is an accounting term that simply recognizes that an asset such as a truck purchased for the business becomes less valuable over time.

Liabilities – what you owe

Liabilities, bills that must be paid, are also classified as either current or long term. Since the startup business usually is run on a cash basis there are few long-term liabilities, which would include loan payments or payments for major equipment. Current liabilities are bills that need to be paid within the coming year. These current liabilities include money owed for supplies, utilities and lease payments. Other current liabilities include the immediate bills due for payments on long-term liabilities.

Accounts payable record money owed by the business to other companies for the expenses necessary in running a business, such as supplies or raw materials. When creative entrepreneurs purchase products for their businesses they will have an account with the supplier who will then bill at the end of the month. The bill that has not yet been paid is a current liability.

Creative entrepreneurs must realize that they may have to collect and pay sales or value added taxes on any product sold. Many federal, state and even local governments have such a tax, which is a legal obligation of the purchaser of a product to pay a tax based on a percentage of the product price. However, the purchaser does not pay this percentage directly to the government. Instead, the percentage is added to the purchase price by the business owner who collects the amount. The business has a legal obligation to then transmit this money to the government on a monthly basis.

If the business makes a profit, another current liability owed would be income tax, which may be due quarterly, at the end of the year or both. In addition, there may be local business (mercantile) taxes due. If the business has employees, the pay that they are owed is also a current liability. Long-term liabilities are money owed that will take more than a year to pay off. These are usually loans or purchases of major equipment or buildings.

Question to consider: What assets and liabilities is it likely my business will have?

Financial statements

It is probably safe to say that very few creative entrepreneurs desire to become their own accountants. However, understanding how to read financial statements is necessary as they provide at a glance a complete picture of the financial health of a company. They are the equivalent of a medical x-ray. While meaningless to those who don't understand what they are seeing, financial statements provide vital information on the health of a business.

Each of the three financial statements, income statement, balance sheet and cash flow, have a distinct purpose. An income statement tracks the revenue and expenses of a company over a specified period of time. The balance sheet is a look at a specific moment in time that shows the business's assets versus its liabilities.

Lastly, a cash flow statement confirms if the business will have enough cash available to pay the bills.

The information for compiling these statements comes from the records of revenue and expense transactions that a business maintains. Analyzing financial statements may not be a favorite activity of the creative entrepreneur, but reading and understanding financial statements becomes easier over time. Even when financial statements are prepared by someone else, it is still essential that they be understood, as they will be used to prepare tax forms, and the creative entrepreneur will be held legally responsible for their contents.

Financial statements

- Income statement: tracks revenue and expenses over a period of time to show profit or loss.
- Balance sheet: photo of the business at a single point of time showing assets, liabilities and owner's equity.
- Cash flow: tracks cash coming into the business from any source and going out for any reason.

Income statement – how much are you making?

The income statement includes both the business's revenue and its expenses and how they change over a specific period of time. This information is needed for planning purposes as it is essential that over the long term revenue exceeds expenses. If not, the business will not be able to pay the bills and will need to close. The major components of the income statement are revenue, cost of goods sold, gross profit, operating expenses and net profit.

Revenue: Revenue includes all the sources of incoming funds that result from the sale of a product. If the business has more than one source of revenue, such as more than one type of product or a product along with other services, each source of revenue should be accounted for separately. Only by doing so will the creative entrepreneur learn what products produce the most revenue.

Income statements are usually divided by month, so each month will have a separate revenue figure. Therefore the business will know the months that produced revenue and the months when there was a loss. These figures are then compared with the budgeted revenue goals.

Revenue is income produced by sale of a product and should not be confused with other funds that are put into the business. For example, if the creative entrepreneur needs to use personal funds to pay business expenses during a period of time when revenue is low, this should be accounted for separately and not listed as revenue from sales.

Cost of goods sold: This is often a difficult component for creative entrepreneurs to calculate. If the business is producing a product, then the cost of goods sold is the price that needed to be paid for the necessary raw materials. It also includes the

cost of packaging the product, including gift boxes and labeling. Shipping costs are not included, as they are considered a cost of doing business or operations.

Cost of goods sold does not include an accounting of the personal hours of work that the creative entrepreneur spent producing the product. While the time that must be allocated to producing a product is critical to pricing the product, the value of the personal time of the business owner is not subtracted as a cost of goods sold. Creative entrepreneurs are "paid" for their time by retaining the profit of the business. However, employee wages would be included.

Gross profit: When all types of revenue are added together and then the cost of goods sold is subtracted, the remaining amount is the business's gross profit. Gross profit tells the creative entrepreneur if the revenue received from sales at least covers the cost of producing the product. If gross profit is negative, either the price of the product must be raised or the cost of materials and labor used to produce the product must be reduced, or both.

Operating expenses: Both businesses that produce a tangible good and businesses that produce a service have operating expenses, including rent or lease payments, utility payments, marketing costs, insurance, travel expenses and general office supplies, which are necessary to keep it in operation. These must be tracked carefully on a monthly basis and then compared to the budgeted amount. Many businesses that produce revenue still fail. They fail not because of a lack of customers, or because their cost of goods sold is too high, but because they did not control operating expenses. The higher the operating expenses, the more products that must be sold in order to remain in business. Businesses that sell services may have a very small cost of goods sold but will still have operating expenses that they must control.

Net profit: This is the number that tells the creative entrepreneur whether the business is viable. However, for a small business, simply having a profit is not enough. There must be sufficient profit to support the creative entrepreneur and, if necessary, the family. This is the reason that some creative entrepreneurs will also have a second job that provides a paycheck while they build the business.

Balance sheet – do you owe more than you own?

The balance sheet is a picture of the financial standing of the business in one moment in time. It shows what the business owns (assets) and what the business owes (liabilities). By comparing one with the other, it can be determined if the firm has enough financial resources to stay in business. This is no different from looking at an individual's assets, such as cash, savings and possessions, and comparing the total with what the individual owes on loans, mortgage and credit cards. The balance sheet components are current assets, such as cash, accounts receivable and inventory, and fixed assets, such as trucks and equipment. There are other categories of fixed assets such as buildings and land, but it is assumed that a small startup creative business will not be in the position to own these.

Cash: It easy to understand that it is necessary to track how much cash the business has. This would include the small amount of cash that might be kept on the business site and any business bank accounts, both savings and checking.

Accounts receivable: While it is understandable that cash is an asset, so are accounts receivable, as this is money that the business has earned, but not yet received. Many creative entrepreneurs run their business on a cash basis, where payment is due when the product is purchased. However, if entrepreneurs are producing expensive products, they may allow the customer to make payments over time. The usual arrangement is to ask for a down payment and then have a written agreement specifying when the remaining payment is due. Even though the money has not been received, the money owed is still considered an asset and listed under accounts receivable.

Inventory: Some businesses might only make products to order and not carry an inventory of completed products. However, most businesses have products that have been produced but not yet sold. Because these products have a monetary value, they are considered an asset to the business. Raw materials used in production are also of value and therefore part of inventory.

Fixed assets: In this section of the business plan are any production equipment, buildings or vehicles. Because fixed assets are expensive to purchase, most small creative entrepreneurs may have few to list. However, if a business does own a fixed asset, such as a vehicle, they must subtract the accumulated depreciation from the value. However, if the business is a sole proprietorship, all vehicles may be in the owner's name and will not be listed on the balance sheet.

Liabilities: A small business will hopefully have limited liabilities since they most likely will be using cash-based accounting, where bills are paid at the end of the month. However, any bills that the business owes, such as the balance on a loan payment or a mortgage, would be considered liabilities.

Owner's equity: The purpose of a balance sheet is to balance the assets with the liabilities. If the business has more assets than liabilities, the difference will be shown as owner's equity. This money can be retained in a business account or withdrawn by the owner for personal use.

If, when the balance sheet is constructed, there are more liabilities than assets, the owner must invest more of their own money into the business or find another source of funds. These funds will then be recorded as cash, so that the account will balance.

Cash flow statement – can you pay the bills?

Probably the most useful statement is cash flow. Its only purpose is to record exactly what cash has been received and what cash has been paid out. Bills need to be paid every month, while income may come seasonally or sporadically. Careful attention to cash flow is imperative because, if a business does not have enough cash to pay its bills, it will become bankrupt and have to close. Not having enough cash does not mean the business did not have customers or sales. Even with revenue, the business may still have a negative cash flow if the outgoing expenses are higher than the incoming cash. This unfortunate fate is not uncommon. The business could have prospered if more attention had been paid to conserving cash whenever possible. Again, this is no different from the situation that everyone faces

in their own personal lives. People can have a paycheck coming in, but, if they overspend, they will soon face the fact that they cannot pay all their bills.

Question to consider: Can I give a reason, using my own business as an example, for the existence of the three financial statements?

Sources of funding for growth

Once a business is established, there still may be a need for additional revenue to fund expansion. A new opportunity may require producing more products, opening a location in another area or hiring additional personnel. The most widely used sources of money to fund these expansion efforts are bank loans and, if the business has potential for strong growth, investment funds.

Bank loans: To obtain a traditional bank loan, a business must demonstrate that it has a track record of producing not only revenue, but a profit. The bank would also want proof that there is a definite opportunity for obtaining more revenue and that the funds will be used to obtain the materials, real estate or equipment necessary to do so. They will not provide funds simply because the business cannot cover its expenses. When preparing a proposal for a bank loan the advice of a commercial lender at a bank should be sought and followed.

Loans can be considered short term, intermediate or long term. Short-term loans are for one to two years and are usually called lines of credit. Most businesses go through periods of time when cash flow is a problem. For example, they may need to purchase raw materials before they are going to be paid by a customer for a large order. With a line of credit, money is borrowed and is then paid back when the business receives funds. This is an excellent arrangement for a small creative entrepreneur, especially if sales are seasonal. The line of credit is usually given for one year and then can be renewed.

Intermediate loans are for longer periods of time, usually for up to five years, and are used for larger projects such as expansion into a new product line. While the loan will be for a specific amount, the funds will only be released as they are needed for the project. Long-term loans are for major expenses, such as the purchase of a building, where it will take years to repay the investment.

Investors: Investment funding is used when traditional bank loans are not available. A bank may view the new opportunity as too risky or that the amount of money that is requested will not be backed by sufficient collateral. The investors are willing to put up the funding for future growth in exchange for part-ownership, or equity, in the company. This entitles them to a share of the future revenue of the company. If the company is successful, they will have a stream of revenue far in excess of the interest that would be received from a loan.

Question to consider: How would I convince someone to loan me money?

Insurance necessities

Another issue that is relevant to the long-term viability of a company is the necessity of purchasing insurance. With any startup, cash is tight, and therefore creative entrepreneurs may be tempted to put off getting insurance, but it is as necessary as any other startup expense. The types of insurance needed include auto, property and liability.

While insurance rates can be found online, there may be value in speaking with an insurance agent, who works with a specific company, or a broker, who sells insurance from more than one company. A small survey of small business owners found that the level of advice they received was as important as price in deciding which insurance company to use (Mazzuca Toops 2013). Agents and brokers can provide advice on the type of insurance and the level of coverage that is needed.

Auto – more risk, more cost

Commercial vehicle insurance is needed if the vehicle is used to transport goods. This might be for finished products being brought to a retail outlet or delivering goods to a local postal or shipping outlet. Commercial vehicle insurance is also needed if business customers or employees are transported. The payment for the insurance is then a business expense that can be deducted against revenue on taxes.

Even if a vehicle is used primarily for personal use and only occasionally for business purposes, the insurance carrier must be notified, as this will affect the rate that is charged. If this is not done, and there is an accident or other loss while using the vehicle for business purposes, the coverage may be void.

Personal auto insurance policies are written with a risk level associated with a daily commute and personal trips. Because there are fewer miles being driven, the risk is lower and therefore the cost is lower. Commercial vehicle insurance costs more not only because there may be more miles being driven, but also because the insurance must cover the cost of damage to any product or equipment that is being carried if there is an accident or loss.

Property – if it can be destroyed, it needs to be insured

The business will also need property insurance to cover the usual risks from fire, theft and vandalism. Most business property insurance covers any physical damage to the business from natural disasters, but even then the insurance policy might specifically exclude some risks, such as flood, hurricane or tornado, if these events are common where the creative entrepreneur lives. To purchase insurance, the creative entrepreneur will need to supply a list of assets so that the policy can be written for the correct amount. The amount of potential loss will be the determining factor in setting the policy cost. However, the creative entrepreneur can

keep the cost down by having a higher deductible, which is the amount of the loss that will not be covered by an insurance payment (known as an excess in the UK). Of course, creative entrepreneurs should be certain that, if there is a loss, they have the funds available to cover the deductible.

Liability – yes, they will sue you

Creative entrepreneurs need to be aware of the risk that is associated when an accident takes place. Of course, it may seem obvious that someone who is visiting the business and is accidentally injured through a fall may file a claim against the business to cover the cost of any medical needs and even additional money to cover pain and suffering. However, a claim can also result from someone who is injured when using a product. In addition, an employee may sue, claiming that the entrepreneur's negligence led to an injury. Rather than assume that this could never happen, creative entrepreneurs need liability insurance to cover claims. A single claim can be high enough to shut a business.

Questions to consider: What types of insurance should I purchase?

Summary

In business, numbers are often used instead of words to tell a story. Numbers express the bottom line of whether the business is financially viable. The numbers don't care if the business owner is enjoying interacting with potential customers or if the business is an opportunity for the owner to express creativity. Both enjoyment and creativity are important, but only the numbers show if the business has made a profit, which is critical if the bills are going to get paid. Therefore creative entrepreneurs must understand the importance of separating business and personal finances. The distinction between assets and liabilities is the basis of gauging the solvency of a business. Even though they may not prepare the statements, the ability to read an income statement, balance sheet and cash flow statement will ensure that the creative entrepreneur understands the financial health of the business. Additional funding from banks or investors may be needed for further expansion of the company. Finally, having adequate insurance protects the company from financial disasters.

References

Clifford, Catherine. "5 Questions You Must Ask Your Credit Card Processor." *Entrepreneur*, June 4, 2012. www.entrepreneur.com/article/223696. Accessed August 25, 2014.
CommerceGate Online Payment Processing. "Credit Cards Overturn Trend of Losing Ground to Debit Cards." November 12, 2013. www.commercegate.com/credit-cards-overturn-trend-of-losing-ground-to-debit-cards. Accessed August 21, 2014.
MacLeod, Hugh. *Ignore Everybody: And 39 Other Keys to Creativity*, New York: Portfolio, 2009.

Mazzuca Toops, Laura. "What Drives Small Business Insurance Purchases?" *Property & Casualty 360* 117, no. 12 (December 2013): 34.

Rhee, Mea. "The Hourly Earnings Project: A Working Potter Spends a Year with a Stop-watch." *Ceramic Arts Daily*, June 1, 2011. http://ceramicartsdaily.org/ceramic-art-and-artists/open-studios/the-hourly-earnings-project. Accessed March 19, 2014.

Steinkirchner, Sunday. "3 Smart Ways To Reinvest In Your Company (Without Adding To Your Expenses)." *Forbes*, October 25, 2012. www.forbes.com/sites/sundaysteinkirchner/2012/10/25/3-smart-ways-to-reinvest-in-your-company-without-adding-to-your-expenses. Accessed August 12, 2014.

Traylor, Polly S. "Accounting Apps for Your Number-Crunching Needs." *Entrepreneur*, May 10, 2013. www.entrepreneur.com/article/226577. Accessed August 10, 2014.

Vivant, Elsa. "Creatives in the City: Urban Contradictions of the Creative City." *City, Culture and Society* 4, no. 2 (2013): 57–63.

Wisniewski, Mary. "Community Banks Roll Out Digital Tools for Small Businesses." *American Banker RSS*, April 28, 2014.

Tasks to complete

Answers to these questions will assist in completing the Finance section of the business plan.

1 Banking

 a Find the name of a bank that you could use for business accounts.

 b Research online three companies that would process your credit card payments.

2 Personal finance

 a How much money do you spend each month right now? How much would you like to spend?

 b What is your plan for improving your credit score?

3 Business finance

 a Find samples of the three financial statements online and interpret each for the business's story.

 b Look on two bank websites to read the application process for business loans.

 c List your assets and estimate their worth.

 d Look up insurance rates on policies you will need.

Visualization exercises

1 Draw a pie chart with the slices representing your spending in terms of percentages.

2 Draw pictures of your assets and liabilities.

3 Draw bad things that could happen where insurance would help.

11 Expanding the business

Introduction

As a business grows, issues of how to distribute the product become more complex. At first the creative entrepreneur may sell to an existing base of customers who were already familiar with the product. The creative entrepreneur may then decide to sell at craft or art fairs. Over time, as business grows, the decision arises of how to expand the product's distribution to new target market segments. Part of this decision will be to decide what new distribution intermediaries to use. Creative entrepreneurs may want to distribute their products in a retail store but are unable to find a retailer that is willing to purchase. In this case the creative entrepreneur might decide to use consignment sales. It may be that the creative entrepreneur wishes to have a storefront for distribution but cannot do so alone because of the costs or a lack of the necessary skills. Forming or joining a cooperative store is then a possibility. In addition, some creative entrepreneurs may wonder if becoming a nonprofit will allow them to distribute their product and service to those most in need.

The creative entrepreneur may also wish to consider how a city's economic development plans could be useful in growing a business. Cities and towns understand that creative industries can not only revitalize economically depressed areas, but they can also attract new businesses and residents. As a result they offer benefits including mentoring and rent reduction to creative businesses to locate in their area. Some communities even have grant programs specifically aimed at creatives who wish to open a business. These grant competitions often require that a business plan be submitted.

What creatives have to say: Amanda Horn Gunderson and Bill Ciabattri

Amanda and Bill are teaching the next generation of musicians at Lycoming College, a liberal arts college in the United States. Besides being a professor of piano and teaching privately, Amanda also performs as a soloist and has toured with Duo Menota, a group that she formed. Bill is the Director of Instrumental Ensembles at Lycoming and also a busy professional musician.

He performs with many professional ensembles, both as a tuba player and a bass trombonist. He is also active as a conductor of both bands and orchestras. They wish that their students also understood:

1 Graduating from conservatory does not guarantee you a job. This is truer now than ever!
2 Understanding only the technical aspects of the music business, such as recording, performing and negotiating contracts, is not enough.
3 Students need to know how to bring in the money! This means understanding marketing, budgeting and taxes.

You can learn more about Amanda's musical career at: www.amanda gunderson.com.

Information on the band program at Lycoming College that Bill runs can be found on www.lycoming.edu/music/bands.aspx.

Consignment sales

Creative entrepreneurs have three choices when wishing to sell their products through retail distribution. First, they can open their own retail store. While this is certainly a possibility, it is not the choice of most creative entrepreneurs because of the amount of capital required. In addition, it takes a great deal of time to manage additional tasks such as maintaining the physical space and hiring staff. Furthermore, more products must be sold in order for the fixed expenses of a store to be covered, which adds to the risk that the business might fail. The second choice is to sell to a retail establishment so that the retailer bears the risk of selling the product. However, because of this risk, the retailer will want to buy at a discounted price, which they will then mark up. This arrangement has disadvantages, as creative entrepreneurs must find a store that is willing to carry their product and they must also be able to deliver a specified quantity of the product at a specific time at a lower price.

The last arrangement is consignment sales of the product in a store. In this arrangement, the creative entrepreneur supplies the product to a store, but the store does not purchase and take ownership. Instead, the store's responsibility is to provide shelf space, assist with marketing, and handle the retail transaction. Once the transaction is completed, the store will retain a percentage of the selling price, usually 25 percent to 40 percent, while the remaining funds are paid to the artist.

The retail store may only agree to this arrangement if they set the final price that will be charged to the consumer. Art is priced based on two factors; the price the market is willing to pay and the assessment of cultural spectators (Lydiate 2014). A retail store that sells to a broad target market segment will price on what the market will pay. A specialized gallery will want the product priced on the assessment of the value by critics and collectors. If the creative entrepreneur insists on a

price that is not in line with the market or specialists, the product will not be put on consignment.

The agreement – get it in writing!

While creative entrepreneurs may be excited by the opportunity to have someone else sell their product as this leaves them time for creative production, they must carefully consider the terms before signing a consignment agreement. First, the agreement should state the percentage of the sale price that will be retained by the retailer. In addition, it should specify when the creative entrepreneur will receive payment. This might be at the end of the month of sale, or it might be the end of the month after the sale is made. For items with high prices, it might be agreed that payment will be made as soon as the sale is concluded, so that the creative entrepreneur will not need to wait for the funds. Additional financial issues that need to be clarified in the agreement include what happens if an item is damaged or stolen and who will pay for shipping charges if customers want the product shipped to their home.

In addition to the routine terms mentioned above, the agreement might also specify when the creative entrepreneur can remove items from the retailer to sell elsewhere. If agreeable to both parties, the agreement might also stipulate the product's placement within the store and the type of marketing assistance provided to sell the products. Because the store has many products to sell, if they do not provide marketing, it may be necessary for creative entrepreneurs to continue their own marketing communication efforts while the product is on consignment.

Cooperative stores

Another suggestion for distributing products is to participate in a cooperative store. A co-op might be limited to a single creative product, such as a gallery that sells oil paintings, or the store might have a number of different types of creative products to sell. The products may be all aimed at a specific demographic group, such as young people, or the products may be all of a specific product line, such as jewelry. A co-op differs from a regular retail operation as there is no single owner to whom the profits will accrue. Instead, the operation is jointly owned by several creative entrepreneurs. By being part of the cooperative, creative entrepreneurs know they will always have a distribution channel for their work. However, with this right to display and sell their products, come responsibilities. The members of the co-op are jointly responsible for the marketing, management and financial tasks involved in running the retail shop. However, there is an advantage in that these tasks can be assigned to each co-op member based on their skills.

There are two ways that the artists can contribute to the operating costs of the business. First they can be assessed a commission that is a percentage of each sale. However, there are some problems with this approach (Thompson 2014). Having a commission-based structure will result in successful artists paying most of the cost, while less popular artists pay little. In addition, artists with works that have higher

prices will have to pay more to cover expenses than artists with inexpensive products. A different model is to charge each artist the same monthly fee to cover operating costs. This will have the effect of encouraging artists who are not selling to change their strategy, while successful artists are not asked to subsidize those artists who do not sell well.

Target market – know thy customers

When starting a new co-op, the owners are jointly responsible for startup costs. However, some cities have launched programs that may help with these costs if the co-op is located in an area that needs economic revitalization. This help may not be in the form of cash, but rather with reduced rent and subsidized utilities.

A co-op that accepts the work of any and all artists will probably fail. A well-designed business plan for a co-op will ensure that the range of products carried is aimed at a sufficiently large single target market segment. As the store still needs a single brand image so as not to confuse consumers, the products chosen should be based on a single customer segment, such as products for children or trendy clothing for young adults. In addition, the target market segment may be based on the values of the artists such as products that provide economic development in poorer countries, chemical- and additive-free products, or products created by disabled artists. Some co-ops limit the products available by media, such as only selling the work of photographers or printmakers, while others welcome artists of any media as long as the works are products of interest to the target market segment. While aimed at a single target market segment, the products from artists should not be too similar, as this will result in fewer sales for each artist as they will simply compete with each other. The store manager, if there is one, or, more likely, a committee of the co-op artists, should meet together to discuss what products should be shown at the store.

A great advantage of participating in a co-op retail arrangement is that it allows creative entrepreneurs to experience the responsibilities of business ownership to learn whether managing a business on their own is of interest. One responsibility that is often shared among artists is the need to market the store. Artists are often expected to attend open houses and special events in order to explain their creations and artistic techniques to customers. They may also be expected to provide lessons on their craft to the public as a way of engaging the community and providing positive public relations.

The disadvantage – problems in the family

One downside of a cooperative store is that the shared ownership, which is part of its strength, can also be the cause of its failure. When sales are strong and expenses are covered by revenue, everyone is happy. When sales decline, difficult decisions need to be made: the same types of decisions that need to be made when a creative entrepreneur's sole proprietorship is in financial trouble. However, with a co-op these decisions need to be made jointly. If the work of some artist is not selling, he

or she may need to be replaced with an artist who is more popular, which of course will disrupt personal relationships. In addition, if some artists are not providing sufficient support to the store, they will need to be confronted.

Because they do not want to make these difficult decisions, co-op stores will sometimes decide to make up for a shortfall in revenue by asking for donations. However, donations do not have any role in a business, as its purpose is to make a profit by providing a product that is desired by consumers. Another idea tried by co-ops in financial difficulty is to "sell" shares for ownership that allow the shareholder a percentage of future profits. If the co-op is already in financial difficulty, then there will be little likelihood that these shares will ever pay a dividend.

Any co-op store is driven by two goals, which is selling the product and also adhering to their mission. Successful co-ops manage to move back and forth between these sometimes competing goals (Blatt 2014). Co-op stores are able to focus on their mission when sales are strong. However, when sales are weak, they sometimes must make their decisions based on ensuring the viability of their store. Once revenue increases and profit meets the co-op's goal, they are then able to again focus on their mission.

Forming a nonprofit

Some creative entrepreneurs have businesses that incorporate a mission statement that goes beyond just selling a creative product. These individuals might think of forming a nonprofit. It might seem easier than running the organization as a business but this is not true as all of the knowledge and skills needed to run a business are also needed to manage a nonprofit. In addition, the creative entrepreneur will also need skills in grant writing and fundraising. Because a nonprofit cannot afford to hire all the needed employees, the creative entrepreneur must also have skill in recruiting and managing volunteers. Lastly, nonprofits must form a board to ensure that the organization is adhering to its mission. As a result the creative entrepreneur must have management skills so as to be able to provide leadership.

Being a nonprofit does not mean that the organization can run at a financial loss. What it does mean is that it cannot survive on the revenue it receives for its goods or services. As a result, it also needs revenue from public grants and individual donors. Public funds are available because the organization provides a good or service that is not being provided by the private sector. The good or service is seen as helping society in a way that simply selling a product does not. Because this is so, the nonprofit may not need to pay some taxes, which would reduce the amount of money that would be available to help society. In addition, individuals who donate money to the organization may receive a tax benefit.

It would be unfair for a for-profit business to receive the benefit of not owing taxes as it could then price its products lower than its competitors, receiving an unfair competitive advantage. Therefore, to be granted nonprofit status, organizations must prove to the government that their work is benefiting society in a way that cannot be done by a for-profit business. This may involve extensive paperwork and also the formation of a board of directors whose responsibility is to

ensure that the nonprofit organization stays true to its mission. Even though not paying taxes, the organization may still need to file yearly financial statements, so all the same requirements for record keeping that are necessary for businesses must still be performed.

There are numerous nonprofit organizations requesting donations from the public. Therefore the management of a nonprofit must spend time on fundraising efforts and grant applications, which is time that cannot be spent on producing the product or providing the service that is the mission of the organization. Time must also be spent on recruiting and then managing board members. In addition, time must be spent on finding and managing volunteer workers. Forming a nonprofit is a strategy that is appropriate for some creative organizations. While there is the same need for marketing and financial skills, management skills beyond the scope of what is needed for a small business are required. Nonprofit organizations still will need a business plan and be managed as a business if they are to survive to accomplish their mission.

Questions to consider: Is there a retailer that would take my product on consignment? What would be the benefits of joining or forming a co-op store? Is forming a nonprofit best for my organization?

You don't have to use a gallery

There are other venues for showing your creative product than the traditional gallery. For instance you could put aside part of your studio as your own personal gallery and promote your own shows. Another choice would be to arrange showings at a library or government building. In addition college and universities may be willing to display work. Other less traditional ideas for displaying your work include home furnishing and furniture stores. After all, many people view creative products as part of décor. Office furniture stores can also be used if the creative product is appropriate for display in an office setting. Lobbies of office buildings may be a good place to have an event and then leave works on display, if security is adequate. Finally, using restaurants as areas to display works well because people have time to contemplate what they are seeing.

Of course, if you wish to make sales you will also need to have events on-site where you are present and ready to process payment and provide packaging.

McKensie 2014

Production issues

Management of the inventory of both supplies used in the production of goods and finished goods ready for sale is an unglamorous but necessary task if the business is to remain in operation. The tasks include purchasing and paying for supplies, maintaining inventory records, production planning and outsourcing. These tasks are particularly critical if the creative entrepreneur is using more than one distribution channel as they ensure that the right type and amount of product will be delivered.

Production issues

- Supply purchasing: choosing the right supplier and the right amount to purchase.
- Inventory management: maintaining adequate supply of raw materials and finished product without straining cash reserves.
- Production planning: ensuring that finished product will be available at the right time.
- Outsourcing: hiring others to do tasks that are not core to the business.

Purchasing supplies – don't just buy anywhere

Creative entrepreneurs need to take extra care when choosing their supplier so that the materials purchased meet artistic requirements but are also priced within their budget. In addition, the creative entrepreneur should ensure that the mission and values of the supplier do not conflict with the mission of the company. Once a supplier is chosen, payment terms can be negotiated. The supplier may grant 30, 60 or 90 days' before the bill for supplies needs to be paid. However, the bill will usually be discounted by a small percentage for early payment. For this reason, when possible, bills should be paid at the end of the 30 days' notice. It is critical that suppliers be paid on time, because if a supplier of the raw material from which the product is made is not paid, they will stop supplying new materials. Late payment will also affect the creative entrepreneur's credit rating, which will make it more difficult to negotiate contract terms in the future.

Unfortunately supplies are usually needed before the product is sold and revenue received. For this reason it is necessary to plan such purchases with cash flow in mind. If there is too large an inventory of supplies, then cash has been used unnecessarily. It also means that there will be a large amount of supplies that will need to be covered by insurance, which leads to additional cost. The same can be said of the inventory of finished goods. While it is necessary to have sufficient inventory on hand to fulfill orders, too much inventory means that better-selling products are not being produced.

Inventory management – making sure you have enough, but not too much

An order received from a supplier will include an invoice and packing list. The creative entrepreneur may be tempted to simply unpack and put the supplies away. Instead, the creative entrepreneur must get into the habit of always carefully checking the order for two reasons: accuracy and quality. First, to verify that the order was received as specified and the price on the invoice is correct, the packing list and invoice should be checked against the order to see that all items were sent and priced correctly. Second, the physical contents should be checked for quality. The company supplying the order should be notified immediately verbally, and also in writing so that a paper trail is established, of any discrepancies or defective materials.

Likewise, the creative entrepreneur should maintain a detailed listing of completed products ready for sale. With this list, the creative entrepreneur will know if there is sufficient inventory to meet orders or if more production is needed. If the shop is open to the public, this list can then be checked against the finished products on hand to see if any pilfering has taken place. This updated list will also be needed for completing financial statements and for insurance purposes in case a claim for loss needs to be made.

Production planning – what to make and when to make it

While production plans are frequently used in the manufacturing sector, they also have their place in creative organizations. While creative entrepreneurs go into business so as to produce a product that has personal meaning, it is likely that they can produce more than one type of product. Therefore choices will need to be made as to which product to produce, how many to produce and during what time period they should be produced. To help with this decision making, records should be maintained on product production. These records should include the costs related to product production, such as specialized equipment that is needed, the cost of raw materials and the hourly cost of the time it takes to produce. It may be tempting to not include the cost of the time, but it is critical to do so as time is a resource just as is money. These costs should then be balanced against the price at which the product is sold.

Gross profit margin is a measure of manufacturing efficiency as it is used to compare revenue to production costs. By dividing gross profit for each product line by revenue, creative entrepreneurs can determine which products contribute the most to profit. Such planning does not mean that products with a lower gross profit margin should not be produced. It does mean that enough higher gross profit margin products need to be produced to ensure that the creative entrepreneur will be able to stay in business. Once this break-even point is ensured, the creative entrepreneur can then schedule time to produce less profitable, but more personally rewarding, products.

At the end of each month and quarter, the creative entrepreneur will want to review their production records. It may be found that there are products that sell

well but with low gross profit margin. The creative entrepreneur can then analyze the production records to determine if there is a way to cut costs by using less expensive materials. In addition, it might be found that there are ways to decrease the time needed to produce a product without impairing quality.

The entrepreneur must balance the production of profitable products that pay the bills with the time needed for production of less lucrative but more emotionally rewarding products. Creative entrepreneurs need this balance, even if part of their work is for their own personal development rather than for the business. From such personally fulfilling work, new economically feasible product ideas may arise.

Outsourcing – you can't do it all

Another issue that becomes increasingly relevant as the business grows is workflow management. It may be that some tasks that are currently performed by the creative entrepreneur will now need to be outsourced to others. This will allow more time for the creative entrepreneur to produce the creative product. Most small businesses might think that outsourcing only concerns large companies manufacturing products in other countries to save costs on labor, thereby increasing the gross profit margin. However, outsourcing is also a distribution issue for small businesses. Every organization has a core function, which is its mission. However, there are other functions that must be performed so that the core function can be accomplished. These functions that are outside the core mission of the organizations can be divided into three categories (Mann Jackson 2014). First there are highly skilled tasks for which the creative entrepreneur may lack the needed skills, such as accounting. Most small organizations will need someone else to do their accounting, even if they must pay to have it done, because no one in the organization has the necessary skill. Second, the creative entrepreneur can outsource specialized tasks. For example, the organization might also hire a specialist to create marketing materials. Paying these service providers will still save money because, by hiring them, the creative entrepreneur saves time that then can be spent on the core function of creating product. Lastly there are repetitive tasks that can be done by someone who concentrates on their performance. Because these tasks are all that they do, they can perform them more efficiently. For example packaging, posting products and paperwork on international shipments can also be outsourced by using a shipping company.

Questions to consider: What is my inventory management system? How should I handle production planning? What activities can I outsource?

Creative industries and economic development

A successful community provides a place for individuals to live, become educated, socialize with others and raise a family. The most successful communities also offer

residents a rich cultural life. However, to be viable, a community must offer residents a means of earning a living. As a result, communities, both large cities and small towns, are concerned about economic development (Burayidi 2014).

There are a number of outcomes that communities seek as a result of economic development. The usual outcomes include increasing a community's ability to compete for companies to relocate within its borders and attract new residents to the area. In addition, economic development might focus on attracting tourists who will spend their money in the community. The purpose of all economic development activities is to increase employment, property values and retail activity, which add to the economic vitality and tax base of the town.

In order to attract companies to locate in the town, traditional economic development has focused on selling the town's geographic location, such as being near transportation hubs, having access to target markets and being home to suppliers within easy reach. Manufacturing companies are usually targeted for relocation enticement because, if the firm opens a location in the town, numerous jobs will be created.

As there are now more towns competing for fewer large manufacturing firms, a different enticement is being used. Communities now understand that companies are looking for more than a convenient location; they want a town where employees will be happy to live. Now communities, rather than only considering marketing the town's location as an asset, understand that the arts and culture sector can play a critical role in attracting new companies (Borrup 2006). Companies seeking to relocate understand that key people already employed by the company will also need to move and, if the town is culturally attractive, it will be easier to encourage them to do so (Lynch 2013). In addition, the cultural sector creates a sense of place, which adds to the quality of life in a way that is not possible by any other type of economic development.

Multiplier effect – what goes around, comes around

The multiplier effect is an economics term that describes how money spent in a community flows through other businesses and individuals. Creative entrepreneurs are often especially welcomed by local economic development authorities because the money spent on purchasing creative products stays in the community.

While products from around the world can now be purchased online, there has also arisen a desire by consumers for purchasing directly from the individual who created the product. As global reach has become easier, there has grown an opposite desire for local attachment. Creative businesses satisfy this need by allowing consumers looking for unique products to purchase directly from local producers. When the product is purchased locally, the money stays in the community.

These creative entrepreneurs who receive payment for their product then spend the revenue locally as they are interested in purchasing their supplies from businesses they know. In addition, creative entrepreneurs are more likely to live in the community and therefore also pay rent and support local businesses with their shopping. The multiplier effect continues because these creative entrepreneurs

attract creative people to the community who may start similar businesses (Markusen *et al.* 2013). If one small creative business is successful and keeps money in the community, it is likely that other creative entrepreneurs will move to the community to also do so.

Question to consider: What cities that have active creative scenes would I like to live in?

Everyone wants economic development

It would be a rare city that didn't want more economic development to provide jobs for its citizens and tax revenue for the government. Why do some cities succeed and some don't? One answer is that the cities that get it right start with lifestyle. You need to be the trendy, exciting sort of city in which young, educated, creative people want to live.

What do these young people want? They want interesting jobs producing products that have a meaning to them. Second, they want social opportunities where they can socialize with others like themselves. Besides lifestyle, successful cities are places that can help a new creative company to grow. It isn't just access to capital, but also access to knowledge. Once some of the creative companies become successful, they can then help others to succeed.

Waltmire 2014

Attracting and assisting artists

A new way of framing economic development strategies that incorporate culture is to consider them facility-centric, program-based or people-centric (Dwyer and Beavers 2014). Facility-centric economic development plans focus on building a performance space, arena, arts incubator or an entire creative district. The creation of these infrastructure projects attracts both visitors and residents. In addition, they add to the quality of life that is sought by all companies for their employees. Therefore it is hoped that companies will locate nearby, providing employment opportunities. However, because of the cost of these developments, fewer communities are taking this approach.

Program-based economic development methods include community-based arts festivals and social programs that use art and culture to improve the lives of local residents. Creative individuals use their talents to develop these social programs, thereby helping to alleviate the community's social problems. However, attracting the residents who will make program-based development possible takes people-centric development.

People-centric development focuses on attracting creative people to the community. This can be accomplished through the development of living spaces that can also be used for the production of creative products. Another means of attracting creative individuals is through programs that provide free or subsidized retail space for startup businesses. By adding a creative ambience to the city, again, it is hoped that companies will want to be located nearby so that their employees can enjoy the cultural life.

Providing assistance – help is on the way

Many local and state governments are interested in attracting creative entrepreneurs to their areas because officials realize that having creative businesses in the community helps to attract traditional businesses. However, to ensure that creative entrepreneurs are successful, advice and mentoring programs are needed, as they may lack business experience. In addition one of the needs for any new creative organization is capital to cover startup expenses. While this is difficult for any new business, creative entrepreneurs who have no previous business experience find it impossible to get a loan. Another issue where creative entrepreneurs need assistance is with leasing a storefront, as it is a challenge to find attractively priced retail space. Finally, a space where the artist can both live and work is difficult to obtain due to zoning or planning restrictions.

Mentoring: Because creative businesses can contribute to the economic revitalization of towns, particularly historic downtowns, many programs have been developed to assist creative entrepreneurs with starting businesses in these areas. Mentoring for new businesses may be already available in many communities through Chamber of Commerce organizations, nonprofits that focus on developing business skills and community college training programs. However, the challenges faced by a creative entrepreneur running a business are unique. Therefore, to encourage the startup of creative businesses, specialized workshops have been developed targeted specifically at creative entrepreneurs. These programs may be run by arts councils or by specialized nonprofits dedicated to this purpose.

Funding: Some of the programs established to attract creative entrepreneurs provide startup funding through low- or no-interest loans that can be repaid over a long period of time. Other programs provide grants to cover specialized startup expenses such as the purchase of supplies and the development of marketing materials. To obtain either the loan or grant, the creative entrepreneur is often required to submit a business plan so that scarce resources will be given to the best prepared creative entrepreneur. In addition, a creative entrepreneur might be required to commit to opening the business in a particular geographic area in need of revitalization. However, these areas often have a unique atmosphere that is desired by both the owner and customers of a creative business.

Rent: Rather than supply help in the form of cash, some assistance programs provide low-cost rent for studios and storefronts. Reduced-rent programs are more common than programs that provide startup funding as they are less expensive for cities to establish. The storefronts that are available, either cheaply or for free, are

mostly older properties that are not of interest to traditional retail outlets. However, they often provide the interesting ambience that fits the brand image of a creative business. One of the advantages of being involved in such a program is that the new business will be located near other businesses of a similar type. As a result the area becomes a destination for local residents to shop and eat. The creative entrepreneurs are often supportive of each other and even use joint promotion to attract local visitors and tourists (Kolb 2006). Working with the local visitors or tourism bureau, the area can then become a destination for tourists.

Because of the lower-than-average earnings of artists they often cannot afford to purchase a building in which to locate their business. Instead they will rent or lease in areas that need redevelopment because they have inexpensive spaces available. However, as an area becomes economically developed through the actions of creative entrepreneurs, more businesses will move in. As a result, rents rise and creative entrepreneurs can be forced out of the very areas that they have re-energized (Vivant 2013). To combat this situation, some cities have started economic development programs that help with this issue by assisting creative entrepreneurs to eventually buy their buildings.

Live/work spaces: Some communities are attracting creative entrepreneurs by providing residential opportunities that allow them to live and work in the same space. By doing so, they help creative entrepreneurs to lower their living expenses, which then enables them to exist on less revenue, freeing them to do more of the work that they desire to create. Furthermore, living in such a space surrounds creative entrepreneurs with like-minded people. Not only would this be enjoyable but it would also help to spark creativity, increase networking and result in ideas for collaborative projects.

These live/work development projects are started with funding from both private investors and also government and nonprofits. Organizations that specialize in developing such residential units understand how to find the right location and also how to put together community and government support. Governments are willing to subsidize the cost of these projects because they are often in older unused buildings in economically blighted areas. Nonprofits are interested in investing in these developments because they know that this type of artist residences build a sense of place that results in a stronger community.

Because tax revenue needs to be used in economic development efforts to encourage creative entrepreneurs, they must be supported by the community (Phillips 2004). Therefore economic development officials look for individuals to live in these developments who will have a long-term commitment to the community. This commitment will result in programs started by the creative entrepreneurs that will both enrich the community and can lead to revenue-producing opportunities for the artist.

To be able to lease an artist live/work space, the creative entrepreneur must go through an application process. While they can also have income from other employment, they must be able to demonstrate that they are a working artist with an established market. To apply, the artist must provide a portfolio of work to a

selection committee. In addition, if accepted, the artist is expected to use their talent to improve the community.

Economic development agencies

Economic development agencies with a mission of attracting and supporting creative businesses can be housed in a number of different government offices and organizations. One of the most common is a redevelopment agency, which is formed by municipal governments to provide business grants and loans. In addition they also have the authority to purchase vacant property and then seek tenants. While advice is wonderful, it is often cash that is needed. Here, economic development authorities can help by subsidizing rent while a business gets established.

Downtown development authorities have less power than agencies to influence overall economic development. These authorities work with businesses at a grassroots level and often are focused on a single downtown area or neighborhood. Of course, advice on running a business may be needed by any type or size of organization, but downtown development authorities often have someone who specializes in working with the unique challenges facing small businesses. Another mission of downtown authorities is to work with business owners to ensure that downtown is an attractive place to visit by focusing on issues such as parking, street maintenance and crime prevention. In addition, downtown development authorities support design initiatives that provide downtowns with a feeling of place. For this reason they are a source of funds for building facade improvements. In addition, the authorities will host regular meetings to provide networking opportunities that put business owners in contact with other entrepreneurs who are facing similar challenges.

Incorporating opportunities into strategy

Artists can use the opportunities presented by economic development efforts, including residence choice, retail location and program development, as part of their business plans. It is not unusual for people to move in search of opportunity. Creative entrepreneurs should consider whether they also could find a living situation better suited to their lifestyle and business needs in another community.

Creative entrepreneurs who are interested in opening their own retail establishments should investigate cities that have programs to attract new businesses to creative districts. Often these creative districts are in blighted areas, but areas that also have character and a sense of place. These are the types of places that people are drawn to visit to have an experience that is outside of their usual daily routines. Creative entrepreneurs may also wish to look for cities or towns that encourage creative business development through reduction of rent and taxes, because limiting expenses is critical during the first few months of operations when cash is limited. During these early months, sales will be low as the creative entrepreneur must first build an image and attract the target market segment. Not only are sales low, but there will be marketing expenses that will be incurred to build awareness

and attract customers. By taking advantage of such reduced expenses, the creative entrepreneur can help to ensure the long-term viability of the business.

These efforts to build economically strong communities through recognizing and encouraging the work of creative entrepreneurs are based on the following assumptions (Katz 2012). Having artists and the community interact on an ongoing basis will make the communities more attractive places to visit and live. The business skills that creative entrepreneurs bring to programs will help the programs to be successful. The interaction between artists will spark innovation that can solve problems or lead to the development of new products. The small businesses started by creative entrepreneurs can lead to jobs for community members. In addition, creative entrepreneurs living in communities help the sustainability of larger cultural organizations. All of these are goals that the creative entrepreneur can endorse.

While the creative entrepreneur may think that they are acting alone when they start a business, in fact they are part of both a creative community and the larger community. By joining a creative community they can both support and learn from each other. By sharing their talents with the larger community, they can influence people who may never buy their artwork.

Questions to consider: Are there any government programs that can help me with startup costs? Should I consider a live/work space? What value can I add to a community?

Summary

As a business grows, new issues will arise. Creative entrepreneurs may decide to engage in new strategies such as selling through consignment, starting a co-op or forming a nonprofit. As business increases, issues such as inventory management and production planning become more critical. Business must monitor inventory levels so that enough raw materials and finished products are available for production and sales. However, too much raw material inventory will tie up needed cash flow and too much finished product indicates a problem with demand. Outsourcing of some tasks may be needed so that the creative entrepreneur can focus on the core function of producing the product. Previously, economic development efforts of cities and towns focused on encouraging large industries to relocate. Now more communities understand that creative entrepreneurs can be critical in economic revitalization. The businesses started by creative entrepreneurs produce products locally and spend their money locally, keeping wealth in the community. In addition, they add to the cultural vibrancy of an area, which makes it attractive to new residents. Creative entrepreneurs can use these programs as part of their business plans. Some of these programs provide startup capital, but often the financial assistance will be in the form of free or reduced rent. Other communities offer living spaces where an artist can also produce work. Both the subsidized rent and live/work options reduce the fixed costs of running a business, therefore making it easier to earn a profit. Besides the financial help, the programs often offer

mentoring and training opportunities. Lastly, forming a creative business among other like-minded entrepreneurs can provide both support and creative ideas.

References

Blatt, Ruth. "What To Do When Two Core Values Compete and Why Musicians Follow Blockbusters with Flops." *Forbes*, June 5, 2014. www.forbes.com/sites/ruthblatt/2014/06/05/what-to-do-when-two-core-values-compete-and-why-musicians-follow-high-selling-albums-with-flops. Accessed August 11, 2014.

Borrup, Tom. *The Creative Community Builder's Handbook: How to Transform Communities Using Local Assets, Art, and Culture*, Saint Paul, MN: Fieldstone Alliance, 2006.

Burayidi, Michael A. *Resilient Downtowns: A New Approach to Revitalizing Small and Medium City Downtowns*, Abingdon: Routledge, 2014.

Dwyer, M. Christine and Kelly Ann Beavers. *Economic Vitality: How the Arts and Culture Sector Catalyzes Economic Vitality*, Washington DC: American Planning Association, 2014.

Katz, Jonathan. "Public Value, Community Engagement, and Arts Policy." In Doug Borwick (ed.) *Building Communities, Not Audiences: The Future of the Arts in the United States*, Winston-Salem, NC: ArtsEngaged, 2012.

Kolb, Bonita M. *Tourism Marketing for Cities and Towns: Using Branding and Events to Attract Tourism*, Amsterdam: Elsevier/Butterworth-Heinemann, 2006.

Lydiate, Henry. "Ways of Working." *Art Monthly*, no. 376 (May 2014): 37.

Lynch, Robert. "Arts Are Definitely Good for Business." *Public Management*, 2013.

Mann Jackson, Nancy. "How to Build a Better Business with Outsourcing." *Entrepreneur*, 2014. www.entrepreneur.com/article/204652. Accessed August 11 2014.

Markusen, Ann, Anne Gadwa Nicodemus and Elisa Barbour. "The Arts, Consumption, and Innovation in Regional Development." In Michael Rushton (ed.) *Creative Communities: Art Works in Economic Development*, Washington, DC: Brookings Institution Press, 2013.

McKensie, Neil. "Art Marketing and Business by Neil McKenzie Creatives and Business LLC." 2014. http://creativesandbusiness.com/3025-galleries-shows-and-other-opportunities-to-show-your-work. Accessed August 24, 2014.

Phillips, Rhonda. "Artful Business: Using the Arts for Community Economic Development." *Community Development Journal* 39, no. 2 (April 2004): 112–122.

Thompson, Patricia. "Daniel Smith – How to Organize an Artist Cooperative." *Daniel Smith*, 2014. www.danielsmith.com/content–id-151. Accessed August 11, 2014.

Vivant, Elsa. "Creatives in the City: Urban Contradictions of the Creative City." *City, Culture and Society* 4, no. 2 (2013): 57–63.

Waltmire, Eric. "Two Ideas for Economic Development: Lifestyle and Exits." *Eric Waltmire's Blog*, April 28, 2014. www.waltmire.com/2014/04/28/two-ideas-economic-development-lifestyle-exits. Accessed August 25, 2014.

Tasks to complete

Answers to these questions will assist in completing the Distribution section of the business plan.

1 Alternative distribution

 a Write draft consignment terms.

 b List three types of cooperative stores in which you might sell.

 c What qualifies your organization to be a nonprofit?

2 Inventory and production

 a List ten different types of supplies that will you need to stock.

 b Describe the production process from raw materials to finished product.

 c Plan out your weekly production plan.

3 Economic development

 a Do an online search for cities that have economic development programs.

 b What are the rental costs for live/work spaces?

 c Check real estate listings for the cost of renting or leasing retail space.

 d What is a social cause on which you would like to work with the community?

Visualization exercises

1 Design a layout for a cooperative store in which you would like to sell your product.

2 Draw a picture of all the raw materials that go into your product's production.

3 Use a timeline to plot production for three months.

4 Design your perfect live/work space.

12 Legal and management issues for growth

Introduction

As creative entrepreneurs will discover, there are a number of legal and management issues that they will face as their businesses grow. For example, creative entrepreneurs will need to understand the basics of contracts and copyright. This does not mean that they should not also seek out professional legal advice. In addition, all creative entrepreneurs should have a basic understanding of copyright issues, licensing, leasing, zoning and permits. There is an old saying that the only certainties in life are death and taxes. While understanding the basic principles of taxation is a necessity for everyone, business must particularly consider how taxes will affect their profits. As their business grows, creative entrepreneurs might also decide that they need to hire employees to handle the increased workload. The basics of recruiting and hiring employees are part of the management skills needed by creative entrepreneurs.

The legal aspects of contracts, copyright, zoning, permits and renting/leasing property will vary from country to country. In fact they may even vary between cities in the same country. Some legal systems will provide more protection to management, while others may seek to protect the employee. In some countries property contracts are flexible, while in others the terms are non-negotiable. The information provided in this chapter is meant to highlight the most common issues facing people managing their own business. However, in all cases, advice must be sought to ensure that the applicable laws are being followed.

What creatives have to say: Sean Farley

Sean Farley is an artist with the guitar. Not only is he a successful musician, he is also a Lutherie, someone who builds stringed instruments. Sean started his career playing in his hometown and is now touring internationally. While playing many genres of music, he has made it to the International Blues Challenge in Memphis three times. Having to balance his business as a Lutherie along with his performance career is challenging. Sean would recommend to other creatives:

1 Staying dedicated to your passion when times are tough is difficult, but long term it is still easier than turning your back on your art.
2 You can hire an accountant, but you should do your own marketing. Not only will it save you money, you know best how to communicate your message.
3 While contracts are written to protect both parties, if you don't have legal advice, the contract will protect the other person more than you.

You can learn more about Sean at www.seanfarleymusic.com.

Managing contracts

While legal issues will vary based on the country, there are basic contract situations and terms that pertain to creative entrepreneurs almost everywhere. For example the specific components of a legal contract will vary but the purpose of a contract is to reduce risk to all the parties involved. The more money involved in any business situation, the more risk and therefore the more critical it is to have a contract. For example, if creative entrepreneurs lend a friend the money to buy lunch, they might not feel the need for a contract to assure repayment. After all, if the loan is not repaid, no serious damage is done. However, if they are lending a friend the cost of buying a home, it would be foolish not to have a contract because, if the loan is not repaid, serious financial damage will result. One way to answer the question of whether a contract is necessary is asking the question of what is the worst that could happen (Gegax and Bolsta 2007). If the answer is that the business would be put at risk, a contract is necessary.

Of course the fact that creative entrepreneurs have a contract does not guarantee that the contract terms will be fulfilled. That is why contracts need to be supported by a legal system that holds them valid, so that business people have legal recourse if the other party to the contract does not fulfill the terms. The court system can then penalize them if they do not comply.

Legal advice – you can't know it all

Creative entrepreneurs may be able to create the product on their own. However, running a business takes expertise that they do not have. A legal expert will not be on the creative entrepreneur's payroll, but will be paid as needed to give advice. Having a lawyer go over any written agreements is a good investment. Using the same attorney each time that a question needs to be answered will allow him or her to become knowledgeable about the business and be able to better protect its interests. While paying a lawyer to review a contract is an expense, it can save the creative entrepreneur a great deal of money and trouble that might occur later.

Issues that should be discussed prior to hiring an attorney include their experience, fee structure and dispute resolution approach (Porter 2013). When deciding to hire a lawyer, it should be remembered that lawyers specialize in types of work.

A lawyer that deals in divorce cases may not have the expertise to deal with business contracts or copyright issues. It is perfectly acceptable to not only shop for an attorney but to also ask for a free initial conversation to determine if it is the right choice. It should be remembered that the expense of hiring a lawyer may be a business expense that can be deducted against income, therefore lowering taxes owed.

Creative entrepreneurs should clearly understand the attorney billing structure. Some attorneys charge a flat fee for services that may be due before the work is started. Other attorneys will charge an hourly fee. In this case, besides knowing the dollar amount, creative entrepreneurs must ask if there is an hourly minimum, despite the amount of actual time spent, or if the hour is divided into 10-, 15- or 30-minute increments. Finally, in case a dispute with a customer cannot be resolved, the attorney may offer arbitration services so that going to court can be avoided.

Question to consider: How will I find a legal advisor?

Property contracts

Before signing any contract it should be read thoroughly and completely. Any portions that are confusing or terms that are not understood should be highlighted. These phrases and words should then be researched before signing the document. While some research may only require looking up words online, it is a wise investment to seek legal advice. Since most contracts use a standard format, having it reviewed by a lawyer should not be a lengthy or expensive process. If the creative entrepreneur is unhappy with the terms of the contract, the lawyer can provide advice and negotiate changes.

Property contracts are normally used when someone pays for a place to work or live over a long period of time. This contract, which commits the signatory to pay a monthly fee, may be in effect even if the signee cannot afford to make payments. If the signee vacates the premises without giving the legally required notice, he or she may still be required to continue to pay until the contract is up. Therefore it might seem that a property contract is beneficial to the building owner but a burden on the creative entrepreneur. However, a property contract is also a safeguard for the creative entrepreneur. For example, the creative entrepreneur's business may be very successful at the location. If there is no contract, seeing this success, the owner of the building could at the end of any month raise the rent. In addition, without a contract, the building owner may be able to ask the creative entrepreneur to vacate the premises so that they can lease to someone else. This would negatively impact creative entrepreneurs as they have established business plans with budgets that they must live within and cannot afford to pay more. Moving to a new location may also result in a loss of customers. A contract, while binding the creative entrepreneur to pay, also binds the building owner to allow the business to reside during the contracted period of time and only charge the agreed-upon amount.

The agreement – read the fine print

Another form of property contract is written on a month-to-month basis. Even if the agreement is written for a year, the agreement can be ended with 30 days' notice. In addition, the landlord can change the terms of the agreement with 30 days' written notice. While this type of agreement provides flexibility to the creative entrepreneur, it does not provide any security.

A long-term property agreement is what is usually signed by business people. They need to know that they can occupy the premises for a year, although the contract might be written for a longer period of time, at a specified monthly cost. Most property contracts are written to automatically renew at the end of each year unless notice is given. Creative entrepreneurs usually sign such long-term contracts so that they can budget the necessary funds for future expenses. When reviewing a contract, the creative entrepreneur should verify the length of time or tenancy. Not only the amount of the lease payment but when the payment is due should be clearly stated. In addition, the lease agreement should state if there is a grace period if the payment is not received on time. Under what situations the landlord can force the tenant to vacate the property for nonpayment should be clearly explained.

The creative entrepreneur should ensure that the contract states the purposes for which the premises will be used, which might include what type of, and during what hours, machinery can be used so as to minimize the annoyance to other tenants from the resulting noise. If quiet is important to the creative entrepreneur, the use of nearby premises should also be verified. There may be terms as to the number of people who can work on the premises and whether the premises can be used for customer sales. Because utility payments can be a significant cost, whether the creative entrepreneur or the building owners pays for electricity, water, sewerage, heat and garbage should be negotiated. Every detail should be put in writing, including if the creative entrepreneur wants to have a pet on the premises. Lastly the landlord's right to access the premises should be clear.

While the above information covers the standard issues that may arise in property contract negotiations, other aspects to consider are site improvements and an escape clause. The square footage under contract may be raw space that will need improvements so as to be useable as a production facility. In addition, if the premises are to be used as a storefront, then the site may need to be improved by the creative entrepreneur so that it will be attractive to the target market segment. It is normally the contract holder who must pay for these improvements. However, if these improvements will increase the value of the site after the creative entrepreneur vacates the premises, a few reduced or free lease months may be negotiated. Another consideration is what will happen if there is a major disruption to the premises, such as failure of the building's heating or cooling system, if road construction blocks access to the premises or other tenants move out, reducing customer flow. The contract may state that in these cases the lease payments will be renegotiated. The creative entrepreneur cannot rely on the good nature of building owners as in these circumstances they will also be short on cash. The time to negotiate these issues is when the contract is signed.

One last issue is to think long term. In the excitement of finding the right location and getting an acceptable contract with good terms, the renewal of the contract might be forgotten. The contract can include a clause that limits the amount by which payment can be raised each year. After the first year of hard work, creative entrepreneurs do not want to face a payment increase that is unaffordable, particularly if they have improved the site. In addition, customers will have learned the location and a change may result in a decrease in revenue.

Alternative property arrangements – not your traditional agreement

There are two other means of acquiring space that should be considered (Thompson 2013). When economic activity is low, established businesses may have contracted space that they do not need. Creative entrepreneurs may be able to enter into a "foster" office arrangement where they agree to pay for the use of the space for a specified period. The other arrangement is shared space. There are now buildings that are designed for the use of creative entrepreneurs who pay a monthly fee to use the facilities. Some of these facilities are buildings where creative entrepreneurs get their own office but share studios, receptionists, meeting rooms and other amenities. Other buildings are production facilities for different types of artistic media, where the artists share space and production equipment in exchange for a fee. In both cases a contract will need to be negotiated and signed.

Questions to consider: Do I understand property agreements? What leasing alternatives may be available for my business?

Creative product contracts

There are three types of product legal issues with which the creative entrepreneur will most commonly be faced. These are agreements to reproduce and license work, commissioning work or consigning work to an intermediary. While such legal issues are not what creative entrepreneurs wish to spend their time upon, they are necessary to understand if the business is to be successful.

Necessary contracts

- Creative reproduction and licensing: Selling the right to use your work.
- Commissioning contracts: Ensures that the work will be completed and the creative entrepreneur will be paid.
- Consignment contracts: Covers all details of payment and ownership.

Creative reproduction licensing agreements – get it in writing

At times creative entrepreneurs may be approached by an individual or company offering either a flat fee or a royalty to reproduce their work. Since the creative

entrepreneur is the owner of the intellectual property, even it is not officially copyrighted, permission may be needed for its use. This may be true even if the work has already been purchased. The purchase of a creative object does not give the owner the right to copy the object or to use a reproduction of its image for resale.

Once the right to reproduce the object is sold, the creative entrepreneur may not be able to sell a similar item. Therefore, the creative entrepreneur needs to be compensated for the loss of this future income. The licensing agreement to use a creative work must state the intended use of the object and also the compensation that will be paid. However, in the United States, "fair use" of an idea or image is allowed without payment. This fair use would include commentary, criticism or review of the creative work, where an image or sample of the work can be included without compensation being owed.

Commissioning contracts – they get the work; you get the money

Another situation where a contract should be used is when work is commissioned. Creative entrepreneurs should have a standard contract that they use when they agree to requests for commissioned work. If a work is commissioned, creative entrepreneurs must purchase the needed raw materials and also commit time that could be used to produce other work to sell. Therefore a contact is written that provides a description of the work to be completed, the price to be paid, the dates when payments are due and also the completion date.

This contract should also cover the basic financial information of total cost of the product, which party must pay any sales or value added tax, and dates and size of payments if the total is not paid at signing. Who is responsible for delivery of the product and the method of delivery should also be stated. The contract should address warranty issues, such as if the work is defective in some manner, how it will be repaired. In addition, the contract should also cover more detailed issues, such as rights to reproduction and right to future resale.

This agreement also protects the purchaser of the work so that they know exactly what the work will cost and when it will be completed. If the creative entrepreneur does not adhere to the contract terms, the purchaser may be able to sue and the reputation of the business will be harmed.

Consignment contracts – make sure everyone is happy

Another common reason for a contract is when work is sold on consignment. In this situation the work of the creative entrepreneur, who retains ownership until sold, is shown at a gallery or retail location. If the work is sold, the intermediary retains a percentage of the selling price with the remaining amount to be paid to the creative entrepreneur. The contract for consignments should include the percentage of payments to each party, the type and amount of work to be consigned and also when any unsold work will be returned to the creative entrepreneur.

There are some arguments against relying on consignment sales (Arts Business Institute 2011). The lower the percentage of the sale that is retained, the less incentive the intermediary has to convince the customer to purchase the product. Of more concern, an intermediary may be interested in consignment sales because they are having financial difficulties and do not have the cash to pay for inventory. For all of these reasons, creative entrepreneurs must conduct thorough research of the retailer or gallery before negotiating a consignment contract.

Question to consider: Will I need a consignmentor reproduction agreement for my work?

Getting the learning you need

There is a growing recognition that artists and performers need business training if they are going to make a living based on their creative efforts. The Artist as an Entrepreneur Institute (AEI) has designed training to specifically meet this need. The classes are held on four Saturdays where artists are introduced to the basics of business. The cost is kept low because of funding received by charitable foundations. The classes are taught by both business practitioners and artists. The first day focuses on the product, pricing, business structure and starting a business plan. The next Saturday includes teaching how to understand consumers and research markets. Sales and distribution, along with legal issues, are covered during the third Saturday. The final day is devoted to developing a personal brand.

Another learning option is online courses such as those offered by Fractured Atlas. Their Fractured U offers a series of online courses that cover standard business issues such as accounting. However, they also cover issues specific to arts, such as working with an agent and renting venues.

It doesn't matter where or how the creative entrepreneur receives the information, as long as the needed knowledge is learned somewhere.

AEI; Fractured U 2014

Legal issues

There are additional legal issues that do not involve contracts that will also vary by both country and community. Most communities have a system, often referred to as zoning or town planning, of regulations used by community planners to encourage or discourage the establishment of businesses in particular geographic areas. Businesses may be required to be licensed by the government to ensure that taxation is assessed. Permits are often required to ensure the safety of residents who enter business establishments. In some countries these requirements are strictly

enforced, in others they are not. Of course, even if not required by law, creative entrepreneurs will want to establish their businesses at appropriate locations and ensure the safety of their customers.

Zoning – are you in the zone?

It is most likely that the creative entrepreneur will not have the available funds to purchase a building as a studio or storefront. As a result they will need to sign a lease agreement before they can occupy the premises. While the lease contract will state the length of time the premises may be occupied and the amount of the payment, there are other legal issues that are not covered in the contract. Even before considering a possible location, the creative entrepreneur should determine if the community will allow the desired use.

Zoning or planning restrictions may be enforced by the local government to ensure that the use of a building conforms to a community's long-term development plan. An area may be designated for only residential use, only business use, or both, which is referred to as mixed use. If the area is planned for only residential use, even if the creative entrepreneur negotiates a contract in good faith with the owner of the property, it can still not be used for a commercial business. If the creative entrepreneur ignores this fact and starts a business, the city may force it to shut down and also impose fines. A check with the applicable city government office can confirm the status of any property. If the area is residential, the creative entrepreneur may be able to appeal. However, the variance can only be granted under certain conditions and, even then, if neighbors object, the request may be denied.

If creative entrepreneurs are working out of their home, they may be in violation of the zoning or planning regulations but, in the United States, even where this is the case, there is probably no zoning official who will come knocking on the door (Ennico 2005). What usually happens is that neighbors complain about the increased traffic. A way around this issue is for the creative entrepreneur to use a mailbox company where they can take any orders to be sent, thereby avoiding customers coming to their doors.

Licenses and permits – keep it legal

The creative entrepreneur may need a business license for tax purposes. Cities vary as to the requirements, so the creative entrepreneur needs to contact the government to meet any license requirements for having a business in the city limits. In addition, if goods are sold to consumers, a resale permit may be needed as the business owner may be required to collect sales or value added tax.

The business may also need to obtain a permit verifying that the place of business meets health and safety requirements. Many of these requirements have to do with the ability of the customers to do business safely and to exit the building quickly if there is an emergency. In addition, the business location may be required to meet accessibility requirements for the disabled. If food is served, there will most

likely be additional requirements to ensure that the food is prepared and served in a safe and healthy manner. If any food or beverage is sold, even on a very limited basis, a permit from the department of health may be required. Finally, a fire inspection and or building inspection may be compulsory before the building can be occupied. For example, the number of exits, signage and location of fire extinguishers may be verified.

While the business license and resale permit mostly have to do with taxation issues, the other permits have to do with public safety. Because they are required for a good reason, not obtaining the permits can result in hefty fines and even the closing of the business.

Questions to consider: How do I find out about zoning or planning regulations? Does my city require a business license? What permits will I need?

Creative workers are critical in achieving city livability

Why do economic development agencies want creative businesses in their town? It is not just so that they can buy their products. These agencies really want to attract large companies, as a company with 100 employees will generate tens of thousands in tax revenue and hundreds of thousands in economic spending. However, to attract these large companies, economic development agencies need to sell the town to company management. Companies thinking to relocate want a town with cultural amenities and creative residents. The term that is being used to describe the type of atmosphere desired by businesses is city livability. Cultural entrepreneurs, through establishing creative businesses, are the key to providing this livability.

Another reason that companies thinking to relocate want a city with cultural amenities is that business managers believe that experiencing the arts helps their employees to think in new ways so that they become better problem solvers. This is the reason that small creative businesses are critical for economic growth and why local governments create programs to encourage them in their cities.

Lynch 2013

Copyright issues

Any creative entrepreneur needs to be aware of copyright, which is designed to protect the intellectual and creative efforts of individuals. No one wants someone else to get credit for an idea they developed and, even worse, they would not want others to monetarily profit from ideas that they took the time, effort and money to

create. Therefore creative entrepreneurs also need to be careful not to use the ideas and designs of others in their own work. There are two issues of which creative entrepreneurs must be aware. The first is plagiarism, where any work is passed off as the creative entrepreneur's own efforts because they do not give credit to the idea's creator. The creator of the work may not care that it is being used, but still must be given credit. The second issue is copyright infringement, when copyrighted work is used without permission. Work can be both plagiarized and infringed at the same time. Of course, creative entrepreneurs are inspired by the work created by others, but when this work is knowingly copied, credit must be given and, if copyrighted, permission asked.

There are two principal international copyright conventions, the Berne Convention for the Protection of Literary and Artistic Works (Berne Convention) and the Universal Copyright Convention (UCC), to which most countries are signatories. In some countries, including the United States, work does not need to be formally copyrighted in order to be protected. However, to either stop the use of the work by others or to demand compensation, the creator of the work must be able to prove that the idea was original. Therefore creative entrepreneurs should keep copies of all their work both while in process and when completed. This is easy to do, as digital photographs can be taken of sketches, notes and other preliminary work. In this case the original designs do not need to be kept, as the photos will be documented proof. Of course these photographs should be date stamped and saved onto a secure site. If creative entrepreneurs discover that their work has been copied, they can file a complaint.

Copyright does not just belong to the individual. It can also belong to the creative entrepreneur's heirs. Even if the original creator of the work is dead, copyright can be considered part of the estate that is inherited. As a result, the heirs must receive compensation if the work is used by another. If the creative entrepreneur wishes copyright to be part of their estate, it must be stated in writing.

Avoiding plagiarism or copyright infringement – if in doubt, give credit

However, of more concern to creative entrepreneurs is if someone claims that they have copied the work of someone else. This can happen even to ethical artists and musicians who have no intention of copying someone else's creative ideas. Ideas can seep into the unconscious and become incorporated into a work without awareness (Raspel 2012). Because ideas are spread so widely online and via social media, it is becoming increasingly difficult to come up with a truly original idea. In addition, the practice of knowingly mixing in elements of the work of others into the artist's own work increases the chances of being charged with copyright infringement.

The only protection is for the artist or musician to always create work with the rights of others in mind. When creative work or ideas are used that originated with others, it will be necessary to change them in such a way that the casual observer will not recognize the original. This is not done with the intent of skirting the law.

It is done because then the work is no longer affected by copyright as it is no longer the original idea of someone else.

Of course copyright isn't designed only to be punitive. It exists so that compensation can be paid when a person's ideas are used by another. Therefore the creative entrepreneur who wishes to use the work of others can do so if the person is informed. Perhaps no compensation will be asked but, if it is, the compensation will be stated in a legal agreement that grants rights in exchange for money. It might be that all the original creator will want is public acknowledgement.

Other copyright issues – it's complicated

Copyright issues extend beyond just the idea or image that the artist creates or wishes to use. It can even be true of the work of employees. For example, if a photographer is hired to take images of artwork, those images may belong to the photographer and therefore cannot be reused for other purposes than the original reason for the contract. To guard against this situation, the hiring agreement must state that the photographs will become the property of the creative entrepreneur who hired the photographer.

Sometimes, even if a creative entrepreneur uses the image of a famous person or building, this can be considered copyright infringement. In many countries, this does not pertain to artistic work that is done to educate. Therefore it is not usually an issue for work done at a university or as part of an educational program. However, once creative entrepreneurs have established a business, they then must get a model or building release to use the image in their own work.

Question to consider: How will I copyright my work to protect it from infringement?

Top ten reasons to copyright

The products of creative entrepreneurs include ideas that are written, performed, filmed or visually produced. Once produced and displayed publically, it is easy for others to copy the work. However, these original creations deserve protection. When an original work is created in the United States and is in any written or visual form, it has protection even if is not formally copyrighted. Therefore, even without copyrighting the work, if others use and take credit for the idea, they can be sued. However there are reasons to go through the formal process of copyrighting work.

1 Public notice of ownership: No one can claim they didn't know the work was yours.
2 Credible policing: People are warned that action will be taken.
3 Presumption of ownership: Difficult for others to take claim to an idea.
4 Easy and inexpensive: In the US it can be done online for a small fee.
5 Ability to file: A lawsuit can be filed immediately against infringers.

6 Damages: Not only can you sue, but you can also get damages and legal fees paid.

7 Enforcement: Without formal copyright, there is no ability to collect damages.

8 Making money: The creator gets paid for use of an idea.

9 Copyrights are assets: Having copyright is an asset that impresses funders and investors.

10 Foreign protection: Customs or border agents can seize bootleg copies, if imported.

Ideas should be formally copyrighted even if creative entrepreneurs don't believe they are valuable. It is much harder to file a copyright claim once another company starts selling similar ideas.

Tomanov 2014

Tax issues

While taxation types and amounts will vary, no matter where the creative entrepreneur is doing business, there will be taxes that must be paid. The taxation issues that the creative entrepreneur must face include registering the business with the government, paying business taxes, personal income tax, sales or value added taxes and handling payroll taxes.

Business registration – register now, so you can pay taxes later

Many countries require businesses to register their existence. Some governments require businesses to pay fees for just being in business. To ensure that business fees are paid, the creative entrepreneur may be given a tax identification number. Another consideration is that the business may be located in a special business improvement zone. These zones are created by local development authorities to assess on each business a fee that pays for services beyond what is provided by the government. Registering a business supplies the needed information for government and other agencies to assess fees.

Business income taxes – yes, there are always more taxes to pay

The business may be required to pay taxes on its profits to the local, state or federal governments. Since business expenses may be subtracted from revenue to get profit, creative entrepreneurs should carefully track expenses which will reduce their taxes. Of course, proof of the expenses must be maintained, as the government agency that collects taxes may ask for verification. If this documentation

cannot be produced, the government may disallow the expense. As a result the creative entrepreneur may be assessed more taxes.

Tax law is complicated and varies from country to country and even from city to city. In some situations business income taxes are paid entirely separate from personal taxes. In others, business profit is added to the creative entrepreneur's personal income and then taxes are paid on both. Most creative entrepreneurs would rather spend their time creating a product then spending time reading tax regulations. Therefore engaging the services of a professional to prepare tax forms and make payments may be a good investment. This professional can also provide advice as to what deductions are allowed so that the creative entrepreneur does not pay more taxes than are due.

Lastly, the business may be required to collect sales or value added tax for the government. These taxes are usually a percentage of the purchase price. However, they may not be required on all types of purchases. For example, in some US states, food is not taxed unless it is precooked, and clothing is not taxed unless an individual item costs more than a specified amount. This example is given to demonstrate the complexities of the law. This is another situation where the advice of a business advisor will be needed to ensure that sales and value added taxes are both collected properly and sent to the government on time. Failure to do so is often considered a criminal offense, and lack of legal knowledge is not considered a defense.

Questions to consider: Do I need a license? What fees and taxes will I have to pay?

Hiring employees

Most creative businesses start with only the founder, and perhaps a partner, who both produce the product and run the business. However, if the business is successful, the time will come when the decision will need to be made whether to hire employees. While it might seem like an easy, and maybe even logical, next step, in fact it means that the creative entrepreneur will now become a manager. Taking on the role of a manager means that the creative entrepreneur must now take on new responsibilities, which include job analysis and the tasks associated with recruiting and hiring employees. In addition, the creative entrepreneur must understand the legal regulations necessary to fire employees. All of these tasks will take both time and skill. Therefore the creative entrepreneur should consider carefully if the additional assistance provided by an employee will offset the additional time needed to perform management tasks.

Hiring issues

- Job analysis: deciding what tasks an employee will perform.
- Recruiting: finding qualified candidates for the position.
- Interviewing: asking all candidates the same legal questions.
- Hiring: writing a contract that states conditions of employment.

Job analysis – what needs to be done

The first task when considering hiring an employee is to determine exactly what the employee will be doing each day while on the job. It is not enough to simply state that help is needed, as finding the right employee depends on understanding what skills are necessary to perform the required tasks. If creative entrepreneurs believe they can no longer run the business on their own, they should consider what tasks they are currently doing that could be done by someone else. The higher the level of skill involved, the more likely that the task will need to be done by the creative entrepreneur. However, lower skilled tasks can be performed by others.

A job analysis is a list of tasks that will be done by an employee along with the frequency with which the task must be performed, whether daily, weekly or monthly. This task and frequency analysis will help to determine the days and number of hours that will need to be worked. It may be that a full-time employee is not needed because there is not enough work for five full days a week. However, even if only a part-time employee is needed, it must be determined what days and hours someone will be required to be present.

Once the task list is completed, the creative entrepreneur should determine what skills, education and personality traits are required to do the job. With this information, a job description can be written. It is this job description that will be used to find applicants most likely to be successful once they are hired. However, in addition to looking for specific skills, creative entrepreneurs should also look for a candidate who is also entrepreneurial (Zwilling 2011). The new employee who joins the business should believe in the mission of the organization and not just want a job. In addition, they should have an appreciation of the creative product. In exchange, the creative entrepreneur should not treat the employee simply as someone who is hired to do tasks, but instead help them to understand the bigger picture of the business and develop new skills. In exchange, the employee will be more productive.

Recruiting qualified candidates – they may be hard to find

Most creative entrepreneurs may be tempted to simply hire someone they already know. This is not a problem as long as the person can perform the needed tasks. Hiring someone who is known can even be an advantage as the potential employee already is familiar with the culture of the business. Therefore informing customers, suppliers and retailers that there is a position available is the first step in finding a new employee. In addition, creative entrepreneurs can approach university career offices, especially those with creative majors, and local job placement centers for qualified candidates. Current interns who are already familiar to the creative entrepreneur can be hired on a permanent basis.

If necessary, the job can be advertised on a website or through a newspaper. However, most small business owners wish to avoid this step, if possible, because of

the time it takes to review and respond to all the applications, many of which will be from people who are not qualified for the position.

Interviewing candidates – keep it legal

While the recruitment process can be informal, the interview process needs to be more thoughtful and structured, as it is part of the legal process of hiring an employee. While the legal requirements will vary, normally the first step is to review applications. Even if the future employee is known to the creative entrepreneur, there should still be an application process that asks for education and employment history. An application may be considered a legal document and, if it later turns out that the employee has not disclosed information, such as being fired for theft, this may be grounds for termination. If the application demonstrates the necessary skills and education, an interview can be scheduled.

Before the interview starts, the creative entrepreneur should prepare a list of questions. For fairness and comparability, each applicant should be asked the same questions, none of which should relate to the applicant's personal life, as such questions may be illegal. However, the interview is more than just a list of questions and answers. It is also about matching the applicant's values and personality with those of the businesses. Each business has a culture in which the new employee must fit. Individuals in a small business work closely together and therefore must be able to get along. In addition, during the interview, the creative entrepreneur is also selling the business. Good potential employees may have more than one job opportunity. Therefore, during the interview, interviewees are also determining if this is a business where they would like to work.

If the applicant performs well in the interview, there is one last step to be done before the position is offered, which is to check references. Again, it is necessary to understand the applicable employment law, but it is not uncommon for applicants to either withhold information or outright lie about their qualifications. Letters of reference are not enough proof as they can be easily faked. The applicant needs to provide the name and number of a former employer or other professional reference, such as a professor. Some creative entrepreneurs may feel uncomfortable verifying the statements made by applicants. However, it should be remembered that the business's reputation and financial standing can be harmed by the actions of an employee.

Hiring employees – the fun part is saying, "you're hired!"

Once the decision has been made to hire, the paperwork starts. First the applications of unsuccessful applicants along with notes explaining why they were not chosen, need to be maintained. This is done for legal purposes in case applicants decide they were not hired for discriminatory reasons. Second, the paperwork associated with hiring the successful candidate needs to be prepared. A formal contract may not be needed, but any new employee should be provided with the

written job description, their work schedule and the pay amount. In addition they should be familiarized with any business policies.

Benefits are another issue that must be clarified. Besides being paid a salary, both the employer and the employee might need to pay employment taxes that are mandated by the government to cover social security and disability compensation plans. In addition, benefits that might be either mandated or offered include vacation pay, sick pay, health coverage and a pension plan. The creative entrepreneur must understand the legal issues that will result from hiring staff. Even if benefits are not mandated, the creative entrepreneur may wish to offer benefits so as to attract good employees.

Questions to consider: When will I need to hire employees? Where will I find qualified applicants?

Sometimes you have to say goodbye

Just like in personal relationships, sometimes things just don't work out with an employee. Firing an employee is probably the least popular management task. However, if it must be done, here is a process to follow if you are in the United States:

Step one: First try to correct problem behavior. State in writing the problem, how it needs to be corrected and what will happen if the behavior is not changed.

Step two: Understand that managers can't fire for discriminatory reasons, only for reasons of failure to perform work functions.

Step three: Assemble all documentation including contracts, job descriptions, performance reviews and a letter explaining any remaining pay and additional benefits that are due.

Step four: Hold a termination meeting in a neutral location with a witness present where the benefits due to the employee are outlined.

Step five: Inform other employees that someone is leaving the employment of the company without explaining why.

Sometimes the fired employee goes on to be a successful employee at another company. The employee wasn't a bad person; they were just a bad fit for the job.

Waring 2013

Summary

While dealing with legal topics may not be how creative entrepreneurs wish to spend their time, they are necessary to understand if the business is to survive.

Contracts dealing with property, commissioning and consignment of work will be part of doing business. The creative entrepreneur will need to seek the advice of experts on many of these issues, but still needs a basic understanding of contract components. Copyright to protect the work of the creative entrepreneur must be understood. In addition, issues dealing with licensing, leasing and zoning must be dealt with on an ongoing basis in the life of the entrepreneur. Another unavoidable issue is taxation. Finally, if the creative entrepreneur decides to hire employees, management tasks such as job analysis, recruitment, interviews and hiring must be undertaken.

References

Artist as an Entrepreneur Institute (AEI). Cultural Division. www.broward.org/Arts. Accessed April 4, 2014.

Arts Business Institute. "Art Consignment Is Unhealthy for Your Business." August 28, 2011. www.artsbusinessinstitute.org/blog/consignment. Accessed August 13, 2014.

Ennico, Cliff. "Avoiding the Zoning Trap." *Entrepreneur*, August 15, 2005. www.entrepreneur.com/article/79464. Accessed August 13, 2014.

Fractured U. "Courses." http://courses.fracturedatlas.org/courses. Accessed March 4, 2014.

Gegax, Tom and Phil Bolsta. *The Big Book of Small Business: You Don't Have to Run Your Business by the Seat of Your Pants*, New York: Collins, 2007.

Lynch, Robert. "Arts Are Definitely Good for Business." *Public Management*, 2013.

Porter, Jane. "10 Questions to Ask Before Hiring a Small-Business Attorney." *Entrepreneur*, February 12, 2013. www.entrepreneur.com/article/225395. Accessed August 13, 2014.

Raspel, Petra. "Creative Inspiration vs. Imitation – When Does Copying Turn into Plagiarism?" *Artist Sense*, December 18, 2012. http://artistsense.wordpress.com/2012/12/18/creative-inspiration-vs-imitation-when-does-copying-turn-into-plagiarism. Accessed August 13, 2014.

Thompson, Melissa. "Get Office Space." *CNNMoney*, May 13, 2013. http://money.cnn.com/2013/05/13/smallbusiness/office-space. Accessed August 13, 2014.

Tomanov, Melanie. "Copyright Registration Basics for 'Creative Entrepreneurs.'" *The Licensing Journal*, January 2014.

Waring, David. "How To Fire an Employee in 5 Steps." *Fit Small Business*. October 30, 2013. http://fitsmallbusiness.com/how-to-fire-an-employee. Accessed August 25, 2014.

Zwilling, Martin. "A Growing Startup Should Only Hire Entrepreneurs." *Forbes*, February 23, 2011. www.forbes.com/sites/martinzwilling/2011/02/23/a-growing-startup-should-only-hire-entrepreneurs. Accessed August 13, 2014.

Tasks to complete

Answers to these questions will assist in completing various sections of the business plan.

1 Assistance

 a List the names of a financial advisor and a legal advisor in your area.

2 Copyright

a Look up the copyright laws for your country.

b Find a sample reproduction agreement online.

3 Contracts

a Find a lease agreement and highlight the terms you do not know.

b Find the zoning or planning for the address where you now live.

c Call your city government to find out about business licenses.

4 Taxes

a Determine what business taxes you will be required to pay.

b Find the tax rates (percentages) that you will be required to pay on business profits.

5 Employees

a Look at job-posting sites to read ads for positions for which you might one day hire.

b Find a website that gives typical salaries.

c Call a government office to determine what job benefits are mandatory.

d List five sources of potential employees.

Visualization exercises

1 Make a pie chart representing revenue and visualize what slice will go for government taxes.

2 Draw a picture of your perfect interview candidate.

3 Draw a task chart that lists jobs, when they need to done and who will do them.

Appendix

Business plan template for creative industries and cultural organizations

Below is a suggested outline for a completed business plan. Every plan will vary, as each business opportunity is unique. In particular the distribution, promotion, social media and operations sections will differ. For example, if only direct distribution is planned, then no information needs to be provided on indirect distribution. Likewise, not all promotional methods may be used by the creative entrepreneur.

The plan is a verbal picture of the business that should be well organized and well written. The purpose of the business plan is to 'sell' the entrepreneurial idea to possible investors. It also provides a roadmap that the entrepreneur will follow as the business is built.

Using the completed exercises from the relevant end-of-chapter exercises will help to complete the plan. Follow the three 'Cs' of business writing – be clear, correct and concise.

Clear – have someone else read the plan to determine if what you have written is what you meant to say.

Correct – proofread to ensure that there are no errors, as readers will assume the quality of the plan will be the quality of the business.

Concise – edit to remove any wordage that is unnecessary, as people do not have time to read long documents.

Business plan outline

Title sheet

Name of entrepreneur, business name, contact information
One sentence: passion in life – Chapter 1

Introduction to plan

Mission, vision and value statement – Chapter 2
Description of product and customer – Chapter 1
Goal, objectives and tactics – Chapter 2
Personal bio including paid/unpaid work experience, professional training – Chapter 1

Situational analysis

Internal: financial, people, organization skills – Chapter 2
External: competitors, socio-cultural, technological and economic factors –
Chapter 2
SWOT grid – Chapter 2

Research plan

Research question – Chapter 3
Research subjects and method – Chapter 3
Research findings – Chapter 3

Product description

Product description – Chapter 4
Product benefits – Chapter 4
Competitive advantage – Chapter 4
Copyright protection – Chapter 12

Customers targeted

Targeting strategy – Chapter 5
Target market segmentation description – Chapter 5
Benefits motivating purchase – Chapter 5

Financial standing

Price structure – Chapter 6
Yearly revenue and profit projections – Chapter 6
Tax obligations – Chapter 12
Startup funding source – Chapter 6
Name of bank – Chapter 12
Pro forma financial statements – Chapter 10

Distribution plan

Description of distribution strategy – Chapter 7
Direct distribution channels – Chapter 7
Method of payment processing – Chapter 10
Indirect distribution channels – Chapter 7
Alternative distribution methods – Chapter 11
Rent/lease arrangements – Chapter 12

Promotion plan

Description of brand image – Chapter 8
Marketing message – Chapter 8
Plan for using advertising – Chapter 8
Plan for using sales promotions – Chapter 8
Plan for using networking for personal sales – Chapter 8

Plan for using public relations – Chapter 8

Social media plan

Integrating traditional promotion into social media – Chapter 9
Types of social media utilized – Chapter 9
Posting calendar – Chapter 9

Operations plan

Suppliers that will be used – Chapter 11
Production plan – Chapter 11
Employee job description – Chapter 12
Sources of employees – Chapter 12
Name of financial advisor, accountant, insurance company – Chapter 12

	A	B	C	D	E	F
1	**Income Statement**	January	February	March, etc	December	Total
2	*Sales Revenue*					=SUM(B2:E2)
3	Product/Service 1					=SUM(B3:E3)
4	Product/Service 2					=SUM(B4:E4)
5	Product/Service 3					=SUM(B5:E5)
6	**Total Sales Revenue**	=SUM(B3:B5)	=SUM(C3:C5)	=SUM(D3:D5)	=SUM(E3:E5)	=SUM(B6:E6)
7	Cost of Goods Sold					=SUM(B7:E7)
8	Product/Service 1					=SUM(B8:E8)
9	Product/Service 2					=SUM(B9:E9)
10	Product/Service 3					=SUM(B10:E10)
11	**Total Cost of Goods Sold**	=SUM(B8:B10)	=SUM(C8:C10)	=SUM(D8:D10)	=SUM(E8:E10)	=SUM(B11:E11)
12	*Gross Profit*	=B6-B11	=C6-C11	=D6-D11	=E6-E11	=F6-F11
13	Gross Profit Margin	=B12/B6	=C12/C6	=D12/D6	=E12/E6	=F12/F6
14	*Operating Expenses*					
15	Lease/Rent Payment					=SUM(B15:E15)
16	Utilities					=SUM(B16:E16)
17	Phone and Internet					=SUM(B17:E17)
18	General Supplies					=SUM(B18:E18)
19	Professional Services					=SUM(B19:E19)
20	Online Marketplace Fees					=SUM(B20:E20)
21	Website Hosting Fees					=SUM(B21:E21)
22	Credit Card Processing Fees					=SUM(B22:E22)
23	Marketing Expenses					=SUM(B23:E23)
24	Transporation Costs					=SUM(B24:E24)
25	Shipping Costs					=SUM(B25:E25)
26	Loan Payments					=SUM(B26:E26)
27	Payroll					=SUM(B27:E27)
28	Benefits/Employment Taxes					=SUM(B28:E28)
29	Business Taxes					=SUM(B29:E29)
30	**Total Operating Expenses**	=SUM(B15:B29)	=SUM(C15:C29)	=SUM(D15:D29)	=SUM(E15:E29)	=SUM(F15:F29)
31	*Net Profit*	=B12-B30	=C12-C30	=D12-D30	=E12-E30	=F12-F30
32	Net Profit Margin	=B31/B6	=C31/C6	=D31/D6	=E31/E6	=F31/F6
33						

Figure A.1 Sample Income Statement

	A	B	C	D	E	F
	Balance Sheet	Start of Year	End of Year			
34						
35	**Assets**					
36	Cash in Bank					
37	Accounts Receivable					
38	Inventory					
39	Prepaid Expenses					
40	Other Current Assets					
41	**Total Current Assets**	=SUM(B36:B40)	=SUM(C36:C40)			
42	**Fixed Assets**					
43	Furniture/Computers					
44	Production Equipment					
45	Land & Buildings					
46	Other Fixed Assets					
47	Total Fixed Assets					
48	Total Assets					
49	Current Liabilities					
50	Accounts Payable					
51	Taxes Payable					
52	Other Fixed Assets					
53	**Total Fixed Assets**	=SUM(B43:B52)	=SUM(C43:C52)			
54	**Total Assets**	=B41+B53	=C41+C53			
55	**Long-Term Liabilities**					
56	Bank Loans					
57	Auto/Truck Loans					
58	Equipment Loans					
59	Other Long-Term Liabilities					
60	Total Liabilities	=SUM(B56:B59)	=SUM(C56:C59)			
61	**Owners Equity**					
62	Invested Capital					
63	Retained Earnings					
64	Total Owners Equity	=SUM(B62:B63)	=SUM(C62:C63)			
65	Total Liabilities plus Equity	=B60+B64	=C60+C64			
66	(*Total liabilities + equity must = total assets*)					

Figure A.2 Sample Balance Sheet

	A	B	C	D	E	F
67	**Cash Flow Statement**					
68	Cash at Beginning of Year					
69	**Cash Flow from Operations**					
70	*Cash Receipts from Customers*					
71	Cash Paid for:					
72	Lease/Rent Payment					
73	Utilities/Phone/Internet					
74	General Supplies					
75	Professional Services					
76	Marketplace/Hosting/Processing Fees					
77	Marketing Expenses					
78	Transporation Costs					
79	Shipping Costs					
80	Loan Payments					
81	Payroll/Benefits/Employment Taxes					
82	Taxes					
83	Net Cash Flow from Operations	=B70-SUM(B72:B82)				
84	**Cash Flow from Investing Activities**					
85	Cash Receipts from:					
86	Sale of Property					
87	Sale of Equipment					
88	Cash Paid for:					
89	Purchase of Property					
90	Purchase of Equipment					
91	Net Cash Flow from Investing Activities	=SUM(B86:B87)-SUM(B89:B90)				
92	**Cash Flow from Financing Activities**					
93	Cash Receipts from:					
94	Borrowing					
95	Issuance of Stock					
96	Cash Paid for:					
97	Repayment of lonas					
98	Issuance of Stock					
99	Net Cash Flow from Financing	=SUM(B94:B95)-SUM(B97:B98)				
100	Net Cash Flow	=B83+B91+B99				
101	Cash at End of Year	=B68+B100				

Figure A.3 Sample Cash Flow Statement

Index

accounting methods 175–76
accounts: expense 105; income 103
advertising 139–41
agents and brokers 119
AIDA model 145–46
Angel, Jenny-Lind 24
art: definition 8; purchase motivation 90; value 8–9
artists: attracting and assisting 196–99; and city livability 211; communities 85; success 17
assets 176–77

balance sheet 180–81, 225
banks: 170–71; choosing 106–7
barter 111
Bonilla, Leenda 114
branding: 73–74, 133; social media 157–58; success 134
breakeven point 101
budgeting 103–6
business plan 1–2, 20–21, 221–23
business: defined 12–13; history 19; license/permit 210–11; market 10–11; ownership 18; segments 91–92; structures 13

cash flow statement 181, 226
cash, managing 103
Chang, Jonathan 149
Ciabattri, Bll 186
commoditization, of products 62
comparison product 64
competitive advantage 74–76
competitor analysis 33
community, social media 162–63
consignment: contracts 208; sales 187–88
consumer market 10

contracts: commissioning 208–9; managing 204–9; property 205–7, reproduction/ licensing 207–8
convenience product 63
cooperatives 15, 188–90
copyright 211–14
corporations: defined 14–15, buying art 66
costs: fixed 16, 100–101; variable 16, 101
craft: and art fairs 126; defined 9; vs. art 69–70
credit score 173–74

data analysis 55–56
distribution: direct 115–16; indirect 116; multi-channel 127–28, strategy 116–18

economic: analysis 35; development 194–96; agencies 199
employee: firing 218; hiring 215–18
entrepreneurship: history 19; training 209
environmental scanning 32
external environment 32–34

Farley, Sean 203
finances, personal 172–74
financial: resources 29; statements 179–81, 224–26
focus group 52
Frisbie, Hillary 132
funding: growth 182; sources 107

government: data 46; organizations 12
Gunderson, Amanda Horn 186

income statement 179–80. 224
income, supplemental 17
insurance 183–84
intermediaries, art 11, 26
interviews 52–53

inventory management 193

legal issues 209–11
liabilities 178
lifestyle: business 18; publications 46
live/work spaces 128, 198–99
loan: application 109–10; commercial 108; family/friends 110–11; government 110
Lyke, Allison 79

market: breadth 81–82; depth 81
media: paid 150; owned 150–51, earned 151
mission 25–26, 28
Moore, Chelsea 97
multiplier effect 195

net worth 173
networking 144
non-price competition 99
nonprofits 13, 15, 190–91

objectives 37–38
observation research 53
online marketplaces 144–45
opportunities and threats 36–37
outsourcing 194

pay rate, artists 174
partnerships 14
payment processing 171–72
performance venues 128–29, 191
personal selling 143
pricing: art 98–99; competition 101–2; cost 100; lessons 102; prestige 102
primary data 47
product: benefits 67–69; definition 62; lines 65–66; packaging 70–71; types 64
production: location 120–22; planning 193–94
profit 98–99
purchase process 92–94; social media 159–60

research: competitor 42–43, 54; conducting 54–55; customers 43; definition 42; methods 49–51; process 43; question 44–45; statistically valid 48; subjects 48–49
retail: intermediaries 118–19; location 122–214; types 127
revenue: 98–99, projections 104–5; vs. profit 15–16
Robinson, Stephanie 41
Ruess, David 61

sales incentives 141–42
secondary data 46
segmentation: demographic 86–88; geographic 88; mass customization 91; one-to-one 91; psychographic 89
service characteristics 71–73
skills: personal 30; organizational 31
social commerce 154
social media: branding 157–58; calendar 163–64; customer expectations 158–59; integrating with paid media 152; quality 163–64; rules for success 160; strategy 155–57; uses 161–62
socio-cultural analysis 33–34
sole proprietorship 13–14
specialty product 64–65
strategic goals 20, 37–38
strengths and weaknesses 36
supplies, purchasing 192
survey 50
SWOT analysis 35–37

tactics 37–38
Tanaka, Mariko 169
targeting: consumer segments 80; strategies 82–84; process 84;
tax issues 214–115
technological analysis 34–35
trade: associations 47; shows 126

values 27
variances, analyzing 106
vision 27
Vyvozilova, Helena 7

website distribution 124–26
wholesalers 119